the knot
yours truly

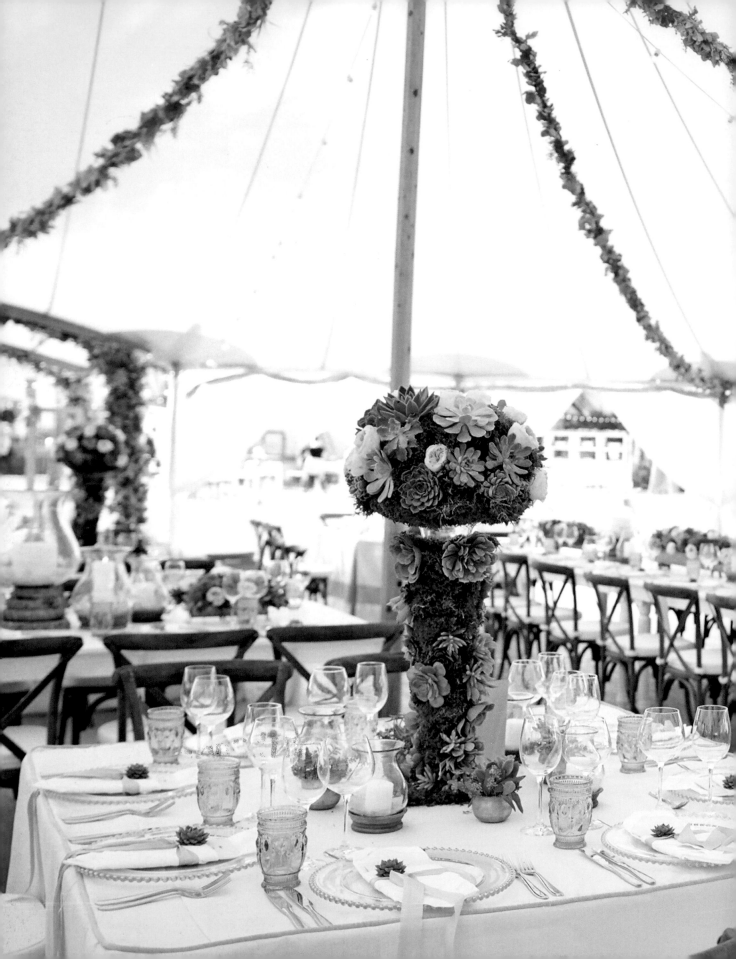

the knot
yours truly

INSPIRATION *and* IDEAS
to PERSONALIZE YOUR WEDDING

CARLEY RONEY
and the editors of TheKnot.com

CLARKSON POTTER/PUBLISHERS
New York

Library of Congress Cataloging-in-Publication Data
Names: Roney, Carley, author. | Knot (Firm)
Title: The knot yours truly : inspiration and ideas to personalize your
wedding / Carley Roney and the editors of TheKnot.com.
Description: New York : Clarkson Potter, 2017.
Identifiers: LCCN 2016057535 | ISBN 9781101906477 (paperback)
Subjects: LCSH: Weddings—Planning. | Wedding etiquette. | BISAC: REFERENCE /
Weddings. | CRAFTS & HOBBIES / Decorating. | PHOTOGRAPHY / Subjects &
Themes / Celebrations & Events.
Classification: LCC HQ745 .R664 2017 | DDC 395.2/2—dc23 LC record available at
https://lccn.loc.gov/2016057535

ISBN 978-1-101-90647-7
Ebook ISBN 978-1-101-90648-4

Printed in China

Front cover photograph by Alexandra Grablewski
Flap photographs by Pernille Loof
Back cover photographs, clockwise from top left, by Sara Kate, Photography;
Pernille Loof; Lauren Fair Photography; Ryan Ray Photography; Pernille Loof;
Jose Villa Photography
Crafts by Lia Griffith

10 9 8 7 6 5 4 3 2 1

First Edition

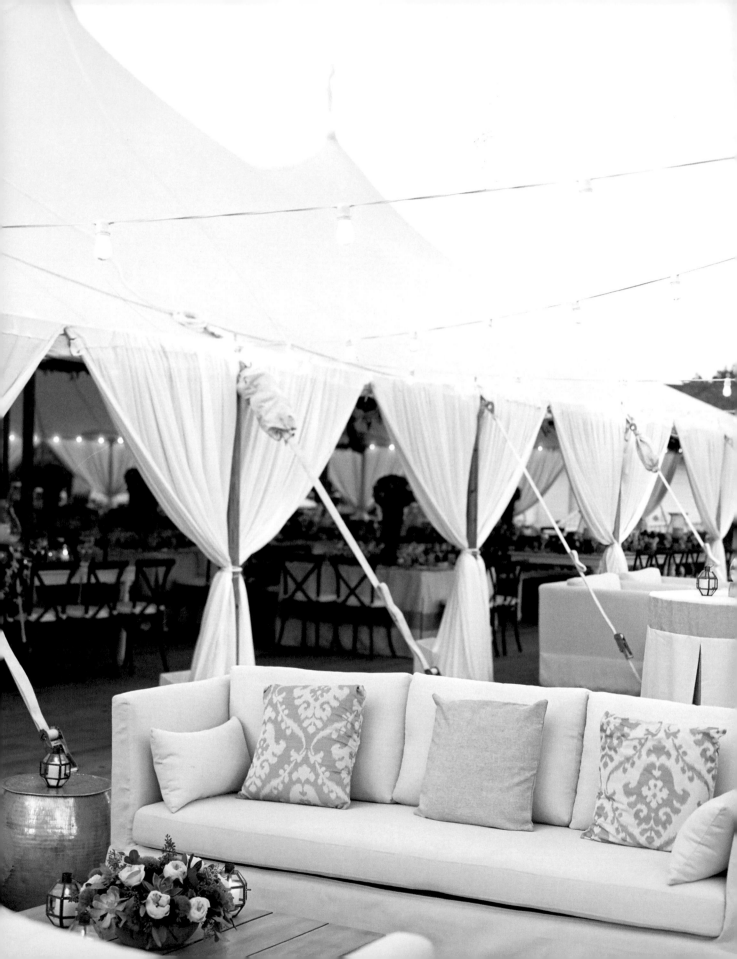

contents

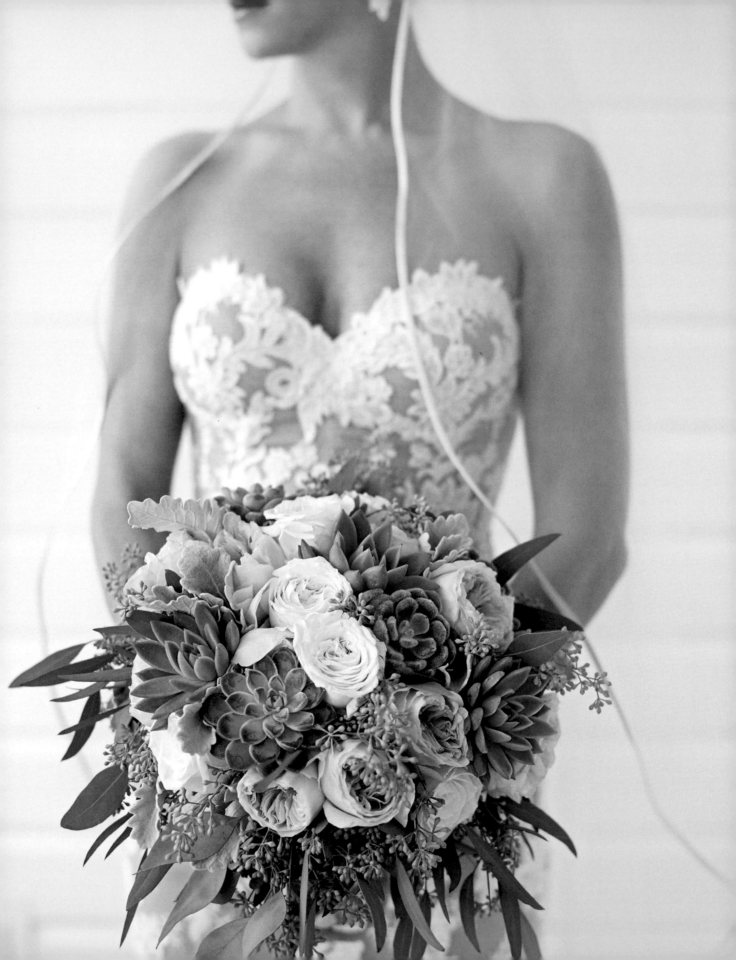

introduction

Our idea of a perfect wedding is one where guests walk away declaring, "Wow, that was so *them*!" Yes, we want the food to be fabulous. Yes, we want the guests to have fun. But most of all, we want your wedding to be an experience that truly reflects your unique partnership, a party that only you could throw. Don't get overwhelmed—we're here to help.

Wedding planning always begins with a rush of images, from memories of weddings you've attended to the thousands of real wedding stories on The Knot. It's thrilling to see those couples and how their weddings came to life, but what about *yours*? You don't want to risk losing yourselves in the treasure trove of inspiration. As for trends—what will be overdone before you even say "I do"? It's a lot to consider. So how can you make the most of the resources available to you while making your wedding your own?

Start by reminding yourself that you already know what you like and ultimately what you want. You two are the most important element here—it's your moment to show the world exactly who you are as a couple. Before you get carried away with the details (though we'll certainly get to those), take a moment to reflect on what you find most meaningful—or most fun—about your dynamic duo. Is it how you always find a way to make each other laugh? If so, make sure to squeeze some jokes into your vows. Is there an activity you enjoy doing together? Find a way to weave it throughout the day's décor. A reference to something as small as your Sunday night pancake dinners (pancake bar at a black tie wedding? Yes, please!) will go a long way to making your day feel like a true representation of you two. It's the personalized details—not the ones you feel pressured to include—that will stand out in your mind and in the memories of your guests.

And don't be afraid to create your own traditions. If everyone in your town gets married at a hotel, but your heart is set on celebrating at the summer camp where you met when you were 12, do it. We'll make sure you're covered on everything from the rustic ceremony to the bonfire after-party. If you want to exchange vows at the same church where your parents did decades ago, go for it. We'll help you find ways to honor their event and still set the two celebrations apart.

Welcome to The Knot take on weddings. We know the rules, but we'll help you break them brilliantly. We want your wedding to be truly your own.

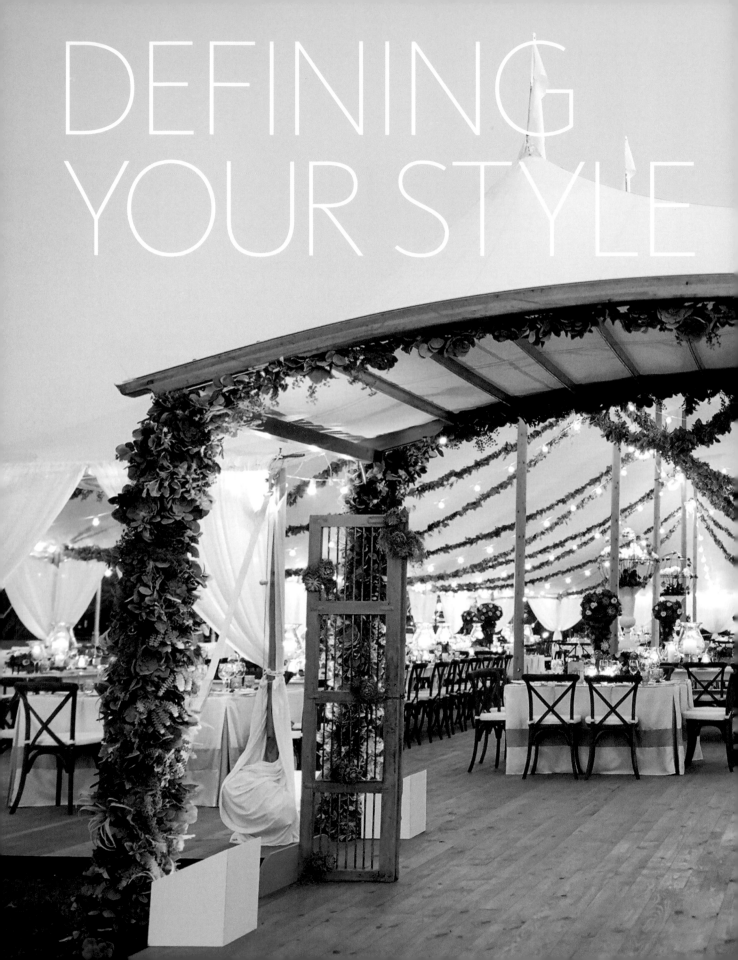

DEFINING YOUR STYLE

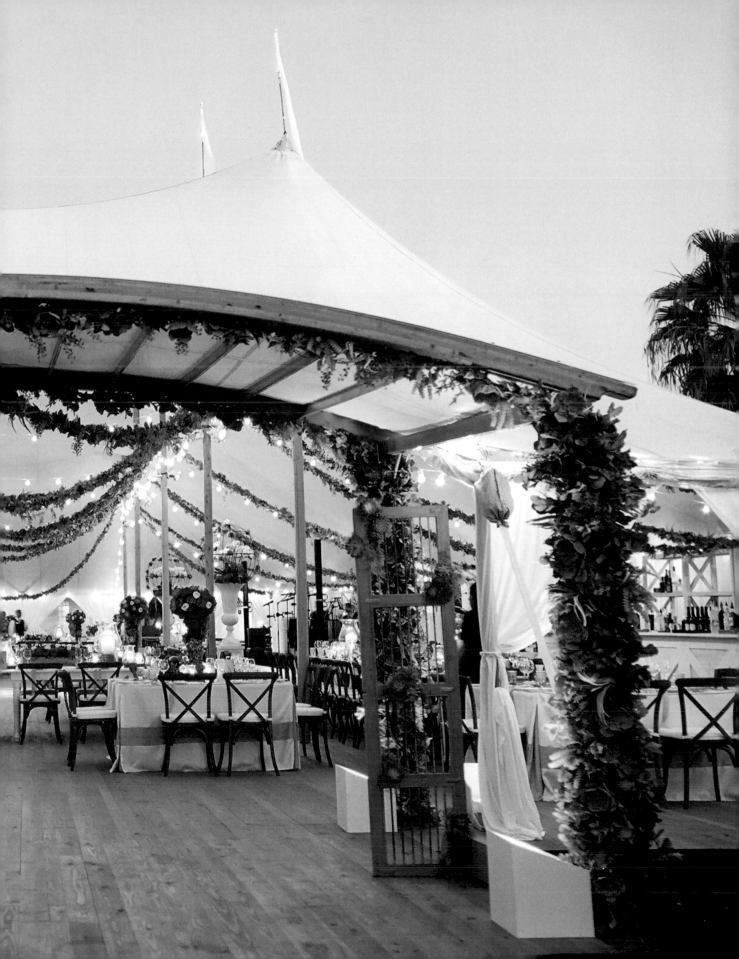

SUZETT & SAM
DECEMBER 17

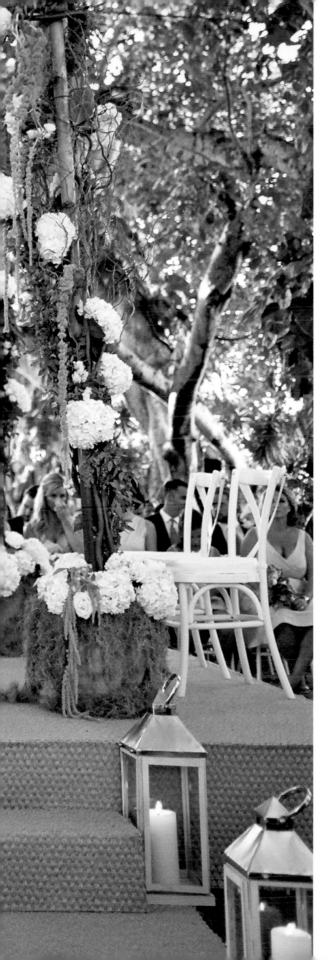

ENVISION YOUR WEDDING

Before you start obsessing over centerpieces, sit down and visualize the grand scheme of the wedding as a whole. Setting an overarching concept and sticking to it is crucial for a celebration that feels cohesive and reflects your unique tastes. The guiding principle for your day could be as simple as a palette (yellow and gray) or as specific as a scene in a play or movie (*A Midsummer Night's Dream* enchanted garden). Where you start—and how far you carry the concept—is entirely up to you two. No matter how elaborate you get, simply having a common thread woven throughout the day will help your vision come alive.

Picture your ideal wedding day—what does it look like? Are there waves crashing at your feet? Or maybe you're walking down the aisle in a candlelit ceremony? Is it religious or festive? Are you celebrating inside a beautiful barn or a fancy ballroom? Do you hear the clink of glasses and conversation or the steady beat of dance music? And how many people are there with you—is it a small, intimate affair of 50, or are there 500-plus guests?

Once you've got a handle on the big picture (location, scale, mood), identify your nonnegotiables—you know, the things you're just not willing to compromise on. If your heart is set on having a jazz band, or if you're determined to get married in your parents' backyard, make sure everyone is well aware of your wishes from the start. Not only does this avoid any surprises down the road, but this way you—and your families, if appropriate—can plan efficiently and accordingly.

FIND A PERSONALIZATION MUSE

The best way to create a unique wedding is to personalize the details around something you're both passionate about. A personalization muse can come in many forms, whether it's a favorite classic film, an artistic era ('20s art deco to '80s punk rock), or something as simple as your favorite flower. Symbols, patterns, architecture, illustration styles—they can all be muses. Honing in on a personalization muse is a great way to pinpoint your style inspiration and create a cohesive yet original event. Your muse may even be a memory you share—like where you had your first date or your favorite vacation spot. Think about what matters most to you as a couple. Going through your photos or feeds is a fun way to brainstorm.

TALK IT OUT TOGETHER

Chances are your dream wedding ideas are slightly different—at least in part—from those around you. The sooner you get it all on the table, the better. Part of the visualization process is putting your ideas side by side to see how they work together. After all, being able to compromise is necessary (and really good practice for marriage). Start by having a frank

conversation with your spouse-to-be about how you both imagine your wedding day. Don't start defending or deflating each other's visions too quickly. With the variety of events involved in a wedding, there will be a moment to incorporate everyone's unique fantasies.

And although it can be uncomfortable to talk money, it's essential to determine who's contributing what to the wedding costs and how much you both want to spend. Before you define your budget, get on the same page with your partner. Maybe you're doing it on your own, and you're each giving fifty-fifty to the total cost. Or perhaps you're both contributing funds along with your respective families. This step is important for a number of reasons, but in large part because those who contribute financially generally get to have a say in how the money is spent.

DEFINE THE FORMALITY

The formality of your wedding day can affect the menu, flowers, décor, entertainment, and more. How formal you go is totally up to you—ultra-formal, formal, semiformal, or informal; what suits you best? If you're a T-shirt and sweats kind of couple, an informal or semiformal affair (think cocktail attire) may be most appropriate for your celebration. On the other end of the spectrum, couples dreaming of white-gloved waiters and towering floral installations will likely find themselves drawn to an ultra-formal affair. Once you've settled on the level of formality, it's important to make sure the rest of your day looks and feels consistent.

Your venue and time of day are two of the biggest factors in determining the formality of your wedding. Here are some basic guidelines to help you decide what's best for your celebration.

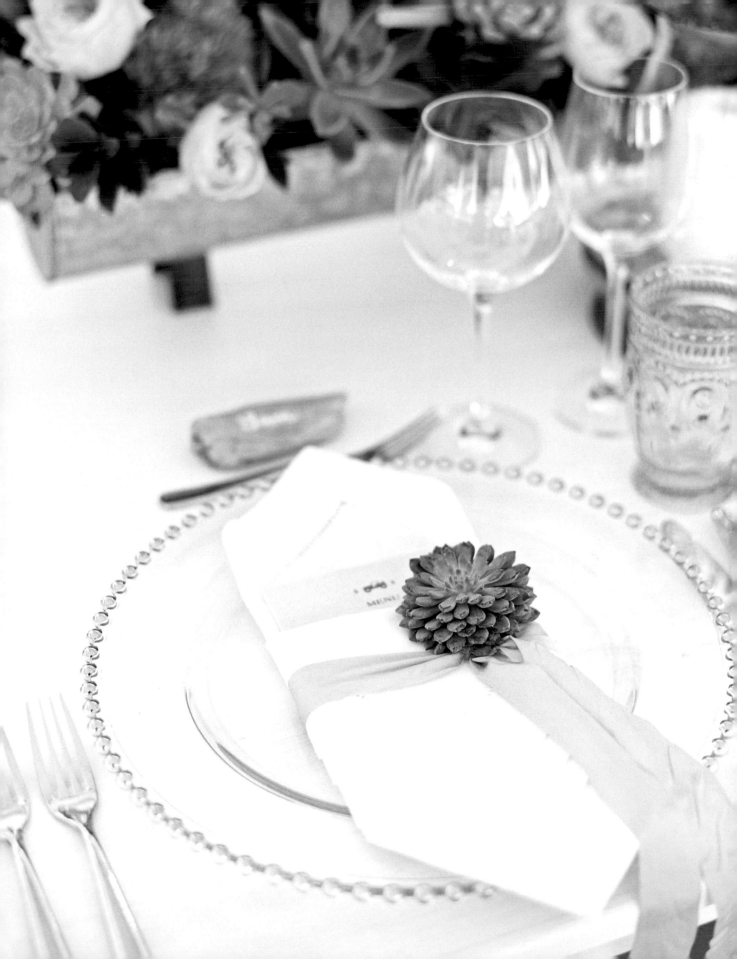

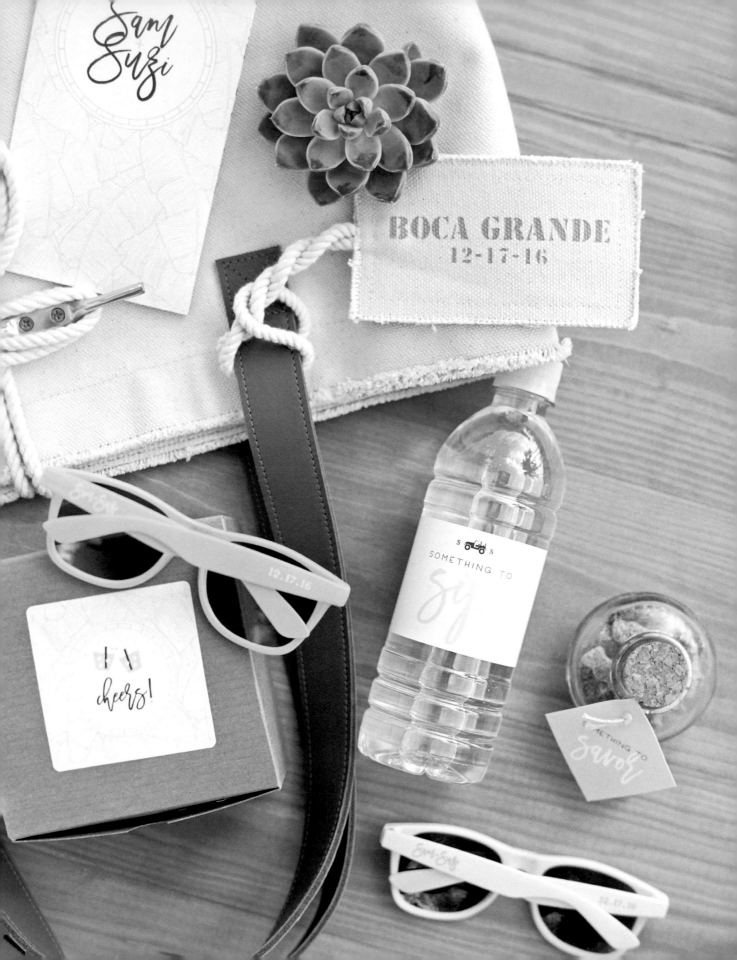

ULTRA-FORMAL: A ballroom or grand hall type of setting, complete with a twenty-four-piece band and over-the-top centerpieces. This kind of luxury style (à la state dinners and the Oscars) works only in the evening and requires the most formal of all dress codes, with black tie for guys and floor-length gowns for the ladies.

FORMAL: A late-afternoon or evening affair that's slightly less formal than a black-tie event and might be at a museum, historic building, or picturesque estate. A tuxedo isn't required, but the event is still formal enough for one to be appropriate; it's just casual enough for a formal dark suit and tie to be suitable as well. Women can choose a fancy cocktail dress or a floor-length gown. "Black tie optional" and "cocktail attire" dress code instructions both fall under this category

SEMIFORMAL: A late-afternoon or evening affair that could take place anywhere from a country club or loft to a winery or restaurant. "Cocktail attire" is customary, with a suit and tie for the guys (dark or light depending on the season and time of day) and a cocktail dress or a dressy skirt and top for the ladies.

INFORMAL: Anytime and (almost) anywhere affairs—think stylish backyard, rustic barn, mountain-top lodge, or beautiful beach. Ties are optional for the men, and sundresses or skirts are suitable for the women.

CONSIDER THE VENUE

The setting plays a major role in shaping the feel of your day. While you can make any space your own with the right décor, it's always easier (and more cost effective) to work with something already in place. So look for a venue with décor that fits your style.

And if you're planning on hosting the ceremony and reception in separate venues, you'll want to choose spaces that have a similar vibe and are ideally close in distance so they're easy for your guests to move between.

Don't be afraid to think outside the box. Maybe your first date was at a funky Mexican restaurant, so a hacienda-style hotel may be a perfect reception venue. If you're both outdoorsy, consider a waterfront or mountaintop setting and rely on Mother Nature for the wow factor. If you met and fell in love during college, why not wed on the university's gorgeous grounds? Long gone are the days when a couple's best option was the nearest event hall. Today you can rent a Tuscan villa, get married at a vineyard, say your "I dos" on a yacht, or even set up a camp in the woods. Look for a space that feels authentic to your passions and style.

USE THE SEASON

What season feels the most romantic to you? Certain seasons hold significant sentimental value for many couples. Fall may be when you fell in love, or maybe you've dreamed of an outdoor summer wedding by your beach house since childhood. Getting married during a meaningful time of year only adds to the significance of the day. The season can also help you decide on food, music, flowers, favors, décor, and even what you wear. You can think of the season as a sort of secondary theme, or it can lead the whole planning process. The easiest and most subtle way to high-light the time of year is through your color palette. Light pastels and barely there hues like blush might be pretty in spring but could look washed out in fall. Dark colors like burgundy work well in fall and win-ter but are best reserved for accents (or paired with brights) if you're having a summertime fete.

INCORPORATE FAMILY AND CULTURAL TRADITIONS

What customs or traditions have each of your families included in past weddings? Incorporating rituals (whether it's a Chinese tea ceremony, Scottish bagpiper, or reciting the same vows your parents did) from both of your backgrounds is the number one ingredient to a personalized wedding. Even if you're unsure how your friends will react to the dollar dance, but it's something your family loves, do it! If you all join hands and pray before eating at family gatherings, work it in or even reinvent the idea: Ask everyone in the room to hold hands in a long chain from table to table. It's the unique traditions—no matter how unusual—that make for the best moments.

Religious and cultural traditions are also parts of you that make you who you are, so celebrate them.

Pick and choose which to include or which you want to honor in a new way (like wearing fuchsia instead of red for a Chinese ceremony). If some of your guests aren't familiar with certain customs, use your programs, wedding website, an announcement, or other signage as an opportunity to explain them. Or ask your wedding attendants to be your ambassadors—they'll have everyone dancing the hora in no time. If you don't share the same religion, consider creating an interfaith ceremony as your first new tradition in a lifetime of blending rituals.

ADD A THEME

The more specific you get with your vision, the easier it will be for you to choose all the details and convey your ideas to a team of vendors. Instead of stopping

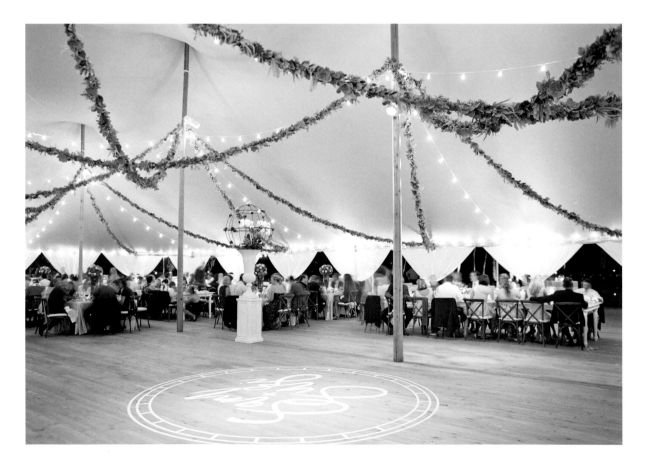

at "glam," decide whether you want "art deco glam" or "old Hollywood glamour," for example. Or if you're picturing a garden party, consider whether you want an English garden theme or a rustic country garden party. They're different, and distinguishing your theme early on will keep everyone on the same page (and save a lot of time in the long run). Your theme can be anything from a favorite era, hobby, or place in the world to your heritage or culture, the season, a type of food, or even something inspired by your wedding locale. Just make sure whatever theme you choose meshes with the formality and venue you've chosen.

Of course, you want everything to look fabulous, but make sure your wedding celebrates who you and your spouse-to-be are as a couple. Choose a theme that reflects something personal about you, whether it's your cultural backgrounds or your shared love of books, modern art, or skiing. Opt for one concept that applies to both of you, not a mash-up of ideas—trying to incorporate multiple themes into your four-hour reception can be tricky. The rehearsal dinner, after-party, and morning-after brunch are all great places to display another powerful theme, so don't table anything just yet. Also play into the details—gifts for your wedding attendants, a groom's cake, double dessert courses, a late-night-themed snack, and even your vows offer ways for each of you to share your personal passions.

PLAY UP YOUR PERSONALITIES

What interests or obsessions do you have that really say who you are? What do you do together on the weekends? You don't have to go all out to the point of kitsch—you might just choose to personalize a single detail. No matter what your passions are (be it bowling, listening to obscure bands, biking, or binge-watching TV), there's something authentic to the two of you that's worth celebrating.

If you're having trouble identifying your interests, take a moment to think about your favorite things or things people associate with you (together or individually), and write them down—no matter how silly they seem. You don't need to incorporate every single one of them into your wedding, but pick a few that fit together. If one of you really likes pickles, why not have a pickle bar during cocktail hour? Your guests will pick up on the connection if you name it "Mel's Pickle Bar," and more importantly, it will be an element that's uniquely yours.

PERSONALIZE YOUR PALETTE

Color is arguably the biggest unifying factor between all of your wedding elements. Your wedding palette can inspire your wedding style, help create the right vibe, and even be used as the theme of the celebration. Most couples choose one main color and an accent color (rose and gold) or two equally prominent complementary colors (colors that are directly opposite each other on the color wheel, like green and pink or yellow and purple) for a bright contrast. But you could also choose an analogous or more monochromatic scheme—putting together three colors that fall side by side on the color wheel, like blue, periwinkle, and violet, to bring out the subtle nuances of one color family. Sticking with two or three colors will keep the look coordinated. For inspiration, pick something personal: the signature robin's egg blue of the hotel from your first vacation, burgundy because you both always choose red wine over white, and, yes, for all you sports fans, team colors can work too.

putting it all together

ORGANIZE

By our estimates, the average couple makes well over 500 distinct decisions to execute a wedding. The only way to keep it all organized and easily accessible is to go digital—using online tools and apps to store documents, notes, photos, and contacts. A binder is also essential for samples and the inevitable paper contracts that will come your way. You may want to create a new email address exclusively for all wedding-related correspondence, so all your conversations with vendors will be in one easy-to-access place. The Knot wedding planning tools and apps make it easy to find and store vendors, images, and ideas, as well as track every to-do, guest RSVP, and gift purchase—a real sanity saver.

BOOKMARK YOUR FAVORITES

Sign up for notifications from The Knot—we'll send you a list of to-dos tailored to where you are in the planning process along with tons of inspiration. We also help connect you to a team of vetted professionals who will help bring your vision to life. It's never too soon to start saving your favorite ideas and wedding pros you want to consider. This will help you remember where you found them and allow you to refer back to your favorites throughout the planning process. The themes, moods, colors, and personalization muse words you decide on make great search terms and hashtags to browse regularly too.

INSPIRATION BOARDS

Creating a dedicated space for your wedding images is essential—this means you don't need to scroll through the 4,000 vacation photos to find that bouquet you loved when you want to reference it in a florist meeting. Make sure they are organized into categories (flowers, ceremony ideas, hair and makeup, etc.) and can be accessed and shared from any device. Start out by just saving anything and everything that catches your eye. Slowly edit and curate your images as you get a clearer picture of your style. Always keep a board called "out" for ideas that you don't want anymore. You'd be surprised how often you go back to things you've vetoed as your wedding style takes shape. Sharing a board with a wedding designer (and your other pros too) is the easiest way to be sure when you both say "modern" you mean the same thing.

STAR POTENTIAL VENDORS

Take note of wedding pros who inspire you. Even if you're months away from booking a baker, for example, save that incredible cake artist you accidentally came across for later. It is a good idea to read reviews or look deeply at their portfolio. And add them to your official saved "maybe" list early on, as wedding business names quickly start to sound very similar. If you decide to hire a planner, they'll have lots of vendor recommendations for you as well, and it's nice to organize everything in one place.

TRUST YOUR GUT

At the end of the day, your wedding is about the two of you. The minute you pick up a wedding magazine or log into a planning app, you're going to be inundated with gorgeous photos. It's easy to feel tempted to change your mind or choose something that's pretty—for someone else. While the resources are there to inspire you, it's important that you stay focused on finding what works with your personalities, budget, and sense of style. A day that is authentically yours will really go down as the best day ever.

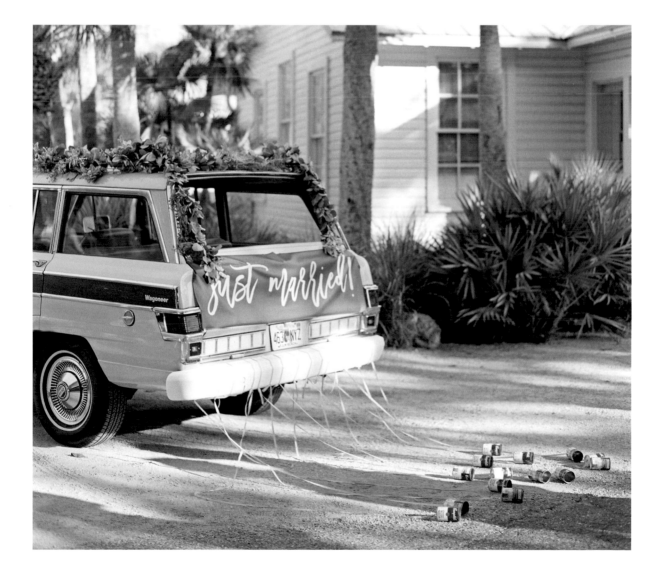

REAL WEDDINGS

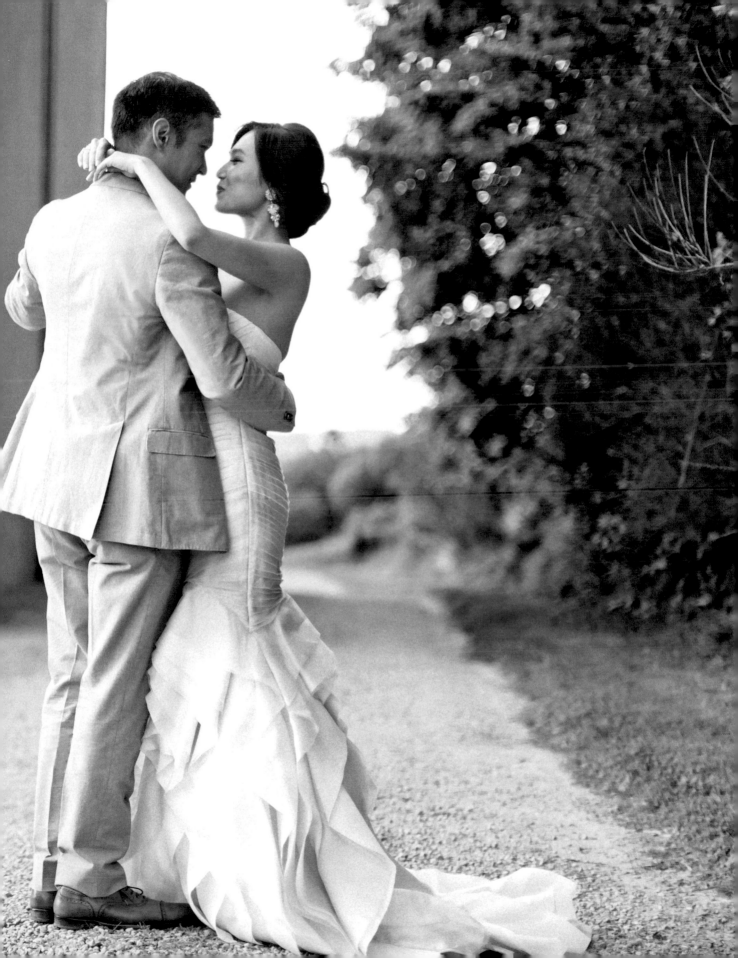

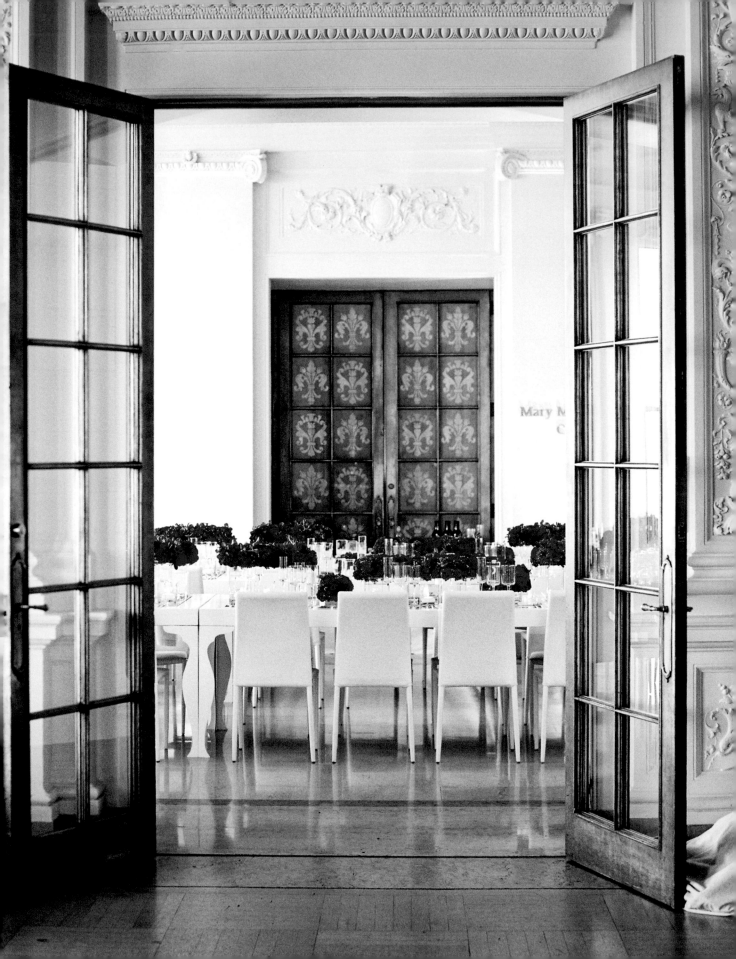

No matter the style, your wedding should look and feel like you. That may be nontraditional and spirited with a true bohemian (page 26) vibe. Or it could be timeless and rich, with elements that are a nod to your grandparents' classic (page 48) affair. A bright palette and a mariachi band, to pay homage to your first vacation together, will help you pull off an eclectic (page 70) fete. Perhaps you've got your heart set on throwing the glam (page 95) party of the year with lush floral installations. Or maybe you want something sleek and modern (page 118) with pops of color and geometric design elements. And while every wedding is romantic (page 137) in its own right, you could decide to infuse details of your own love story, creating an intimate ambience with vintage touches and candlelight. If you two are more laid-back, a casual rustic (page 163) wedding, complete with comfort food, might be for you. To help define your style, take a look at some of our favorite weddings across these categories. Get inspired by the personalized details in the pages ahead—and then make them your own.

bohemian

If *nontraditional*, *free-spirited*, and *bold* are words people often use
to describe you as a couple, a bohemian wedding is the perfect
way to say "I do." These vibrant affairs rely on mismatched patterns,
warm hues, untamed blooms, and an assortment of earthy textures
and nature-inspired elements, which makes them perfect for the
hippie-chic couple looking to host a unique celebration.

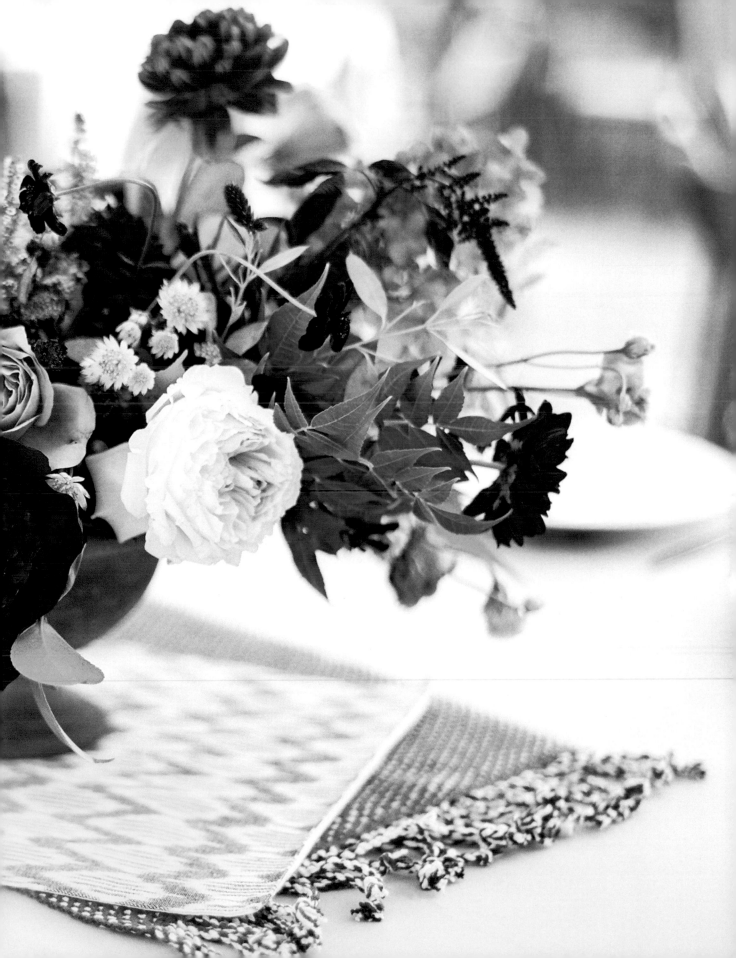

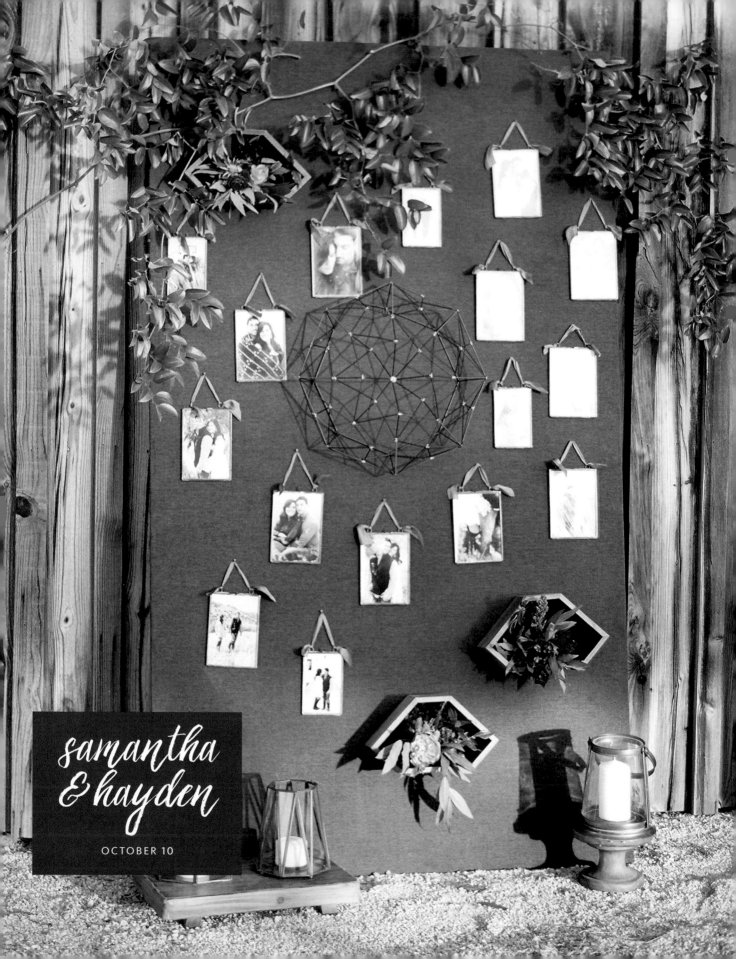

samantha
& hayden

OCTOBER 10

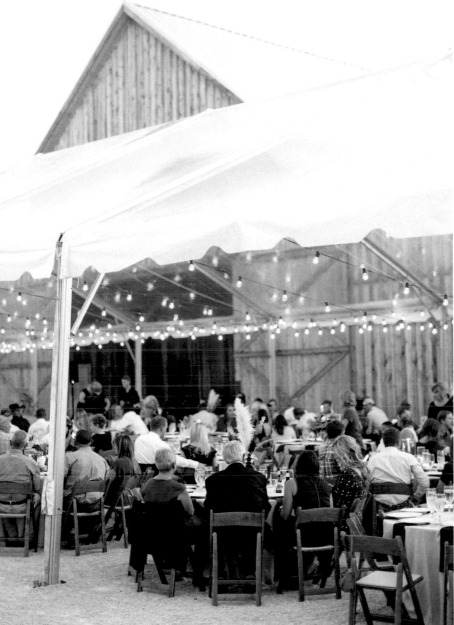

CLOCKWISE FROM OPPOSITE PAGE
The couple shared their engagement photos at the wedding. • String lights added an air of romance to the tented portion of the reception. • Samantha's overflowing, unstructured bouquet mirrored the day's relaxed vibe. • The bride's mother wore a delicate ranunculus corsage on her wrist.

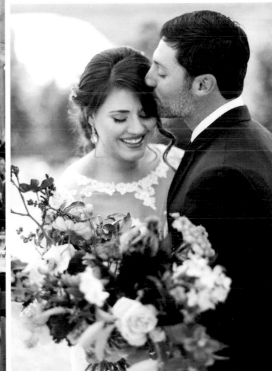

Romantic jewel tones, whimsical florals, and a mix of textures and patterns gave Samantha and Hayden's nuptials a relaxed but special feel. Unfazed by their venue's limited capacity, they turned the barn into a spacious dance floor and set up a large clear tent right next to it for dinner. Despite a nearly 500-person guest list, the couple's brilliant use of space combined with their laid-back personalities (and Samantha's bohemian aesthetic) came together to create a decidedly intimate vibe for their day.

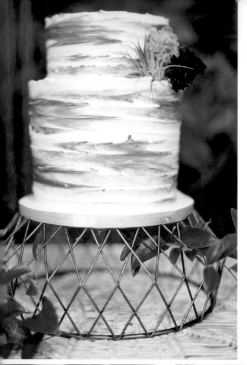

"Although the reception was held in a barn, I wanted to steer clear of the whole mason-jar-rustic vibe. I wanted a more organic bohemian-eclectic ambience."

SAMANTHA

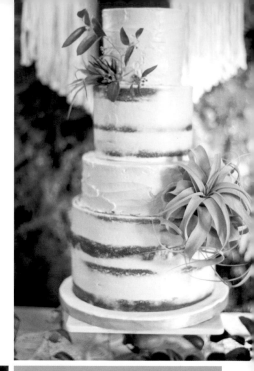

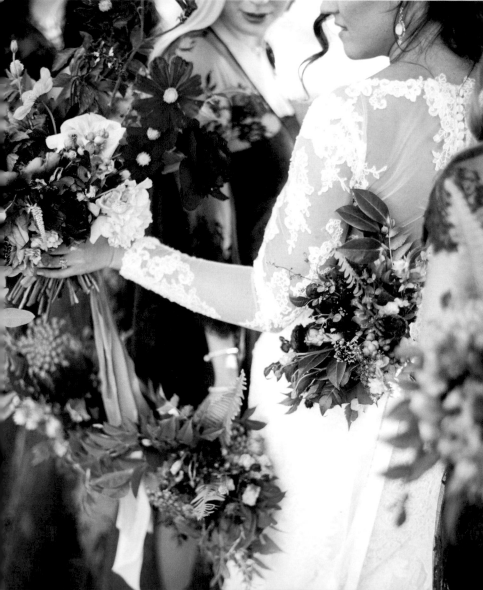

tip

CONSIDER USING TWO SPACES—ONE FOR DINING AND ONE FOR DANCING—TO ACCOMMODATE A LARGE GUEST LIST.

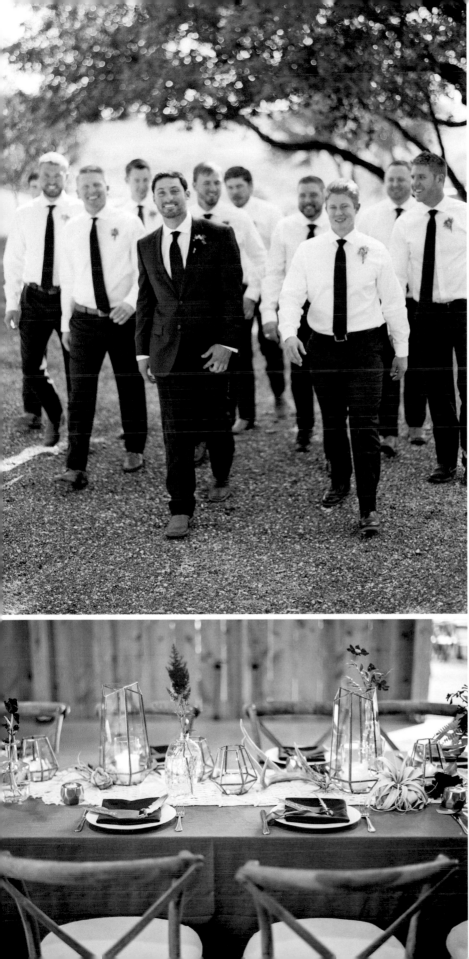

Samantha and Hayden served not one but five wedding cakes, including this two-tier confection brushed with burgundy accents. • The dessert station also included a tall nearly naked cake adorned with air plants. • Hayden's 10 groomsmen went sans jackets for a more casual look. • A guitarist serenaded the guests during the alfresco cocktail hour. • Low floral arrangements allowed for easy conversation among guests at the reception. • The ring bearer looked dapper in plum pants, burgundy suspenders, and a checked bow tie. • Sheer long sleeves with lace appliqués gave Samantha's gown a timeless feel.

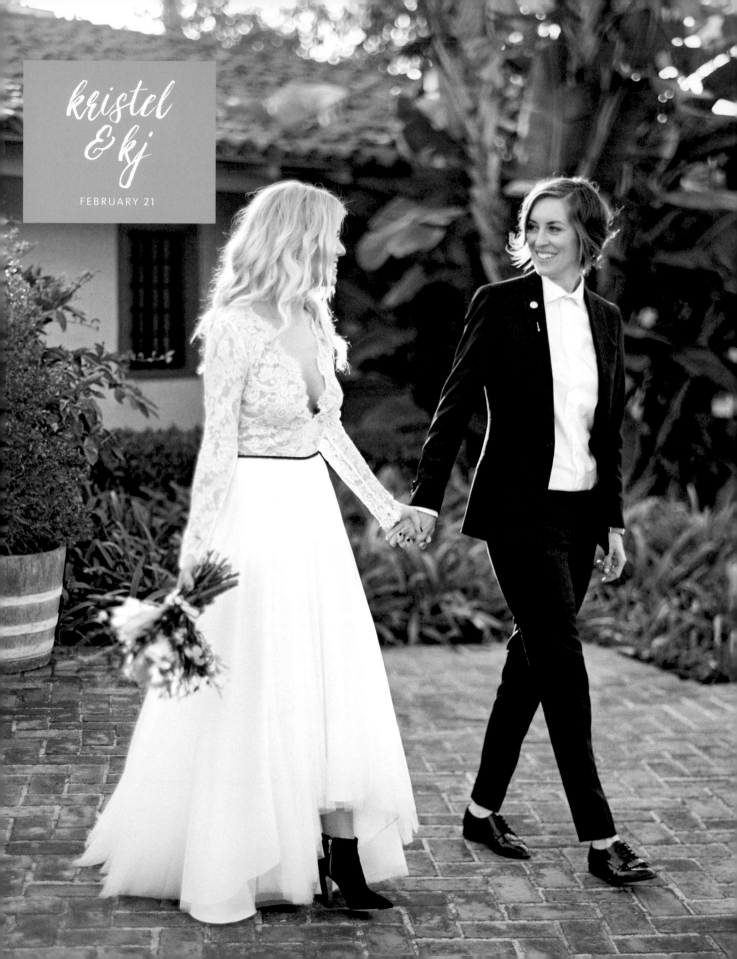

kristel
& kj

FEBRUARY 21

THE PLEASURE OF YOUR COMPANY
is requested at the wedding celebration of

KJ + Kristel

sunday, the twenty first of february, two thousand and sixteen

THREE
o'clock in the afternoon

Rancho Los Cerritos
4600 Virginia Road | Long Beach, CA 90807

| continuing the celebration |

FIVE
o'clock in the evening

Padre
525 East Broadway | Long Beach, CA 90802

please rsvp by 2.7.16 at
kristelandkjsayido.wix.com/kandk

*"There is beauty
but you've got to get
allow yourself the
and relish in the sacred sweetness
that is unique to every day."*

CLOCKWISE FROM OPPOSITE PAGE
Kristel accessorized her high-low wedding dress with a black raw-leather belt and black ankle boots. KJ wore a custom black suit and a white button-down shirt for the occasion. • The brides engraved their own invites into pieces of wood. • Guests sipped on kombucha and cold-brew coffee during the ceremony. • Squares of black leather formed a unique runner for the long reception tables.

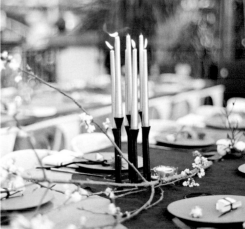

Kristel (left) and KJ didn't have to look far to find design inspiration for their wedding. The couple simply expanded on the color palette and style of décor they used in their own home, which they describe as "mid-century modern meets organic and homey," to bring their hippie-chic affair to life. The clean lines and natural elements of one furniture piece in particular (a vintage Eames chair made of wood and black leather) proved particularly influential in the overall design.

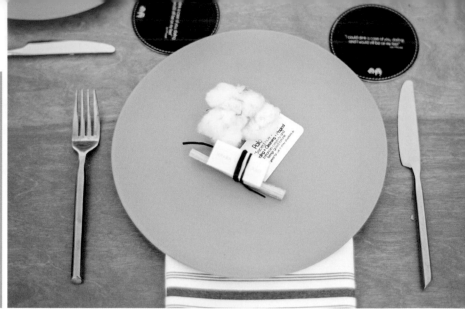

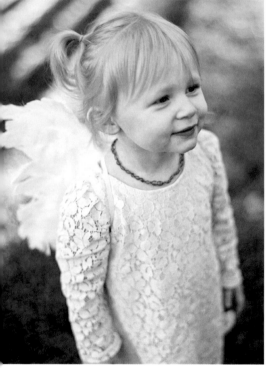

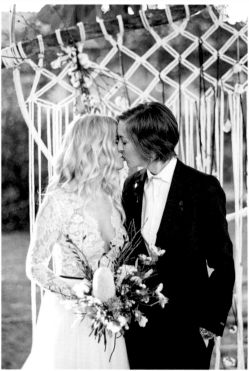

"It's your day, so make it your own. Reflect on yourself, the two of you as a couple, what makes you happy, and run with it. Don't do things just because you 'should.'"

KRISTEL

CLOCKWISE FROM TOP AND OPPOSITE
"We didn't want anything that felt too cliché," KJ says. The place settings included copper flatware and matte-gray stone plates. • The couple skipped linens and let the natural wood of their hairpin tables take center stage. • KJ surprised Kristel at the reception with a song she wrote just for her. • Kristel's five nieces wore white lace dresses and feathered fairy wings. • Cotton details were woven throughout the day, including the giant macramé dream catcher that served as their ceremony backdrop.

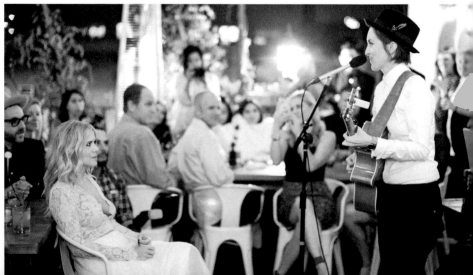

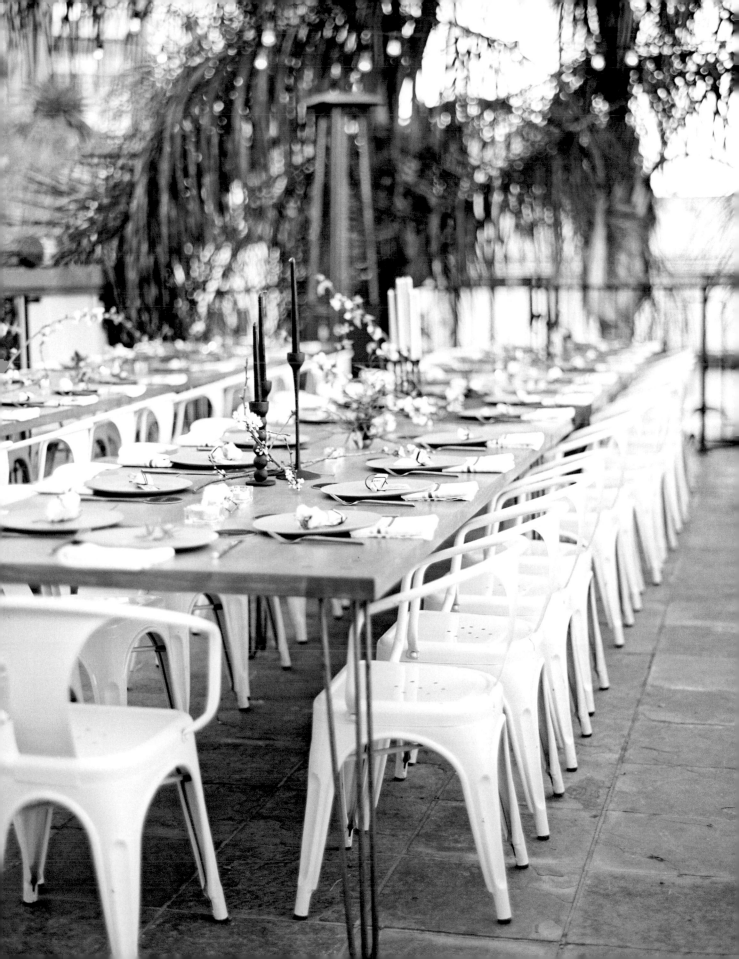

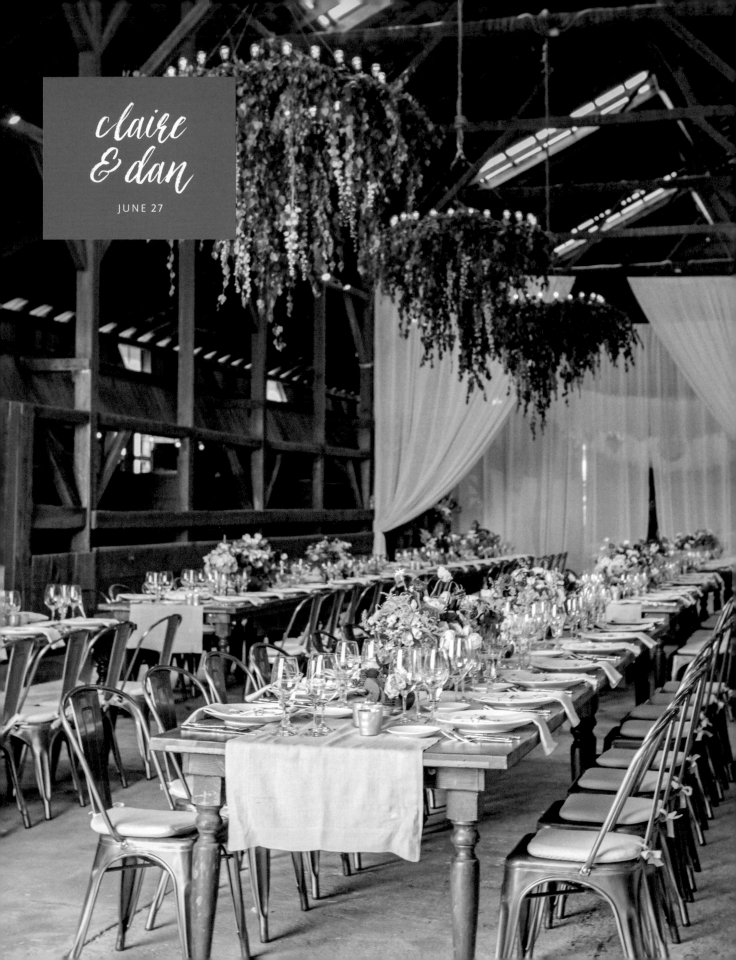

claire
& dan

JUNE 27

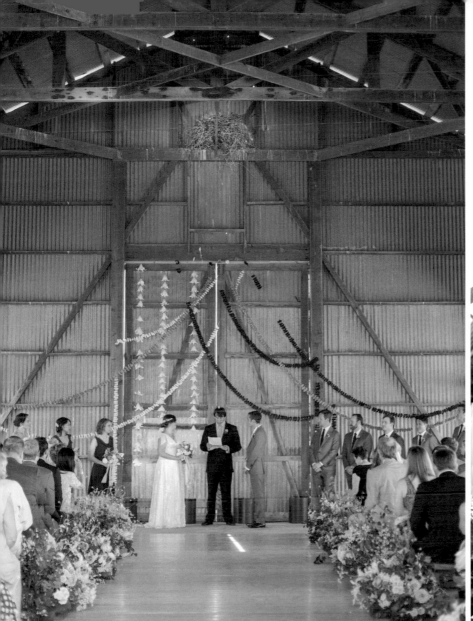

Chandeliers made with hops hung from the rafters above the farm-style reception tables. • Garlands of lilies and carnations created a backdrop for the couple's "I dos." • Suspended tassels and glittering piñatas (that Claire and her friends spent a year making) ensured the dance floor was the focal point of the night, which is exactly what the couple hoped for. • Pink, orange, and red tassels were used throughout the day—from the bridal bouquet to the place settings—for fun pops of color.

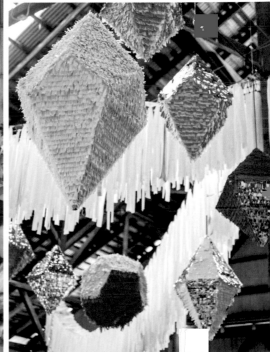

C heerful shades of orange, yellow, and pink with pops of burgundy set the stage for Claire and Dan's joyful day at the bride's historic family ranch. Raw wood details and low floral arrangements complemented the sprawling 100-year-old barn that served as the backdrop for both the ceremony and reception. The couple skillfully balanced whimsical and rustic elements, plus some DIY touches for a look that felt totally them.

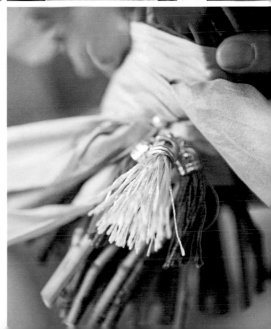

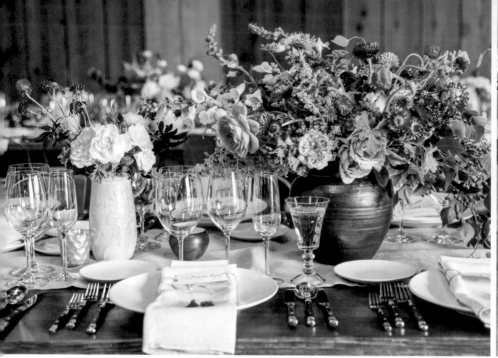

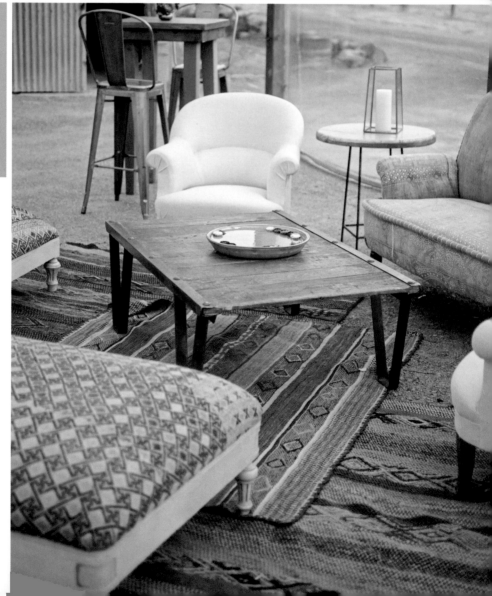

tip

A FAMILY-OWNED VENUE IS OFTEN
A SENTIMENTAL CHOICE FOR A
WEDDING, BUT BE PREPARED FOR
LOVED ONES TO HAVE PLENTY OF
OPINIONS ON HOW TO USE IT.

CLOCKWISE FROM TOP LEFT

Bright arrangements displayed in mixed pottery
made for dynamic centerpieces. • Guests
enjoyed four specialty sips, including the
groom's own barrel-aged Vieux Carré during
cocktail hour. • "We wanted everyone to dance
the night away and keep the party going, so
we tried to make the dance floor the place to
be," Claire says. Nearby lounge furniture meant
guests didn't have to go far to take a break.

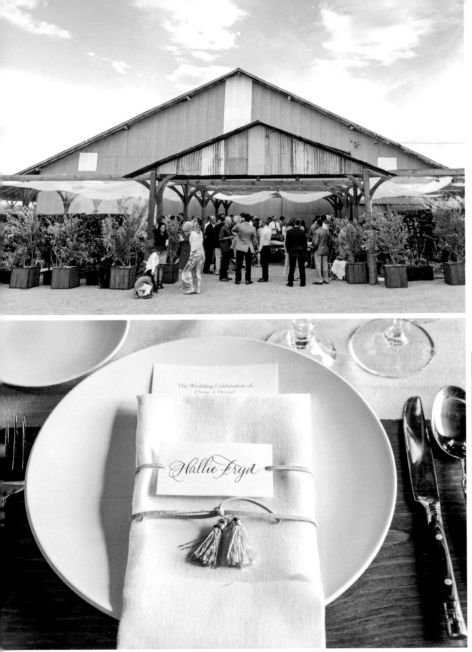

CLOCKWISE FROM LEFT
The ceremony took place in an old hay barn on the property. • "I wanted something simple yet not super traditional," Claire recalls of her search for the perfect wedding dress. In the end, she opted for a gown with an overlay of silver polka-dot chiffon that gave it just the right amount of whimsy. Dan wore a custom gray suit. • Tassel-wrapped place cards adorned each table setting.

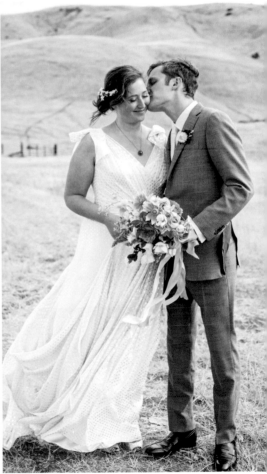

"We got married at my family's ranch in Sonoma, California. My mother grew up there, and I spent much of my childhood there. I always thought it would be the perfect venue for the wedding."

CLAIRE

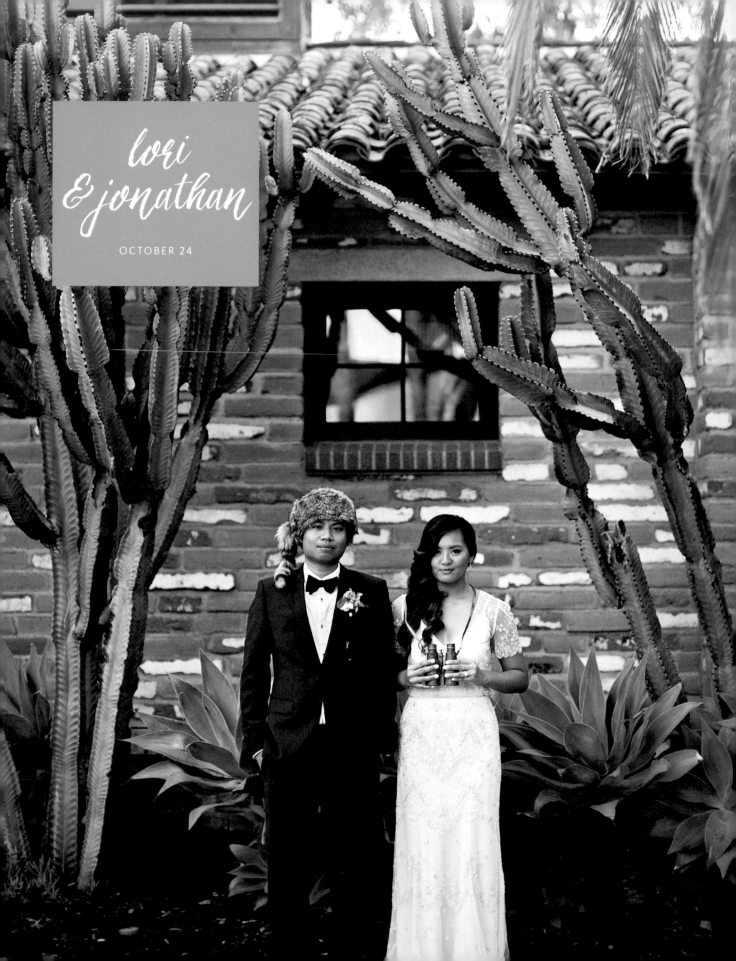

lori
& jonathan

OCTOBER 24

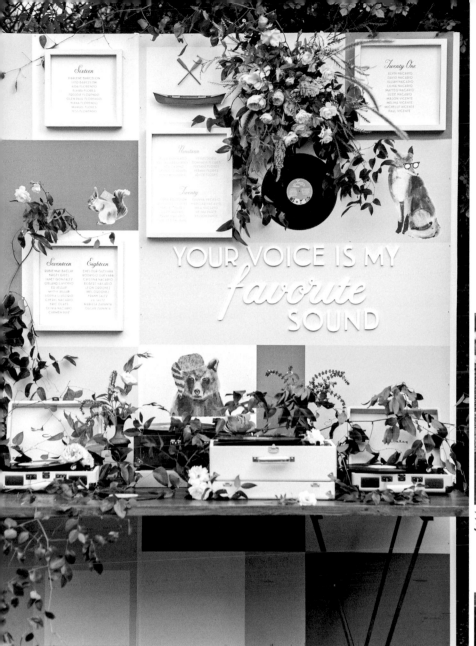

YOUR VOICE IS MY *favorite* SOUND

CLOCKWISE FROM OPPOSITE PAGE

A pair of vintage binoculars (similar to ones in *Moonrise Kingdom*) topped the head table and doubled as a fun photo prop. • Seating assignments were displayed on a table decorated with vintage record players, an ode to Jonathan's collection of records. • Each escort card featured a hand-drawn bear wearing a raccoon hat, a fox wearing glasses, or a squirrel holding a flag, representing steak, chicken, and vegetarian meals, respectively. • The reception tables were marked with little wood peaks and numbers calligraphed in gold.

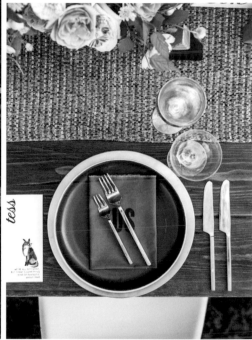

For their charmingly original wedding, Lori and Jonathan drew inspiration from Wes Anderson films—particularly *Moonrise Kingdom* and *Fantastic Mr. Fox*. An inviting color scheme of navy, merlot, and blush, along with playful references to the movies, teamed with their resort's lush backdrop to create a wholly enchanted effect for their fall nuptials.

"One of the first things Jonathan gave me when we met was a mix CD, and in turn I made him one. Through music, we got to know each other better. So we thought it would be a great idea to give our guests a mix CD soundtrack telling our story. Each track was chosen by Jonathan and me to represent a key moment in our relationship. And each song worked as a response to the other. All together, the soundtrack portrays a back-and-forth conversation between us."

LORI

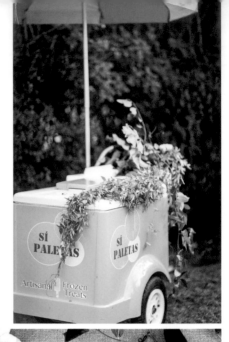

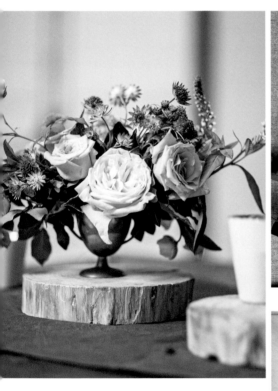

CLOCKWISE FROM TOP

A gourmet ice pop cart delighted guests at cocktail hour. • All of the paper goods included clever nods to *Moonrise Kingdom*, from the invitations to the RSVPs, which asked guests, "Will you join the hullabaloo?" a reference to the scouts' annual gathering in the film. • The altar space was marked by a white arch decorated with colorful square bunting. • The floral arrangements were a mix of wildflowers, greenery, and blush roses.

tip

SPELL IT OUT. USE A QUOTE OR
PHRASE THAT'S MEANINGFUL
TO YOU AND WEAVE IT INTO THE
DAY'S DÉCOR FOR MAXIMUM
PERSONALIZATION.

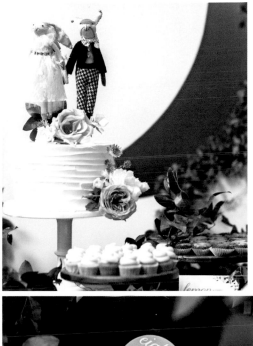

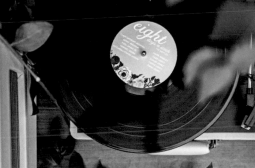

CLOCKWISE FROM TOP LEFT
Lori knew she wanted a wedding dress with
sleeves and a little bit of sparkle. After trying
on over 100 different gowns, she finally found
her beaded V-neck column dress. • Handmade
woodland creatures topped the couple's rustic
wedding cake. • Seating assignments were
printed on records, and each table number was
paired with a classic song title, like "Two of Us"
by the Beatles for table two. • Mismatched
glassware and brass floral vessels gave
feasting tables a relaxed vibe.

Your *Bohemian* Blueprint

This free-spirited soiree has a way of looking incredibly chic with minimal effort.
The décor is eye-catching, the colors are vibrant, and the details are playful.

ruby	craft	cerulean	jade	cream

colors

Strong colors are the key to pulling off a bohemian wedding day. A mismatched collection of patterns and vibrant hues is more important than a cohesive color scheme, but pops of saturated red, yellow, green, and blue—no matter how you choose to incorporate them—will best convey your bright and airy, relaxed aesthetic. If color is not your thing, you can totally pull off the look with a mix of textures in a neutral palette.

favors

- Homemade soy candles
- Jars of jam
- Donation to a favorite charity

—

"You don't find love, it finds you. It's got a little bit to do with destiny, fate, and what's written in the stars."
—Anaïs Nin

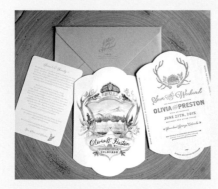

paper + signage

There are many ways to infuse your bohemian style into your stationery. Mandalas, feathers, arrows, and flowers are go-to motifs for bohemian affairs, but don't feel tied to anything too predictable. Consider printing your invites on worn kraft paper or textured stock and using handwriting-inspired script and wispy laurel flourishes.

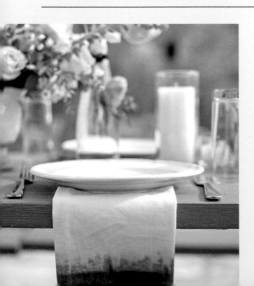

menu

Your wedding day is the perfect opportunity to treat your guests to foods they may not often get the opportunity to taste or enjoy. Use your menu to showcase local produce prepared using exotic spices or garnished with pretty edible flowers. Anything you can eat with your fingers is fair game, such as olives, ripe raspberries, and imported cheeses. Rustic loaves of bread served with infused butter and an assortment of homemade preserves are ideal accompaniments. A pig roast is another decidedly boho idea; just make sure you have options to accommodate all your guests' dietary needs. A naked cake or homemade hand pies are a sweet ending to the celebration.

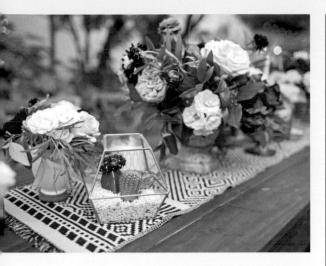

flowers

Your floral arrangements should match your relaxed theme: loose, carefree, and colorful. Steer clear of tight, monochromatic bunches in favor of overflowing bursts punctuated with unique textured elements like king protea, thistle, lotus pods, dinner-plate dahlias, and cheery sunflowers.

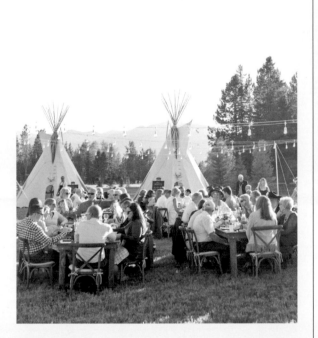

venues

Anything from a restaurant to a campsite can serve as the ultimate setting for your bohemian celebration. Your venue will help set the tone of the affair, so make sure your vision and your setting are in sync. Country clubs, ballrooms, museums, and any sort of ornate room will make it harder to pull off a boho vibe.

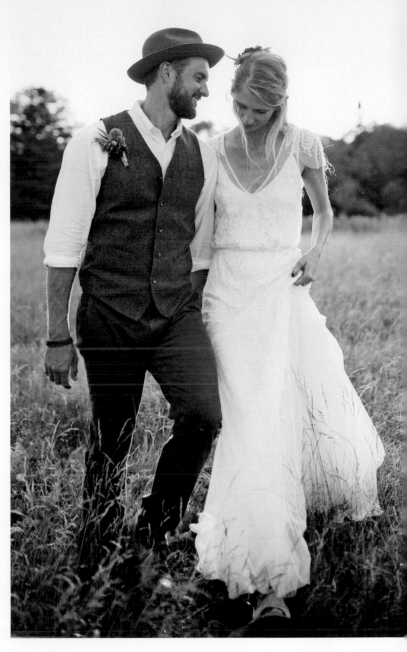

attire

HERS:
- Free-flowing silhouette
- Floral pattern or lace embroidery
- Flower crown

HIS:
- A navy or gray suit
- Colorful tie or pocket square
- Patterned shirt or vest

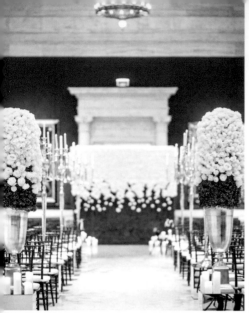

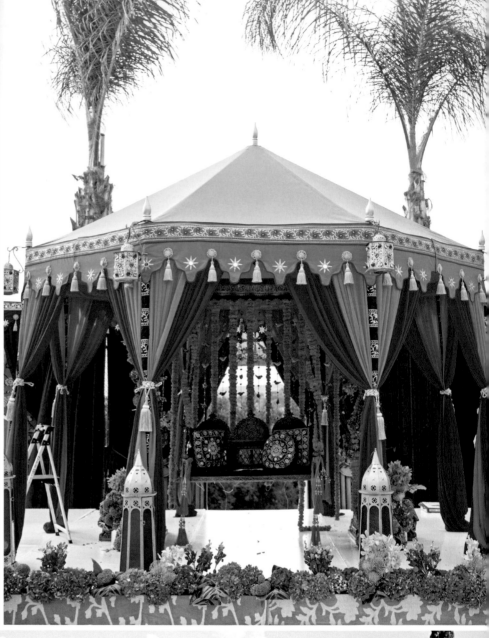

Ceremony
Details

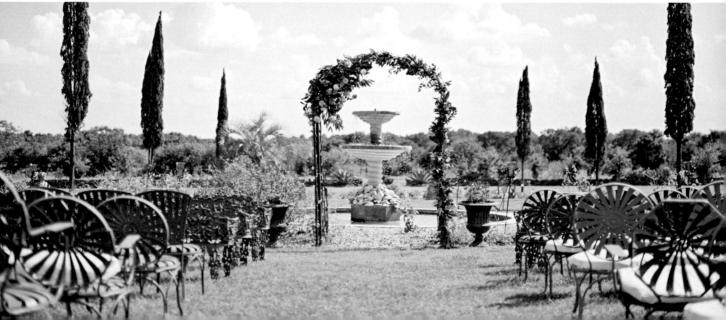

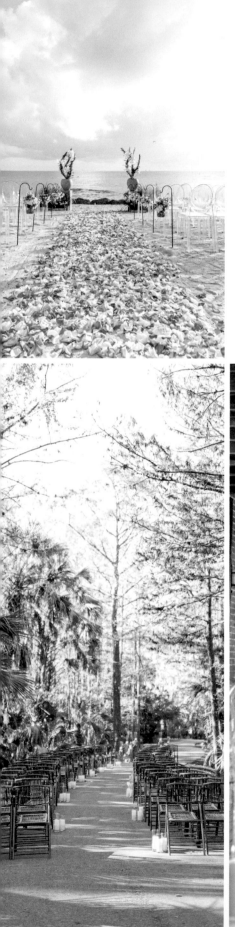

The most important part of your day can feel like the hardest to personalize. From the way you arrange the chairs to how you say "I do," nearly every ceremony detail is open to interpretation. Switch up the seating with circular arrangements, ghost chairs, or antique couches—you can get as creative as you wish, as long as guests can see the altar. That goes for the rest of the ceremony details too. If you share an affinity for beer, for example, consider swapping out a traditional unity ceremony for a beer-pouring one, or decorate your arbor with fresh hops and flank your altar space with wood kegs. Or embrace your individual cultures with a fusion ceremony or nods to both of your heritages with readings or a tradition, like jumping the broom.

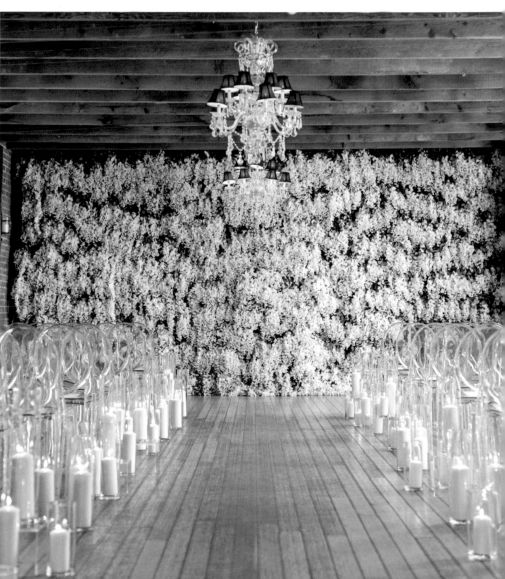

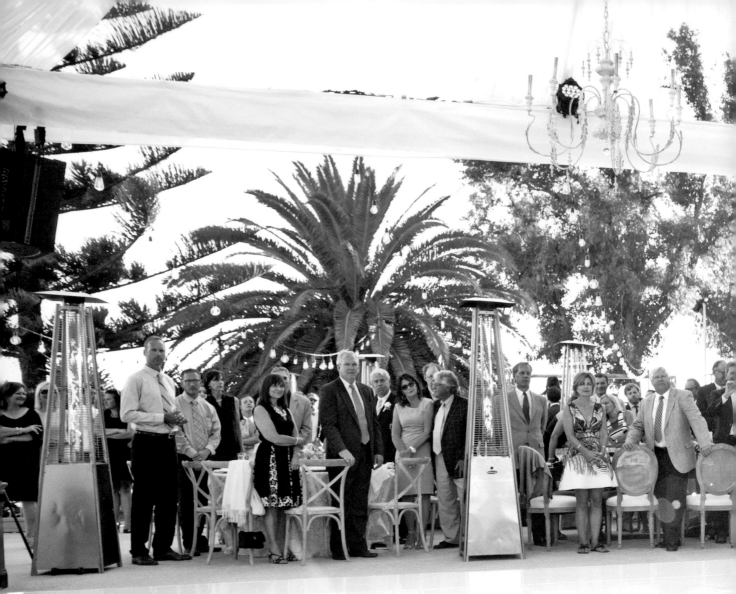

classic

Aiming for timeless with a hint of tradition? A classic wedding is the choice for you. Borrow elements from your parents' or grandparents' nuptials, like ceremony music, similar bouquet blooms, or an heirloom cake topper. These often formal affairs update tried-and-true details, giving them a modern, personalized spin.

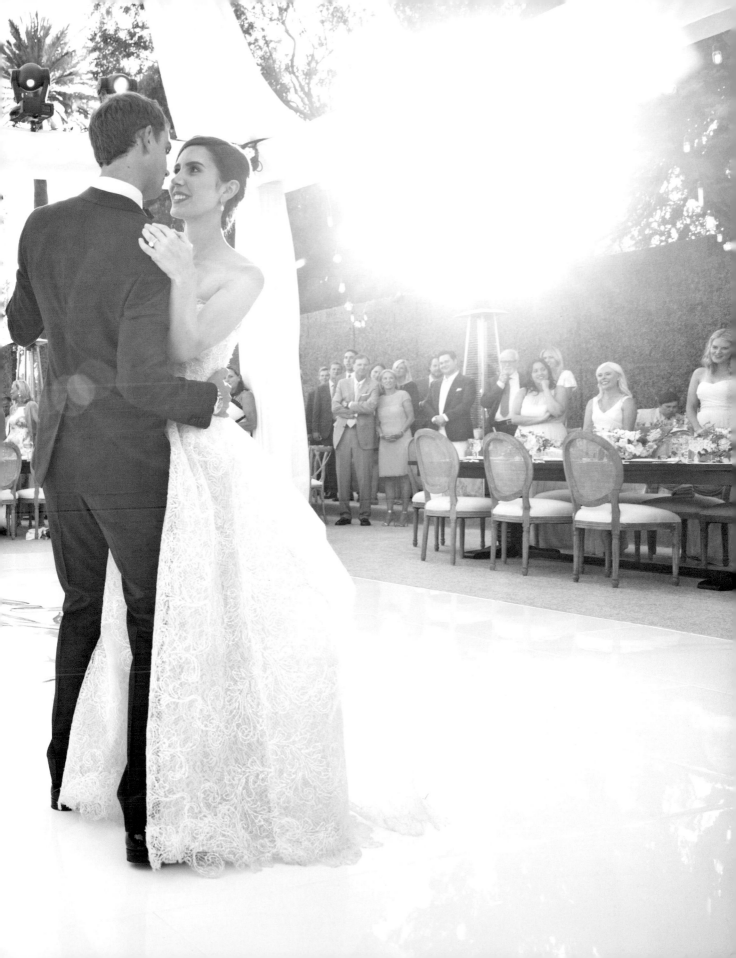

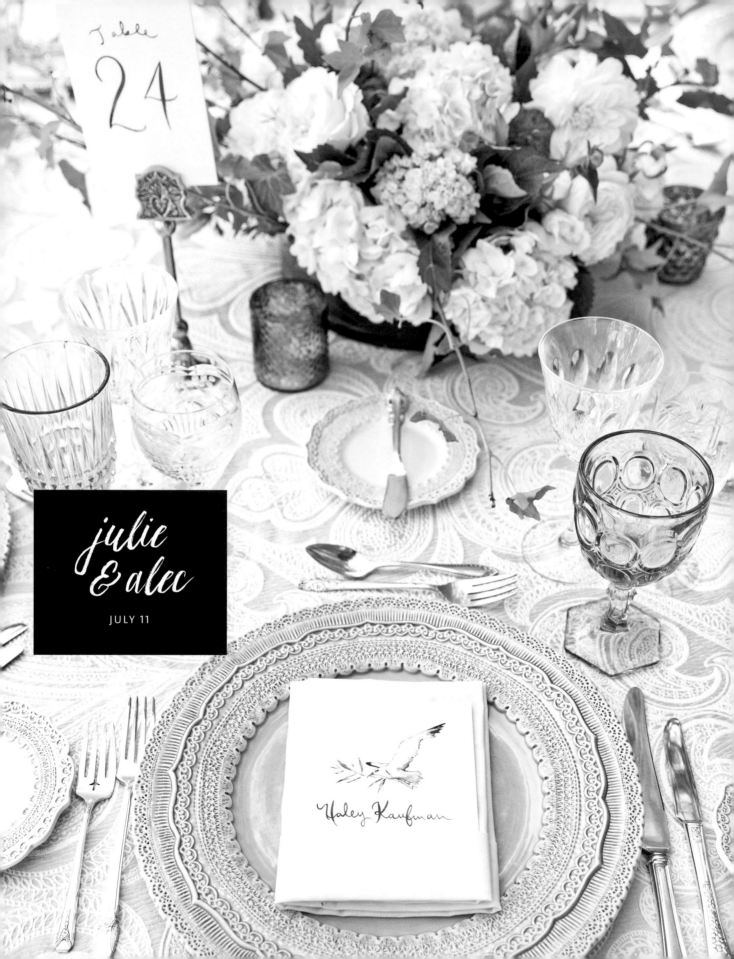

Table 24

julie
& alec

JULY 11

Haley Kaufman

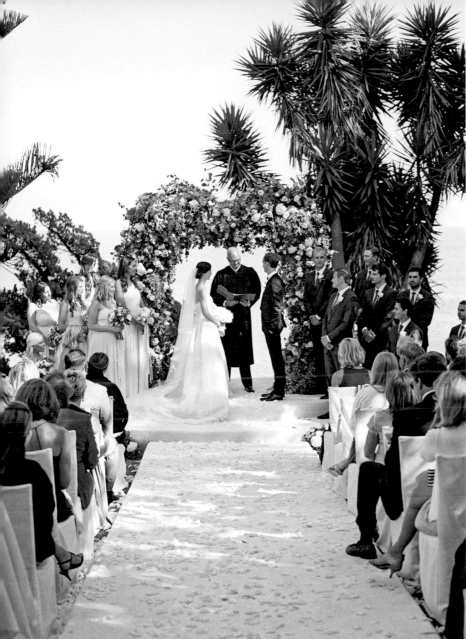

CLOCKWISE FROM OPPOSITE PAGE
The couple used blue in the linens, glasses, and chargers on the dining tables, while personalized menus awaited guests at their places. • A tiered altar kept the couple's large bridal party from blocking the view of the ocean during the ceremony. • Julie and Alec used a custom crest on everything from invitations to favors. • Julie's niece took her flower girl duties very seriously. "I'm pretty sure she thought it was actually *her* wedding day," she says.

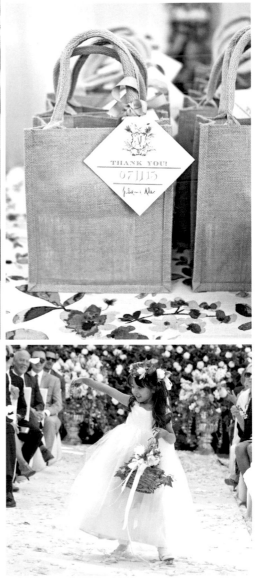

A fter meeting and falling in love in Los Angeles, Julie and Alec knew there was no better place to celebrate their marriage. The couple allowed the ocean views from their stunning seaside estate to inform their blue and white color scheme and used California's comfortable and elegant vibe to inspire the day's dreamy décor.

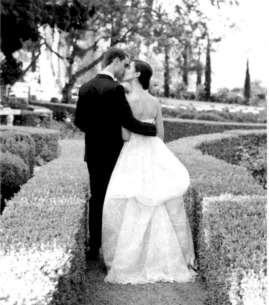

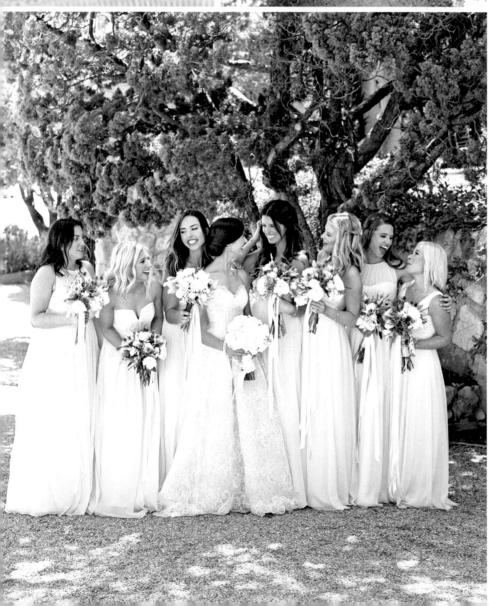

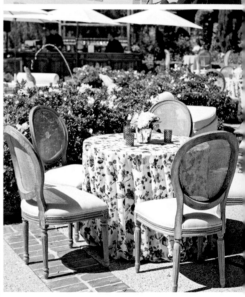

CLOCKWISE FROM TOP LEFT
Each place setting included a box of chocolate truffles with the couple's custom wedding logo. • For the ceremony, Julie wore a ball gown with a corseted bodice and a romantic lace overlay. • Seating assignments were dispayed on a floral-draped board. • The couple hosted an alfresco cocktail hour complete with a jazz quartet. • Julie dressed all seven of her bridesmaids in floor-length champagne gowns.

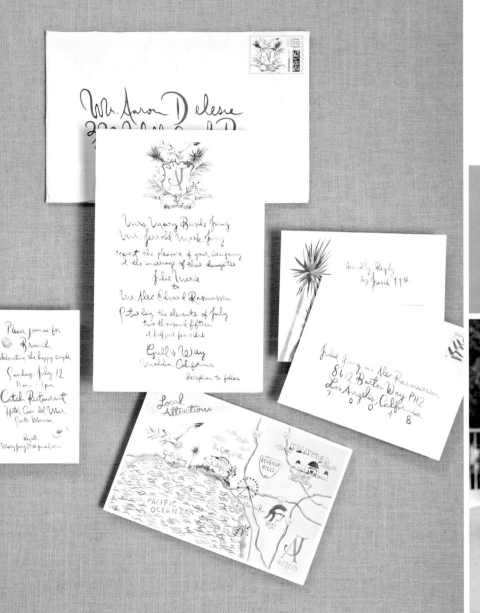

CLOCKWISE FROM LEFT
The custom invitation suite included a hand-drawn map with highlighted spots for guests to visit in Los Angeles. • The second and fourth layer of the cake featured the same lace pattern as Julie's dress. • She carried a timeless all-white bouquet of roses, peonies, and phalaenopsis orchids.

tip
USE MULTIPLE SHADES OF THE SAME COLOR FOR A DYNAMIC YET COHESIVE AESTHETIC.

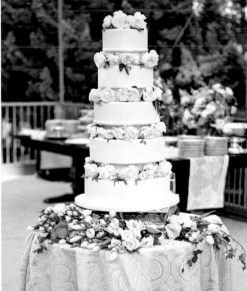

"We wanted personalized vows and thought it would be a fun and meaningful experience to write them together. We loved writing our vows since it gave us an opportunity to discuss what marriage meant to us and what we wanted to promise to one another."

JULIE

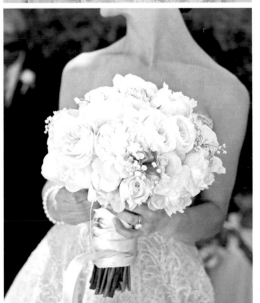

jasmine
& evan

AUGUST 29

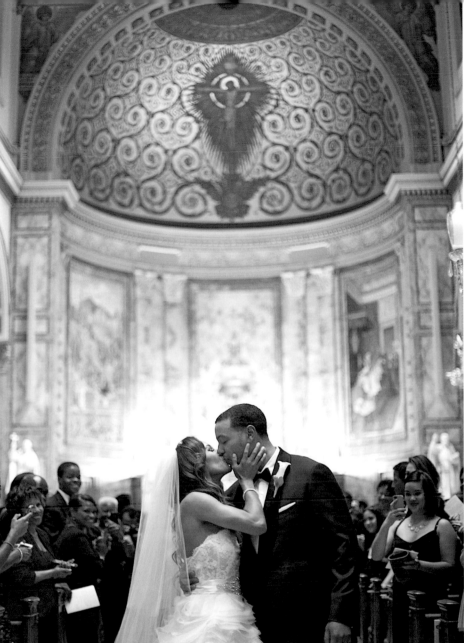

CLOCKWISE FROM OPPOSITE PAGE
Lush white arrangements dressed up the wood-paneled reception space without overpowering it. • "Because the church is so grand and ornate, it was important not to compete with the beauty that already existed," Jasmine says. • Jasmine's only requirement for their towering seven-tier wedding cake was "go big or go home." Mission accomplished! • Candles of varying sizes ran the length of the reception tables, filling the cavernous space with a warm glow.

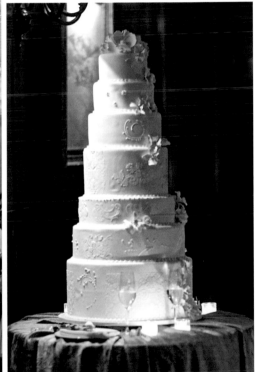

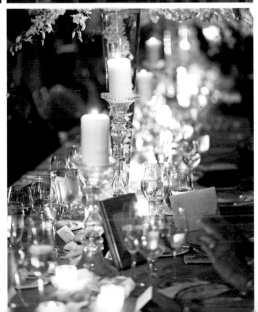

J asmine and Evan built their timeless big city affair around the fusion of his New York City upbringing and her Southern roots. Touches of Southern hospitality merged with the glamour of their regal city ballroom to represent both of their backgrounds. Romantic candlelight and neutral hues like cream, white, and soft pink and the occasional pop of gold fit seamlessly in the setting.

"We were married in a Catholic church, but since many members of our family are not Catholic, we chose to have a simple ceremony and to be married by both a Catholic priest and Baptist pastor, my dad's childhood friend. It was important to us to be married by someone who knows us personally and could speak to us as individuals and as a couple."

JASMINE

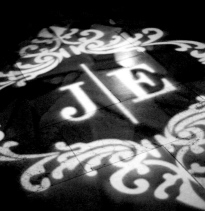

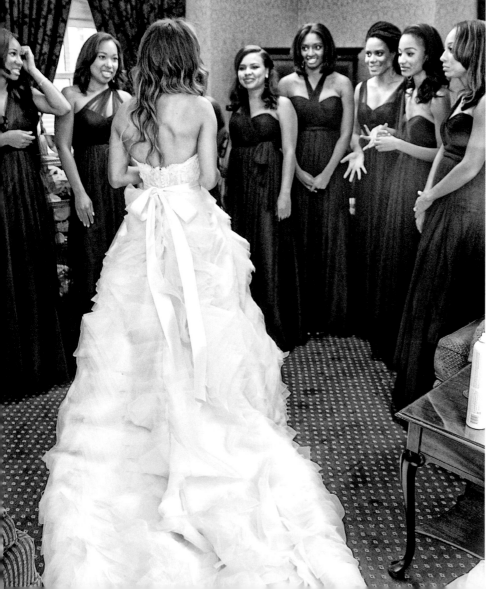

tip
A CUSTOM MONOGRAM WILL PUT YOUR MARK ON ALL ASPECTS OF THE DAY, LITERALLY.

CLOCKWISE FROM TOP
In addition to cake, Jasmine and Evan treated guests to an assortment of monogrammed cookies in the wedding's color scheme. • Gobo lights projected the couple's monogram onto the dance floor at the reception. • The bridesmaids coordinated in floor-length black dresses.

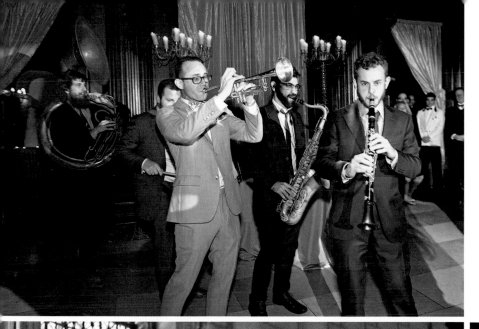

CLOCKWISE FROM LEFT

The newlyweds made their grand entrance with the help of a second-line band, as a nod to Jasmine's Southern roots. • Tall arrangements drew guests' eyes upward to the venue's elaborately painted ceiling. • The couple's round menus matched the rest of the day's elegant gold-and-white stationery. • Jasmine and Evan hitched a ride to the reception in a vintage silver Rolls-Royce.

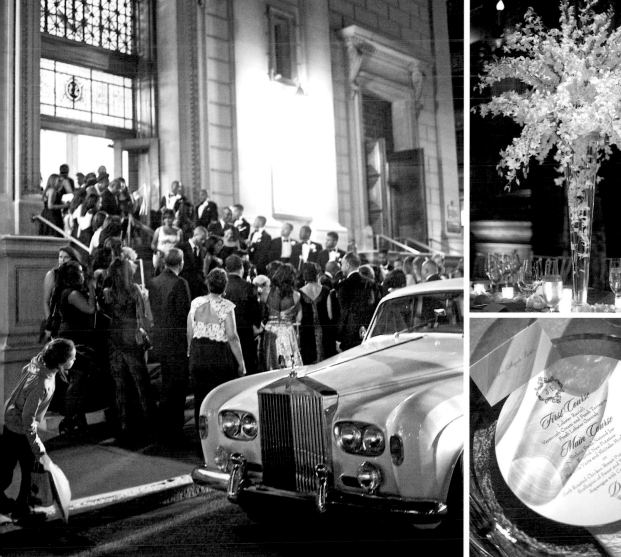

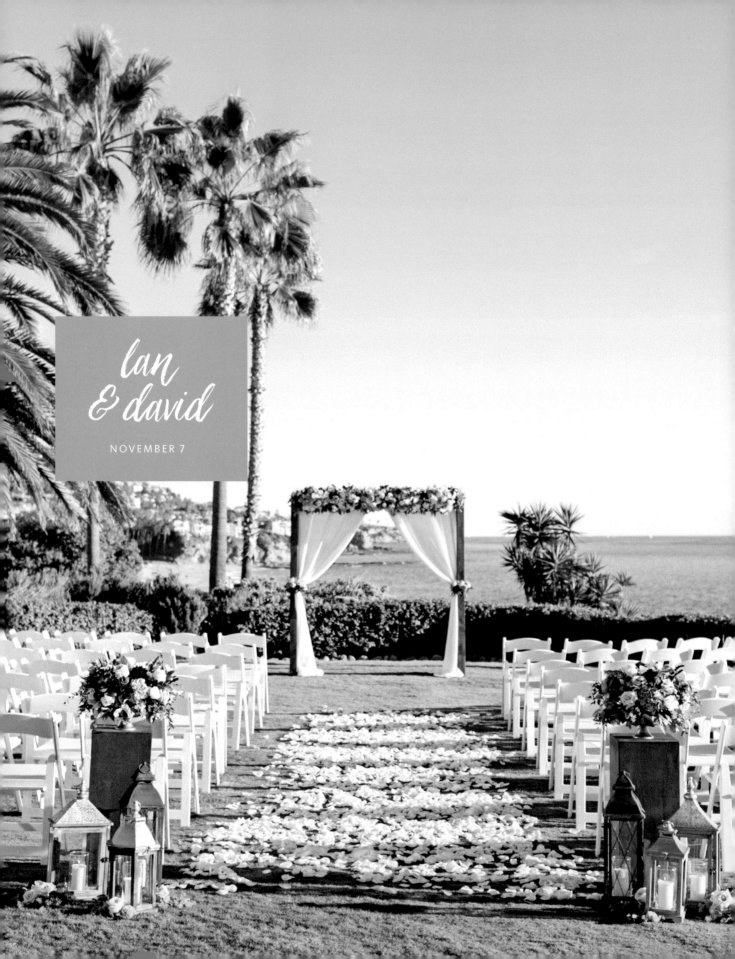

lan
& david

NOVEMBER 7

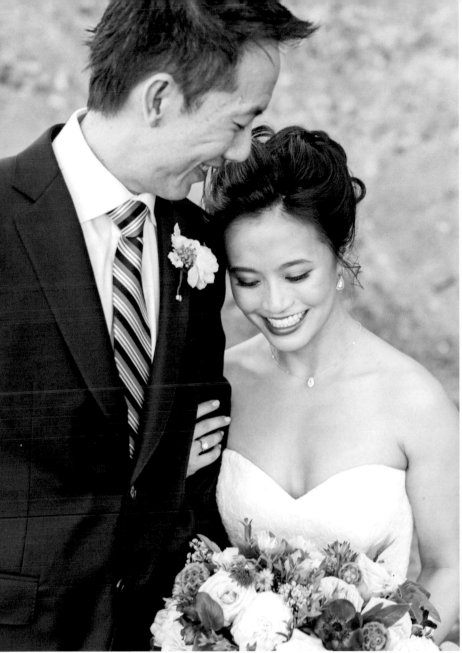

Ocean views were a must for Lan and David's quintessentially SoCal affair. • The pair opted for a classic wedding look. David wore a tie that Lan gave him a few years prior. • The couple's menu featured an original watercolor design. • Table numbers were printed on the same purple watercolor paper as the escort cards.

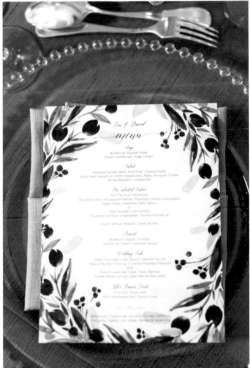

Lan and David didn't let their November wedding date confine them to warm autumn hues. Instead, they opted to decorate their oceanfront day in white, dusty pink, lavender, peach, and mint, with accents of navy and aubergine. Lush blooms, overflowing greenery, and a painterly floral motif nodded to the bride's love of nature as well as her career in environmental protection.

"David and I are kind of goofy people, so ballroom dancing didn't feel like us. We chose 'Hooked on a Feeling' by Blue Swede because it's fun and easy to dance to. We probably rehearsed our dance moves twice, but luckily we had forgiving guests."

LAN

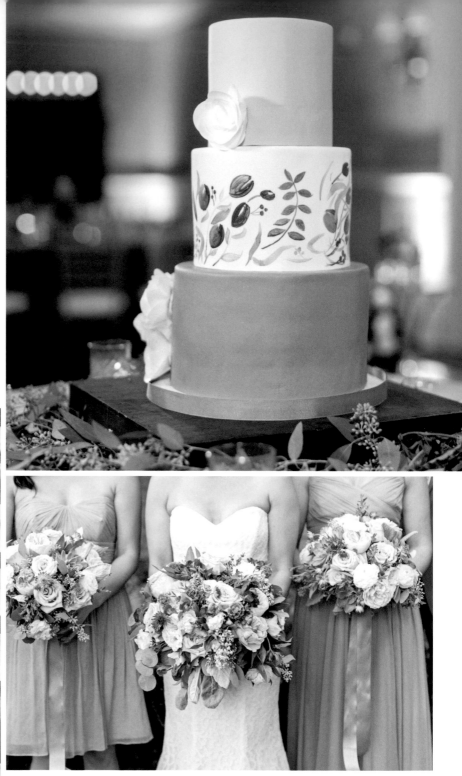

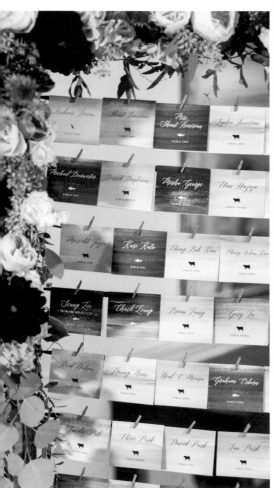

CLOCKWISE FROM TOP

The couple's wedding cake featured a hand-painted floral design that matched the day's décor. • The bridesmaid dresses coordinated with the lavendar ties worn by Lan's two bridesmen. The girls carried bunches of local florals, including seeded eucalyptus, dusty miller, and succulents. • The escort cards were hung from string inside a floral-encrusted picture frame.

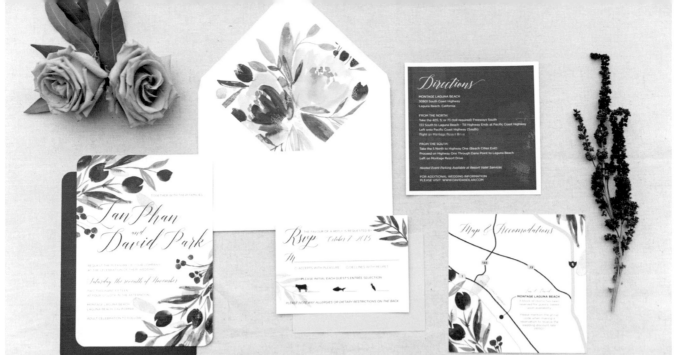

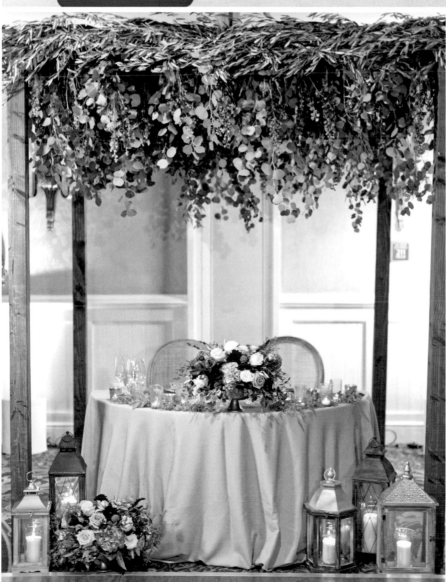

tip
THESE DAYS GENDER ROLES ARE A THING OF THE PAST. BRIDESMEN AND GROOMSWOMEN ARE A GREAT WAY TO PERSONALIZE YOUR WEDDING PARTY.

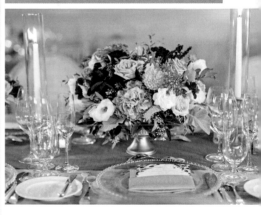

CLOCKWISE FROM TOP

A painterly floral design tied the couple's custom invitation suite together. • "We wanted our guests to feel like they were having an intimate dinner with us," Lan says of their vision for their reception. • Lan and David sat at a sweetheart table beneath a stunning floral installation of fresh greenery, seeded eucalyptus, and hanging amaranthus.

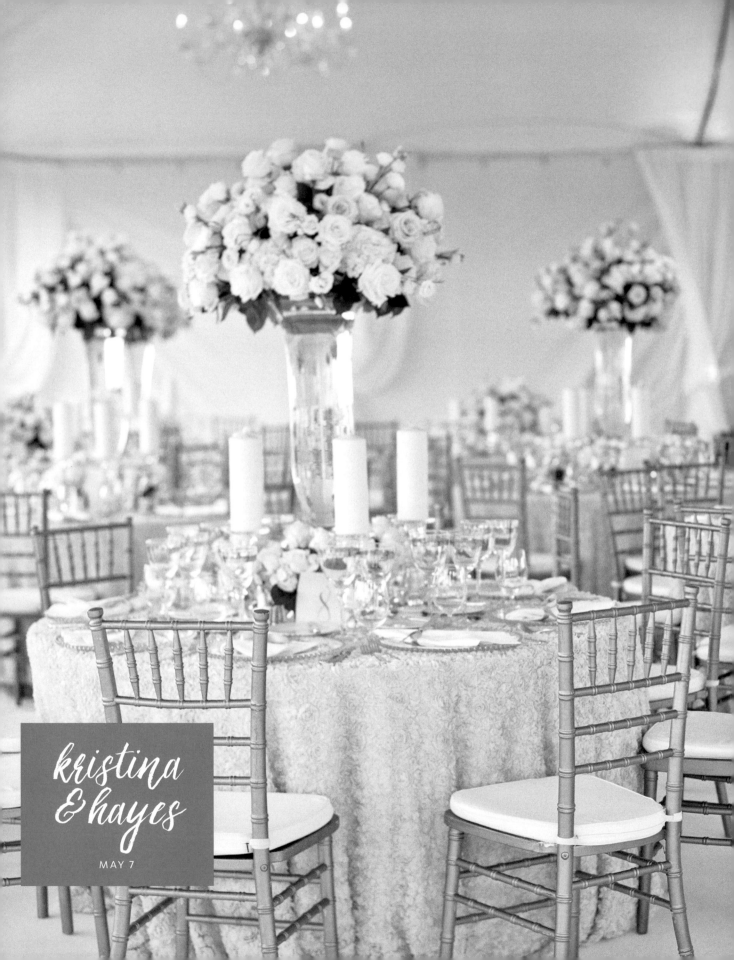

kristina
& hayes

MAY 7

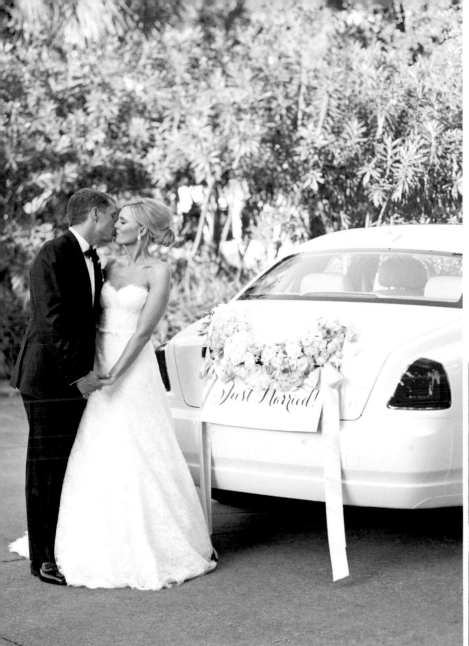

CLOCKWISE FROM OPPOSITE PAGE
Tall fluted glass vases held rounded arrangements of all-white blooms. • Kristina and Hayes decorated their white Rolls-Royce with a "Just Married" sign, pink ribbons, and a garland of pink and white florals. • The bride glammed up her day-of look with a custom Swarovski crystal clutch with her monogram in pink and a pair of sparkly heels. • The couple's ceremony location had an amazing view of the ocean and a few palm trees that perfectly framed the altar.

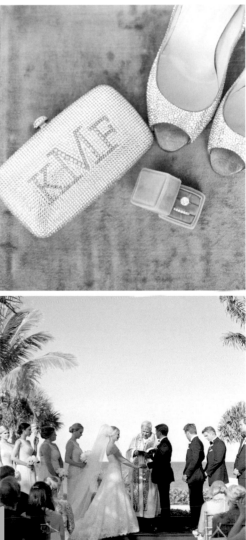

A former wedding planner, Kristina always knew she wanted a traditional, preppy wedding worthy of a princess. With luxurious fabrics, lush white floral arrangements, feminine bows, pops of bling, and Hayes (her prince) by her side, she was able to bring her vision to life. An all-white color scheme punctuated by rich gold accents and punches of pink gave the couple's classic affair an ultra-chic look.

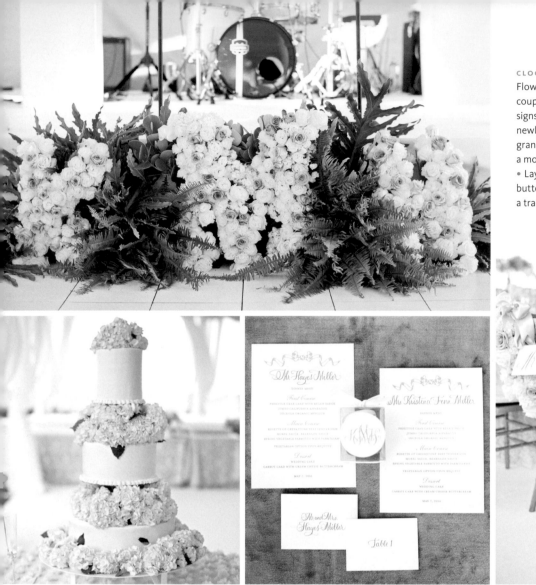

Flower-studded initials spelled out the couple's new monogram. • "Mr." and "Mrs." signs and a swag of blooms were affixed to the newlyweds' chairs. • The night ended with a grand sparkler exit. • The pair treated guests to a mojito signature sip and a champagne tower. • Layers of white hydrangeas flecked the classic buttercream wedding cake. • The couple chose a traditional ecru-and-gold invitation suite.

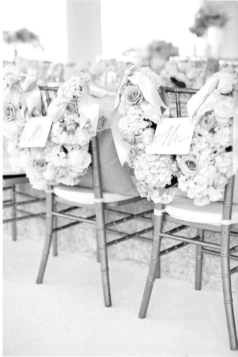

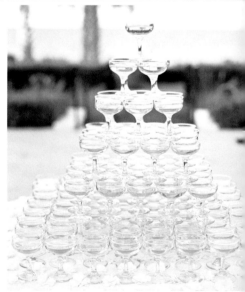

"One of the important themes in the wedding was the use of satin ribbons. I had a blanket as a child that had satin edges, and since then I've been obsessed with satin ribbons. I also love bows, so having satin ribbon bows on everything from the programs and the bouquets to the 'Just Married' sign on the back of our car was the perfect nod to this part of my history. We even made our wedding 'logo' our monogram with a ribbon above it."

KRISTINA

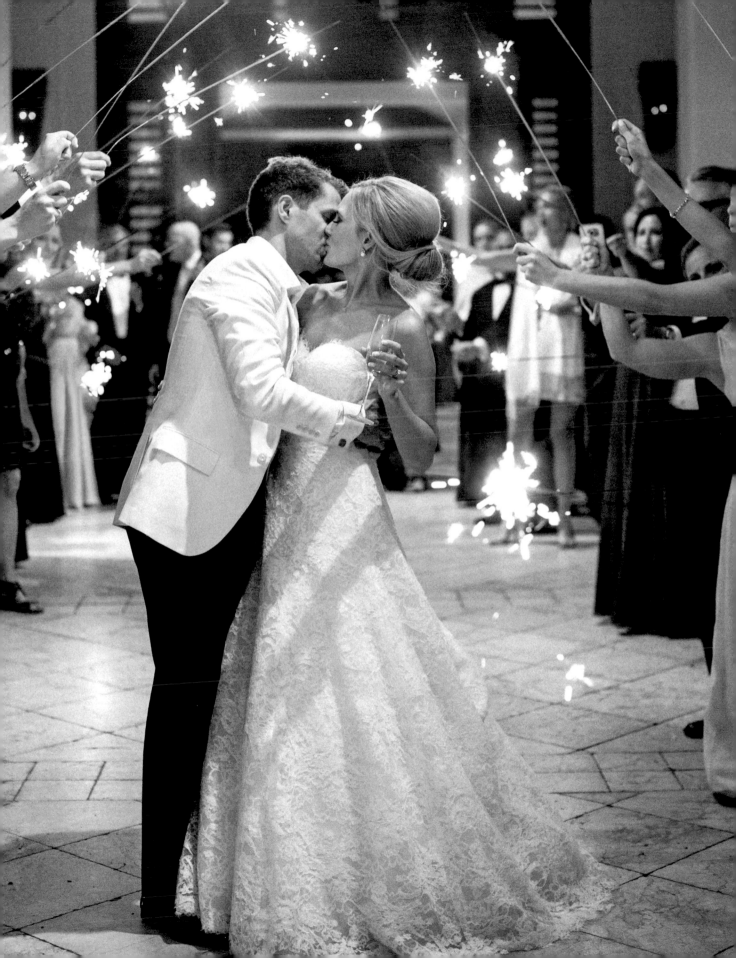

Your *Classic* Blueprint

This timeless affair takes its cues from weddings of the past (think your grandparents' or parents' nuptials). Traditional details are reimagined to create an elegant celebration.

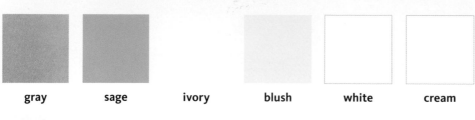

| gray | sage | ivory | blush | white | cream |

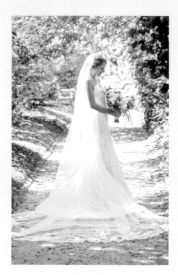

colors

It doesn't get more timeless than black and white or navy blue. For a wedding that will never go out of style, neutrals (gray, ivory, and blush) are also a safe bet. To keep things from looking too washed out, work in splashes of mixed metallics and organic greens as accent hues.

flowers

There's a reason roses are among the most requested wedding blooms: Their full, feminine shape packs a pretty punch, and they come in a rainbow of colors. Not only are roses synonymous with romance, they're also available year-round. Other classic flowers to try: peonies, hydrangeas, lily of the valley, hyacinths, and freesia.

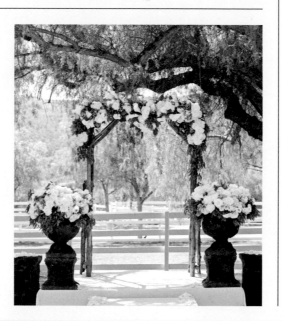

attire

HERS:
- Sophisticated gown with a touch of lace
- Pearls
- Elegant heels

HIS:
- Black tuxedo or dapper navy suit
- Distinguished bow tie and matching pocket square

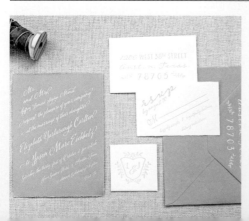

paper + signage

Your invites set the tone for the entire wedding day, so you'll want guests to know your nuptials will be a classy affair. Go traditional with hand-calligraphed addresses and letterpress-printed invites on thick card stock with embossed monograms. Or opt for an elegant script and a floral motif if your fete skews more classic-casual. For an extra bit of flare, consider incorporating a patterned envelope liner in your color scheme, or an illustrated map of the day's festivities. Add your new monogram to all your reception paper goods for a truly bespoke look.

menu

For cocktail hour, champagne served in pretty flutes or old-fashioned coupes is a must. Come dinner, put your own twist on the standard sit-down meal by personalizing the menu beyond the traditional chicken and beef. Food stations and family-style configurations are all fair game. A towering wedding cake and passed petits fours are the finishing touch.

venues

Historic institutions, country clubs, grand hotel ballrooms, and backyard tents provide winning backdrops for a classic wedding day. Work with, not against, your venue's existing décor to execute this theme.

favors

- Playlist of favorite songs from the day
- Small silver picture frame
- A split of champagne with a straw

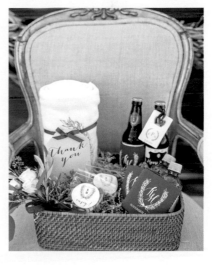

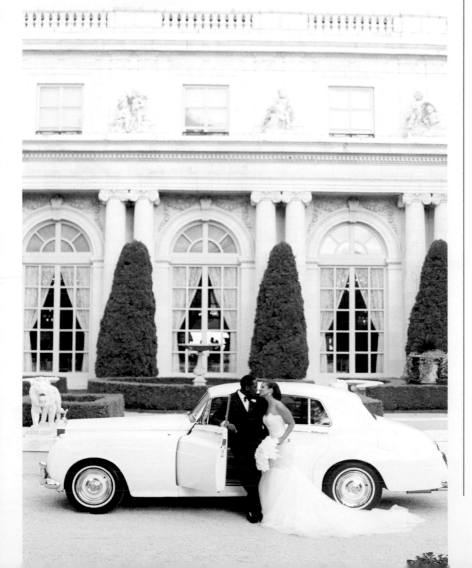

"I would not wish any companion in the world but you."
—*Shakespeare*

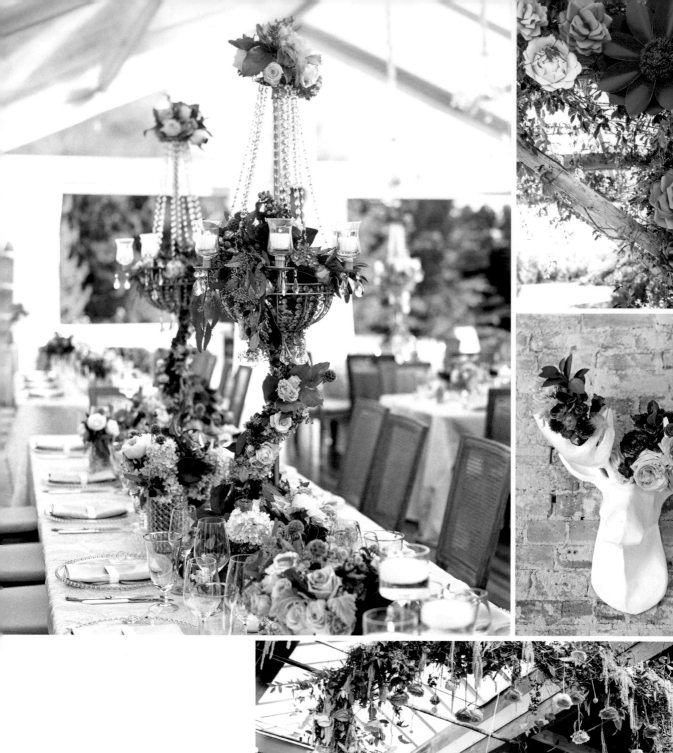

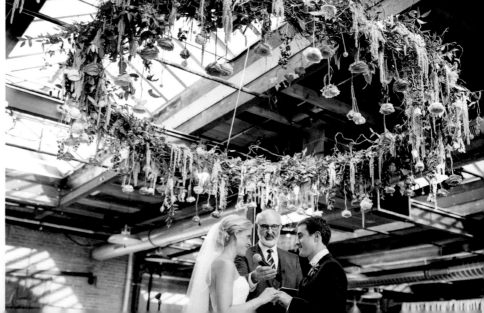

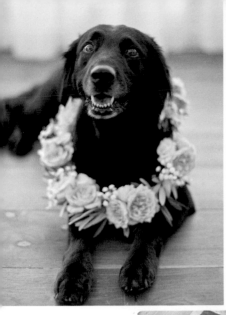

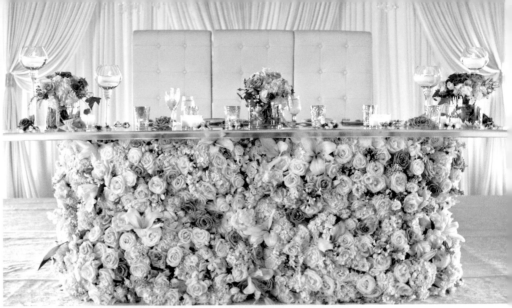

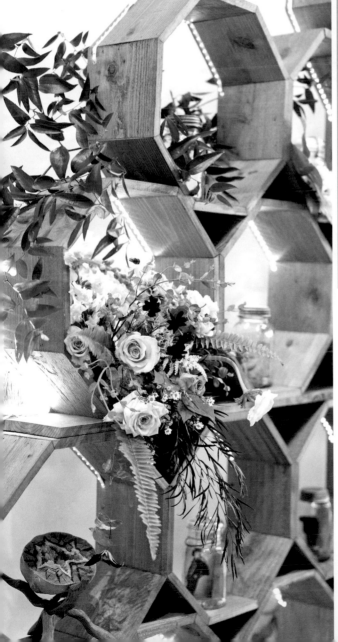

Flowers

Long gone are the days when beautiful stems were confined to vases. Freshen up your florals by displaying them in anything from pineapples to antlers. Flowers are an endlessly flexible medium—you can hang them from the ceiling for the ultimate showstopper, submerge them in water for a contemporary touch, or adorn your four-legged friend with a blooming collar. Foodie couples may want to incorporate edible elements like artichokes and kale into their arrangements, while DIY lovers may be drawn to the paper variety.

eclectic

If your style is a mix of styles, chances are your wedding will be too. Eclectic couples are often drawn to multiple themes, colors, and design elements. Go for mismatched personal details that all have one very important thing in common: you.

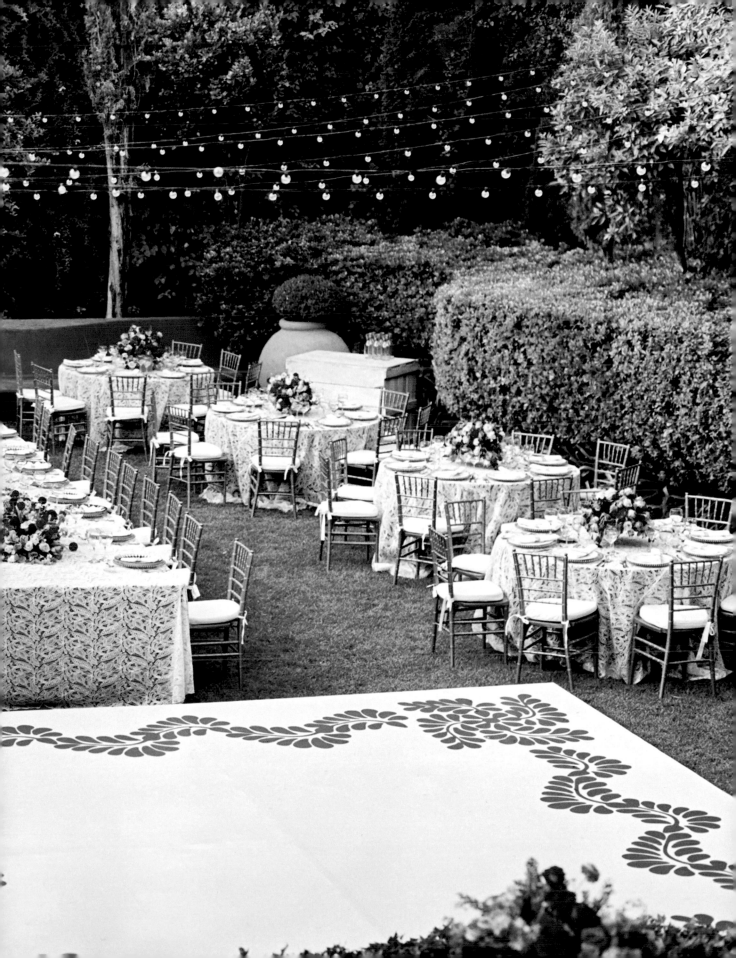

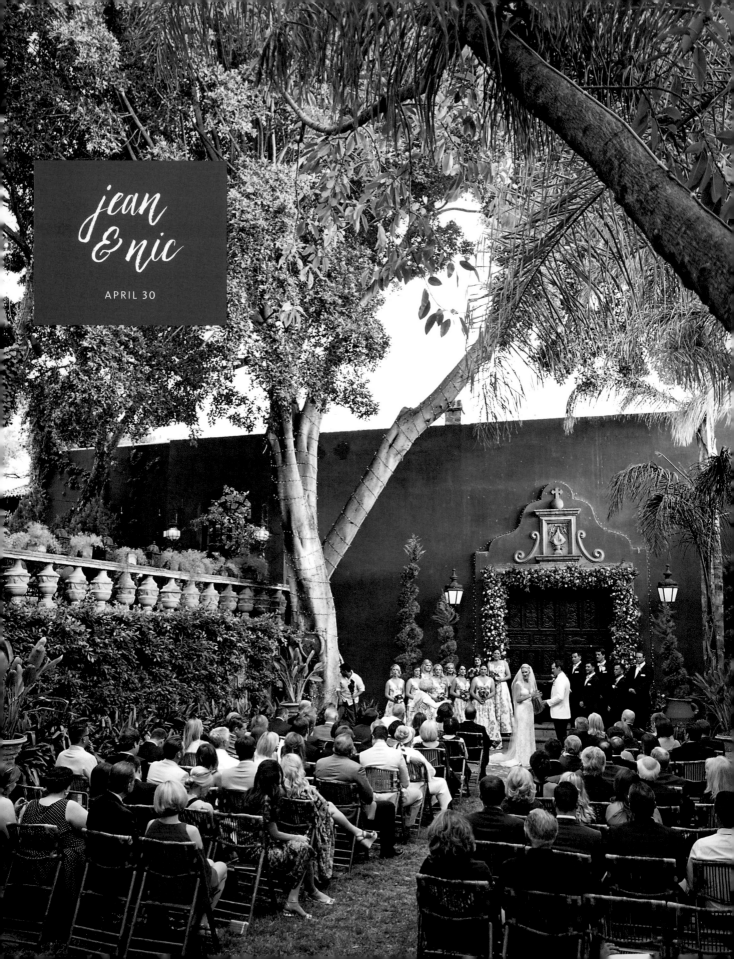

jean
& nic

APRIL 30

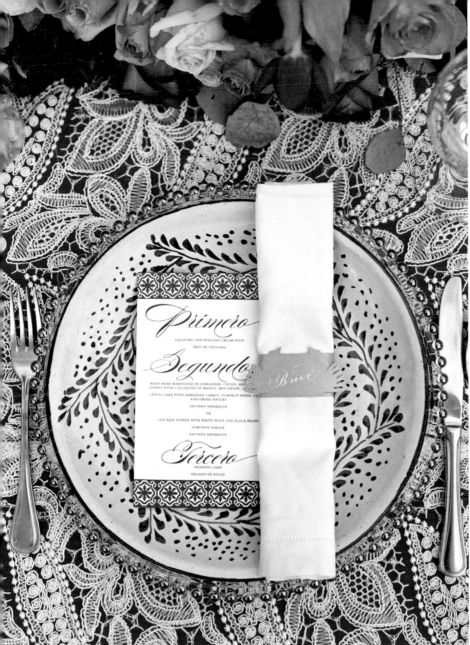

PRIMERO
CILANTRO AND POBLANO CREAM SOUP
TRIO DE CEVICHES

SEGUNDO
MAHI MAHI MARINATED IN CORIANDER, ONION, AND ...
TOPPED WITH A JULIENNE OF MANGO, RED ONION, AND ...
LENTIL CAKE WITH SHREDDED CARROT, PUMPKIN SEEDS, CU...
AND GREEK YOGURT
SAUTEED ASPARAGUS
OR
CHICKEN TOPPED WITH WHITE MOLE AND BLACK BEANS
CORUNDA TAMALE
SAUTEED ASPARAGUS

TERCERO
WEDDING CAKE
HELADO DE DULCE

Brice

CLOCKWISE FROM OPPOSITE PAGE
The ceremony took place in a verdant garden located on the estate's grounds. • Paper napkin rings laser cut with a *papel picado* design served as inventive place cards. • A wood door was adorned with a garland of pink blooms to create an altar space for the garden ceremony. • Peonies can be hard to find in Mexico so the couple used garden roses instead. The bridesmaids carried a fluffy bunch of ranunculus and garden roses in shades of pink, red, and white.

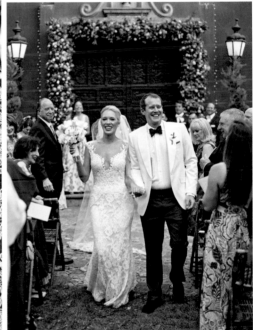

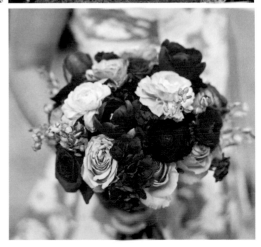

Looking to plan the ultimate colorful wedding, Dallas-based Jean and Nic didn't even have to set foot in their vibrant Mexican estate before they decided to book it for their destination affair—they just knew it was the perfect setting to pull off their vision. Inspired by their pink-and-gold floral save-the-dates, the couple outfitted their eclectic day in the same shades, along with lush blooms and festive nods to Mexican culture.

"Even though neither of us is of Mexican descent, it was important for us to incorporate Mexican culture throughout. We had a Mexican arras ritual at the ceremony in which guests were each given a gold coin as they entered the venue. They then dropped the coin into a container before being seated. The officiant described this ritual during the ceremony to explain that these tokens represented wealth and prosperity in our future."

JEAN

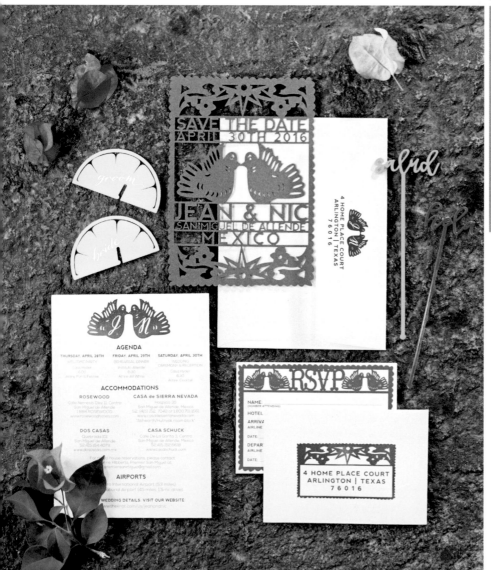

tip
YOUR INVITATIONS ARE THE FIRST GLIMPSE GUESTS WILL GET OF YOUR DAY, SO MAKE SURE THEY SET THE TONE. *PAPEL PICADO,* FOR EXAMPLE, IS A PERFECT (NOT TO MENTION FUN) WAY TO INTRODUCE YOUR GUESTS TO YOUR LATIN-INSPIRED FIESTA.

CLOCKWISE FROM TOP
Table assignments were hand-calligraphed in white ink on pink card stock and displayed on a wall of fresh greenery alongside gilded roses the couple purchased from a local market. • A *papel picado* design, which means "perforated paper," was carried throughout Jean and Nic's custom invitation suite.

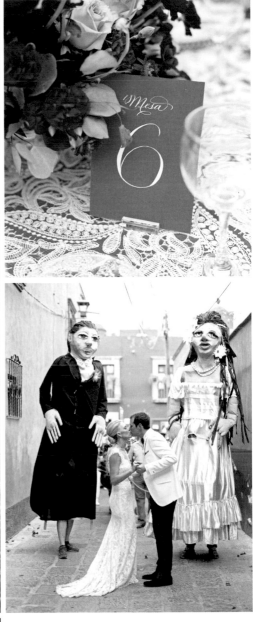

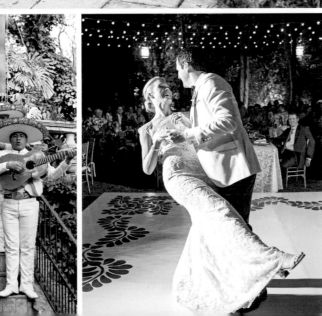

CLOCKWISE FROM TOP LEFT
The couple used an old wood door as the backdrop for their escort card display. • Table numbers were hot pink, coordinating with the linens and florals. • After the ceremony, a mariachi band led Jean, Nic, and their guests to the street for a traditional celebratory parade that included *mojigangas* (giant dancing puppets) and a tequila-toting donkey. • "It was very important to us that our guests of all ages have fun dancing, so we had the band play everything from Earth, Wind & Fire to Britney Spears (my favorite) and hip-hop," Jean says. • The mariachi band serenaded the bride and groom as they recessed down the aisle.

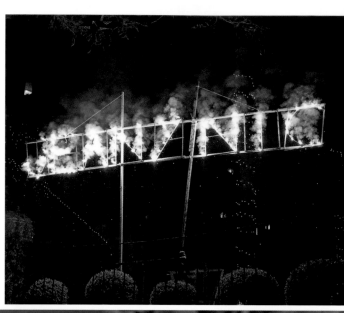

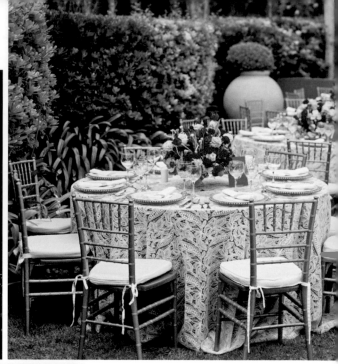

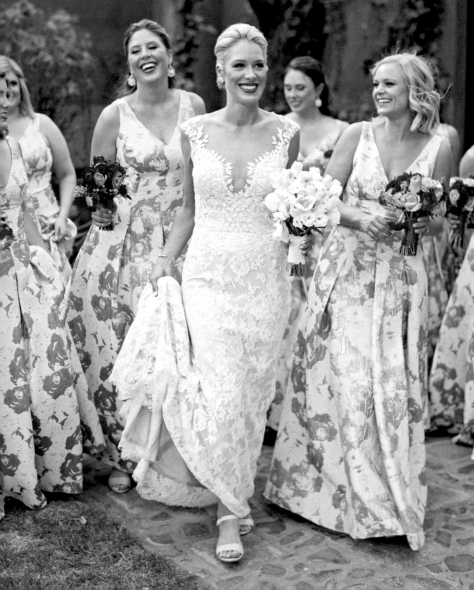

CLOCKWISE FROM TOP LEFT AND OPPOSITE
A fireworks display—including fireworks
that spelled out the names of the bride and
groom—surprised the guests at midnight.
• Reception tables were covered with hot-pink
linens and topped with lace overlays. • Jean
and Nic's carrot cake (their favorite flavor) was
frosted with white fondant and decorated with
a cascade of gold sugar flowers. A hanging
floral installation directly above the cake
created a dramatic display. • The bridesmaids
wore floor-length white gowns printed with a
gold peony design.

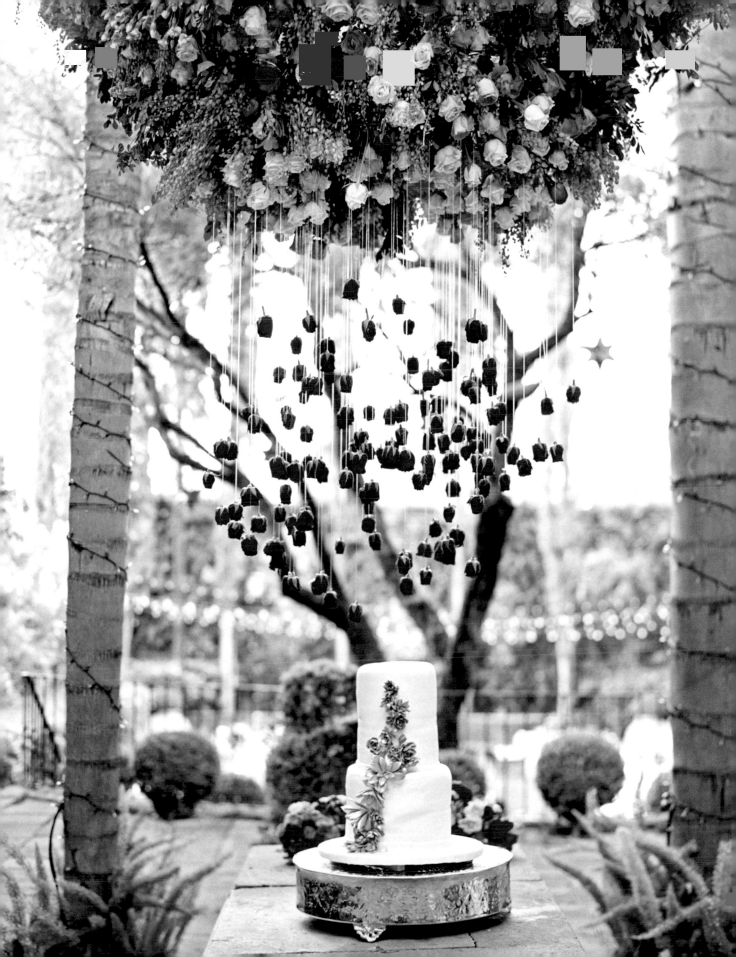

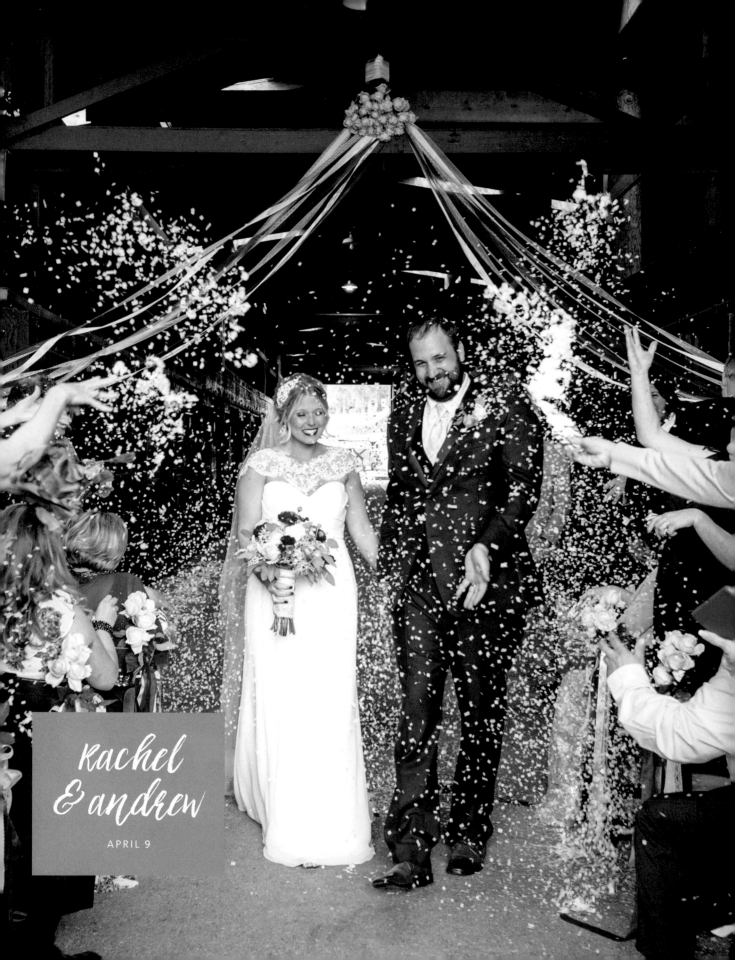

Rachel
& andrew

APRIL 9

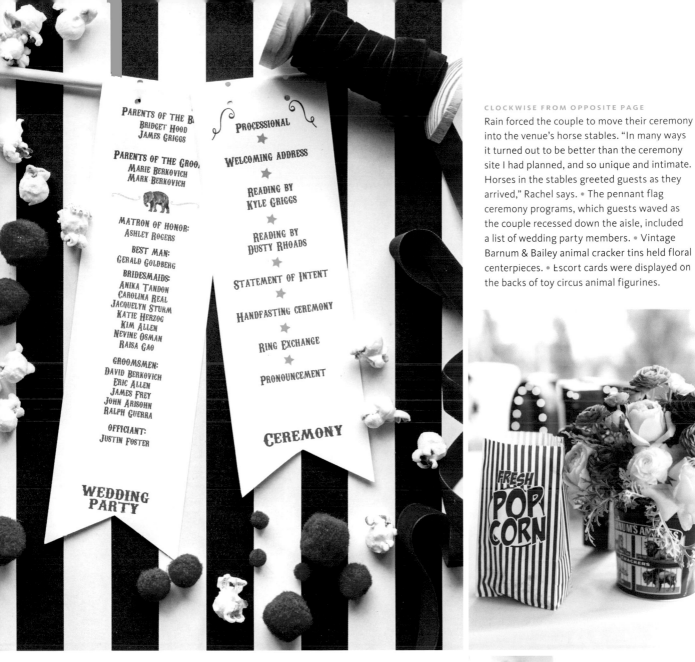

PARENTS OF THE B[R]
BRIDGET HOOD
JAMES GRIGGS

PARENTS OF THE GROO[M]
MARIE BERKOVICH
MARK BERKOVICH

MATRON OF HONOR:
ASHLEY ROGERS

BEST MAN:
GERALD GOLDBERG

BRIDESMAIDS:
ANIKA TANDON
CAROLINA REAL
JACQUELYN STURM
KATIE HERZOG
KIM ALLEN
NEVINE OSMAN
RAISA GAO

GROOMSMEN:
DAVID BERKOVICH
ERIC ALLEN
JAMES FREY
JOHN ARISOHN
RALPH GUERRA

OFFICIANT:
JUSTIN FOSTER

WEDDING PARTY

PROCESSIONAL
★
WELCOMING ADDRESS
★
READING BY
KYLE GRIGGS
★
READING BY
DUSTY RHOADS
★
STATEMENT OF INTENT
★
HANDFASTING CEREMONY
★
RING EXCHANGE
★
PRONOUNCEMENT

CEREMONY

CLOCKWISE FROM OPPOSITE PAGE

Rain forced the couple to move their ceremony into the venue's horse stables. "In many ways it turned out to be better than the ceremony site I had planned, and so unique and intimate. Horses in the stables greeted guests as they arrived," Rachel says. • The pennant flag ceremony programs, which guests waved as the couple recessed down the aisle, included a list of wedding party members. • Vintage Barnum & Bailey animal cracker tins held floral centerpieces. • Escort cards were displayed on the backs of toy circus animal figurines.

FRESH POP CORN

A bove all else, Rachel and Andrew wanted their wedding to be really fun. Looking to capture the happy, carefree feelings they experience when they're together, they decided on a carnival theme and went all out for their big-top day. Accents of gold, silver, and champagne added a touch of class to the predominantly red and white palette.

Dawn
Freyenberger
Table

"Our cocktail hour (or really two hours) was insane. We hosted a carnival, complete with carnival booths and games, a high striker game, and caricature artists. The prizes were our favors: boxes of animal crackers and hand soaps in clear plastic bags that looked like goldfish you'd win at a carnival."

RACHEL

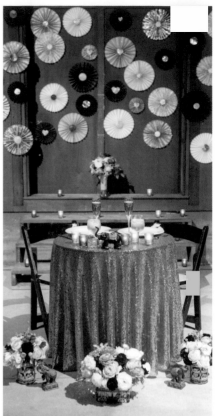

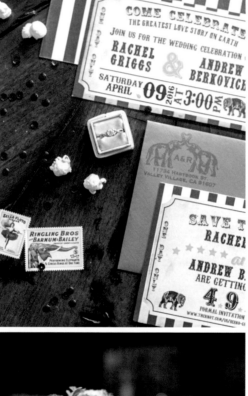

tip

THE KEY TO A WELL-THEMED AFFAIR IS CONSISTENCY. FIND CLEVER WAYS TO INCORPORATE IT ANYWHERE YOU CAN.

CLOCKWISE FROM TOP LEFT AND OPPOSITE
At the cocktail hour, guests played ring toss and other carnival games and the winners were awarded boxes of animal crackers. • An admission ticket was part of the custom circus-inspired invite. • The couple sat at a sweetheart table complete with an elephant figurine. • "Our cake was nothing short of a masterpiece," Rachel says. It was decorated with white Italian meringue buttercream with gold fondant overlays and topped with an edible mini carousel. • The couple found vintage toy elephants on bicycles that they used as décor. • A trackless train transported guests to the ceremony site and then to the cocktail hour.

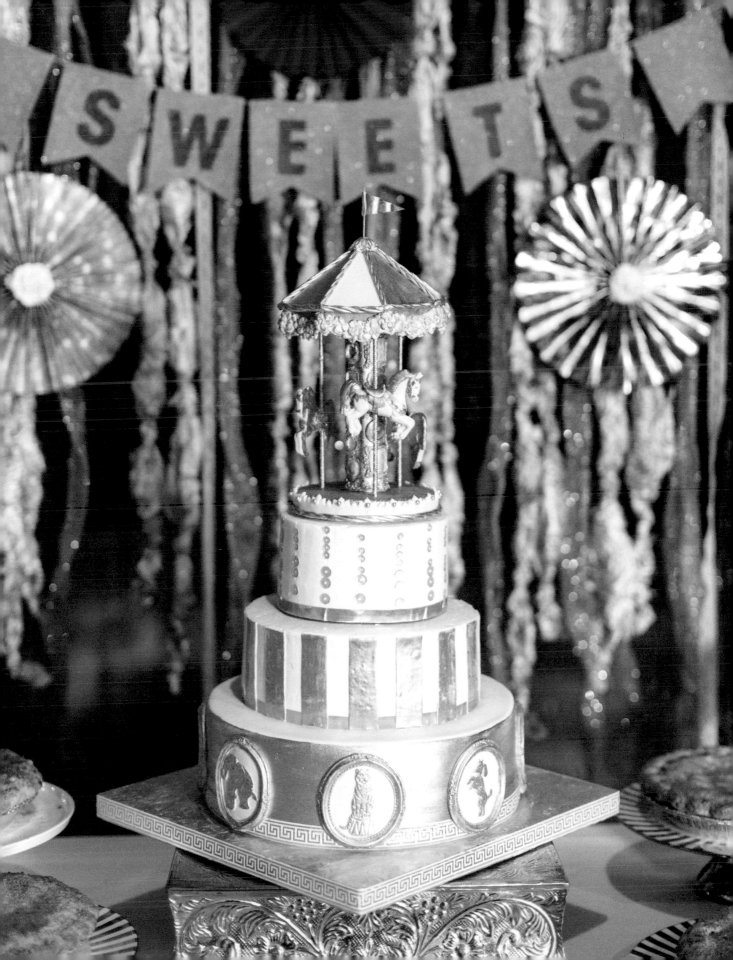

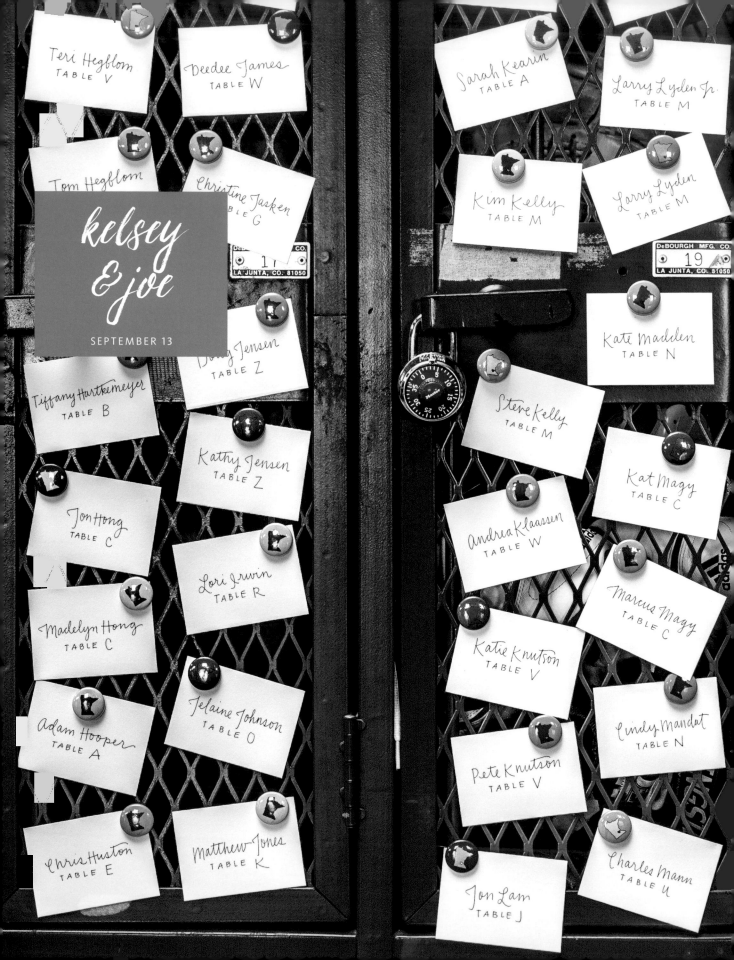

Kelsey and Joe loved the industrial vibe of warehouse venues but just couldn't find the right one for their wedding. Their search for the best space for their day eventually led them to a boxing gym—an interesting choice that ultimately provided an ideal backdrop for their far-from-typical fete. Mismatched vintage furniture, quirky handmade details, and purposefully undone florals created a casual look that fit the setting, and the couple, perfectly.

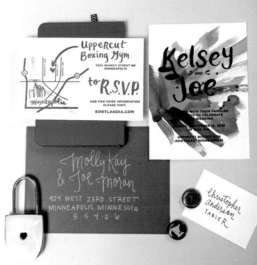

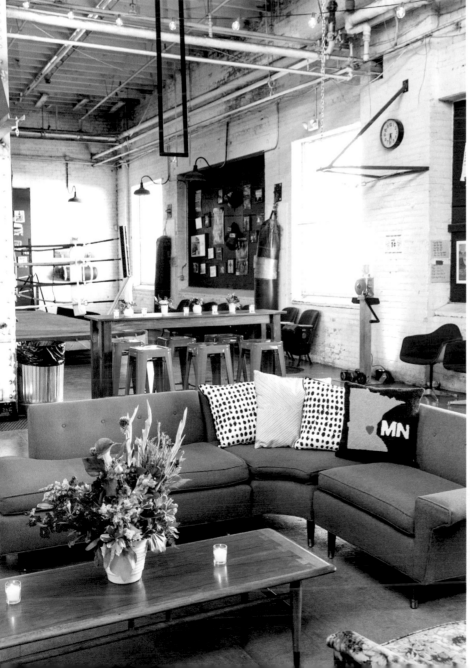

CLOCKWISE FROM OPPOSITE PAGE
Escort cards were stuck to the gym's lockers with state magnets. • The couple's custom invites included a bold watercolor design and gunmetal-foil letterpress. "I wanted our guests to open them and think, 'Whoa—this is going to be a fun wedding!'" Kelsey says. • "I would have felt silly wearing a beaded gown in a boxing gym, so I went with a short, simple dress," she says. • Retro lounge furniture fit the unique space.

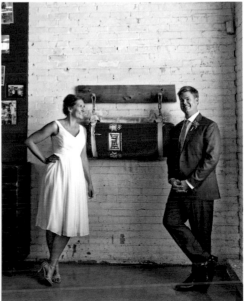

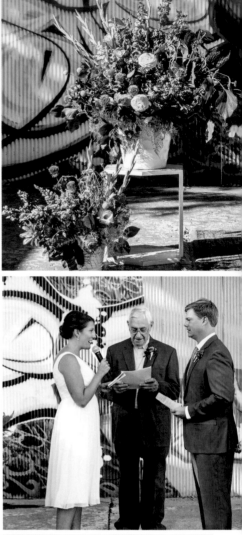

"*Growing up, my mom always used her vintage Fiesta dinnerware whenever we had parties. Now it's what I use every day at our home, so it seemed perfect to have Fiesta at our wedding. I wanted everyone to feel like they were just coming over to our house for dinner.*"

KELSEY

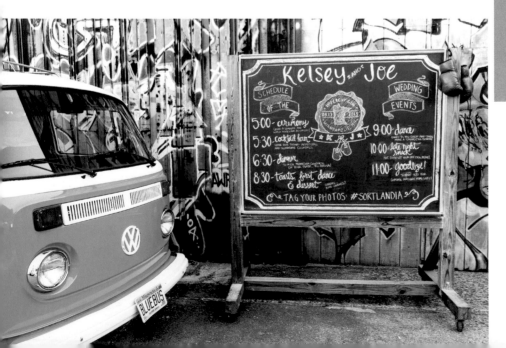

tip
CONSIDER UNCONVENTIONAL VENUES FOR A NONTRADITIONAL WEDDING—IT WILL BE TWICE AS FUN.

CLOCKWISE FROM TOP LEFT AND OPPOSITE
Tables were labeled with vintage marquee letters. • Large colorful floral arrangements and a vintage area rug marked the altar space. • "The high airy ceilings, big windows, and open garage doors were right up our alley," Kelsey says of their unlikely venue. • The reception included a photo booth in a vintage Volkswagen bus, and the night's schedule of events was written in chalk on a vintage blackboard. • The ceremony was officiated by Joe's grandfather, a retired pastor.

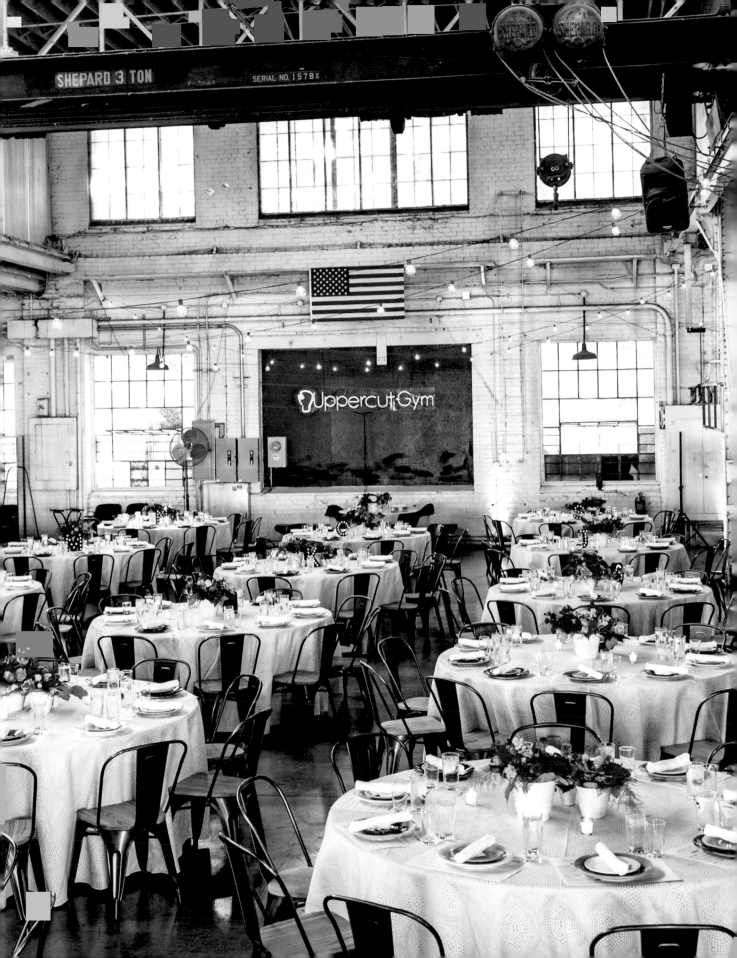

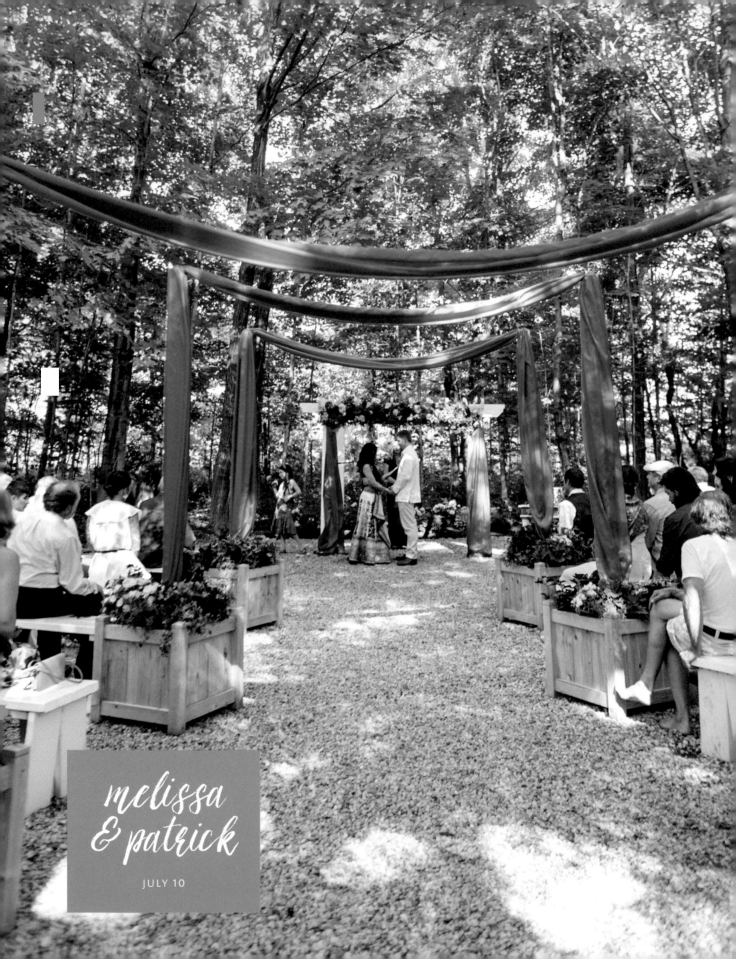

melissa
& patrick

JULY 10

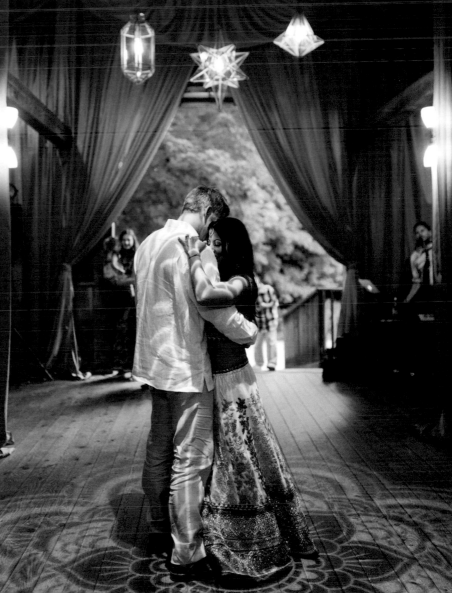

M elissa and Patrick fashioned their joyous wedding day around a vibrant color scheme of orange, fuchsia, and yellow hues. Subtle references to the bride's Hindu roots and their shared spirituality magnified the natural beauty of their rural New England setting.

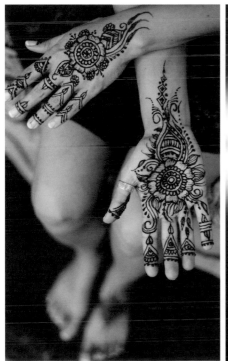

CLOCKWISE FROM OPPOSITE PAGE
A thick garland of fresh blooms in saturated shades of yellow, purple, and red framed the top of the linen-draped ceremony arbor. • The couple's purple-and-gold-foil invitation suite featured an Indian scroll motif. • A large lotus design was projected onto the wood floor of the barn during the first dance. • Melissa's hands and feet were adorned with traditional bridal henna.

> *"Elephants and color represent the way Patrick and I view the world. Elephants, and the joy they represent, are very much a part of our spiritual practice, and we wanted our celebration to reflect this. We meditate in front of Ganesh every day—he had to be present for us on our day."*
>
> MELISSA

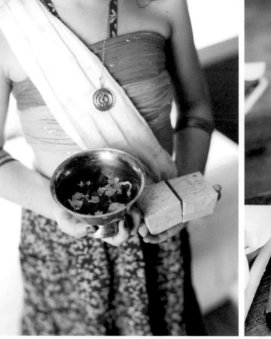

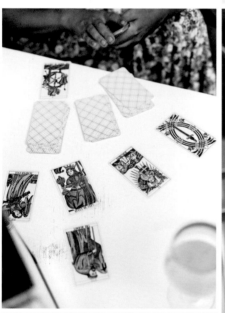

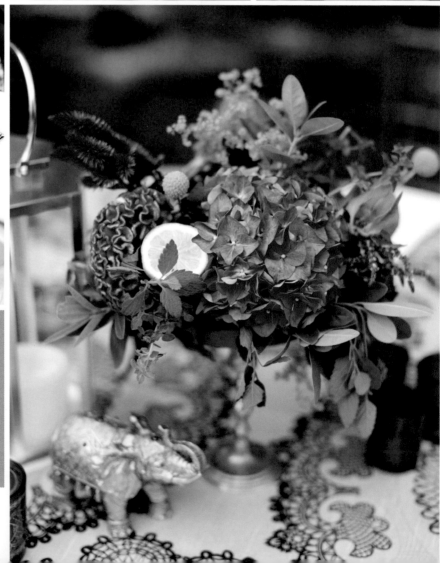

tip
A WOODSY SETTING DOESN'T MEAN YOU'RE LOCKED INTO RUSTIC NEUTRALS. CONTRAST THE ORGANIC HUES OF YOUR SURROUNDINGS WITH A BRIGHT, VIBRANT COLOR SCHEME FOR A BOLD EFFECT.

CLOCKWISE FROM OPPOSITE PAGE TOP LEFT
Boxes held the couples rings. Patrick wanted a ring he would never take off so he opted for a hammered design. • The couple's favorite eats—made mini—were passed during cocktail hour. • Moroccan furniture and throw rugs created a luxurious lounge area. • The bride carried a round, textured bouquet of dahlias, hydrangeas, orchids, stock, craspedia, calla lilies, and celosia in rich jewel tones. • Round tables were draped in colorful floral-patterned linens. • Mixed among the variety of vases and candles on the reception tables were gold elephant and Buddha figurines for good luck. • Guests were treated to tarot card readings.

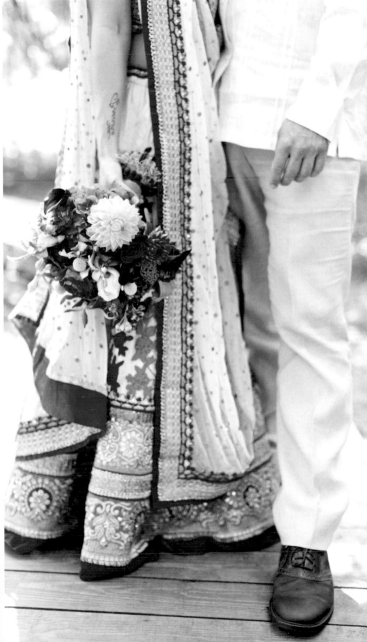

Your *Eclectic* Blueprint

This wedding style is a hybrid of themes that comes together to create something truly original. There may be a strong color palette or a single element (an outside-the-box venue) that inspires the whole celebration.

| turquoise | tangerine | copper | taupe | scarlet | mauve |

colors

When it comes to eclectic weddings, the last thing you want to do is overcommit color-wise. Choose décor pieces that are meaningful to you, and let the day's color scheme evolve organically. In order to keep your wedding from feeling like a little bit of everything, identify one or two vibes or aesthetics, like "industrial" or "carnival," and stay within those parameters.

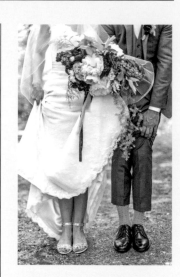

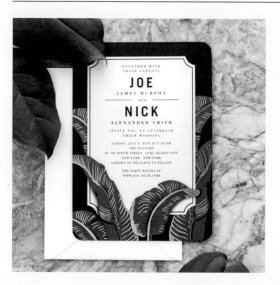

paper + signage

The key here is to have fun. Use your invites to introduce guests to the inspiration behind your day. Is it your venue? If it's a tropical destination, play it up. If it's the coming together of two cultures that shaped your theme, a nod to each of them in the paper goods—either through colors or with symbolism—is a great way to get guests excited for your wedding.

attire

HERS:
• Ethereal gown
• Shorter hemline
• Patterned or colorful shoes

HIS:
• Gray or navy suit
• Trousers and a patterned shirt
• Quirky bow tie and socks

venues

Blank-slate venues are often best suited to eclectic weddings. Clean white lofts and industrial warehouses won't compete with your wide range of colors, textures, and styles. Or opt for an outdoor or offbeat location, like a brewery.

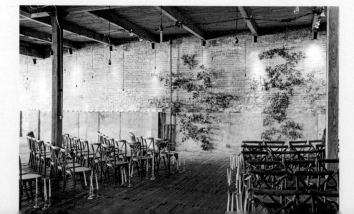

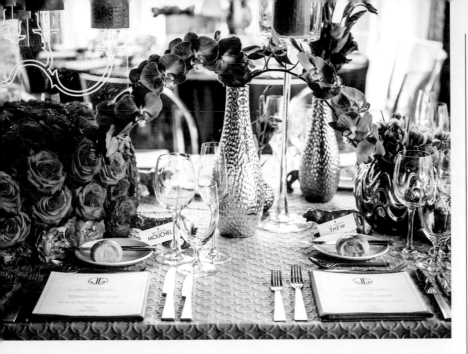

flowers

Identify your flower inspiration—what do you want your flowers to convey? If you're drawn to the raw, untamed look of greenery, work with your florist to come up with pretty arrangements of vines and branches. If you're more about cheery, vivid splashes of color, sunflowers, daisies, and other open-faced, bold blooms might be more your style. Or perhaps you're not into flowers at all. Fabric and paper flowers can be just as beautiful as the real thing, and in some cases less expensive too.

favors

- Sunglasses
- Flash drive of your party music
- A food truck offering up a midnight snack

———

"I would rather spend one lifetime with you, than face all the ages of this world alone."
—Lord of the Rings

———

menu

An eclectic wedding calls for an equally unique menu. Without a real theme tying you down, you can serve whatever cuisine speaks to you. If it's your grandma's mac and cheese and a DIY waffle bar you want, go for it. The beauty of an eclectic wedding is how disparate things come together to represent you. Just remember, while the day is about you two, you want your guests to have fun too, so include some expected menu choices.

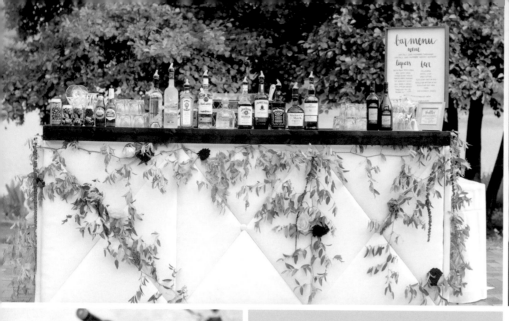

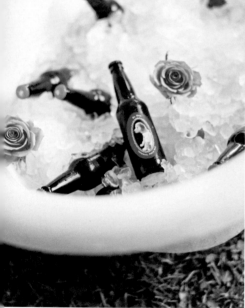

Cocktail Hour

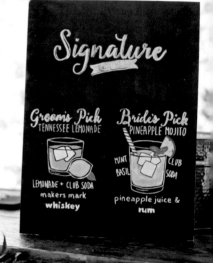

Signature

Groom's Pick
TENNESSEE LEMONADE

Bride's Pick
PINEAPPLE MOJITO

MINT
BASIL

CLUB
SODA

LEMONADE + CLUB SODA
makers mark
whiskey

pineapple juice &
rum

L & W

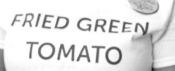

Treat your guests to some snacks, sips, and activities that will tease the evening ahead—spoiler, it's going to be amazing! Everyone will appreciate a signature cocktail that pays homage to your roots or unique tastes. Give yours a cute name (like Head Over Heels for a gal that loves fashion, or Home Run for a baseball fanatic) that hints at who you are or your location. Creative cocktails always encourage conversation. Pair with some delicious bites for the ultimate sensory experience. Hosting alfresco? Invite guests to participate in a handful of your favorite yard games, like bocce, corn hole, or Jenga. Interactive activities will turn the volume up on the mingling, big time.

glam

If a glittering party, destined to be the talk of the town, sounds like your dream wedding, then a glamorous affair is the only choice for you. These opulent soirees feature showstopping floral installations and over-the-top details that make guests feel like they're at the party of the year (because they are, of course).

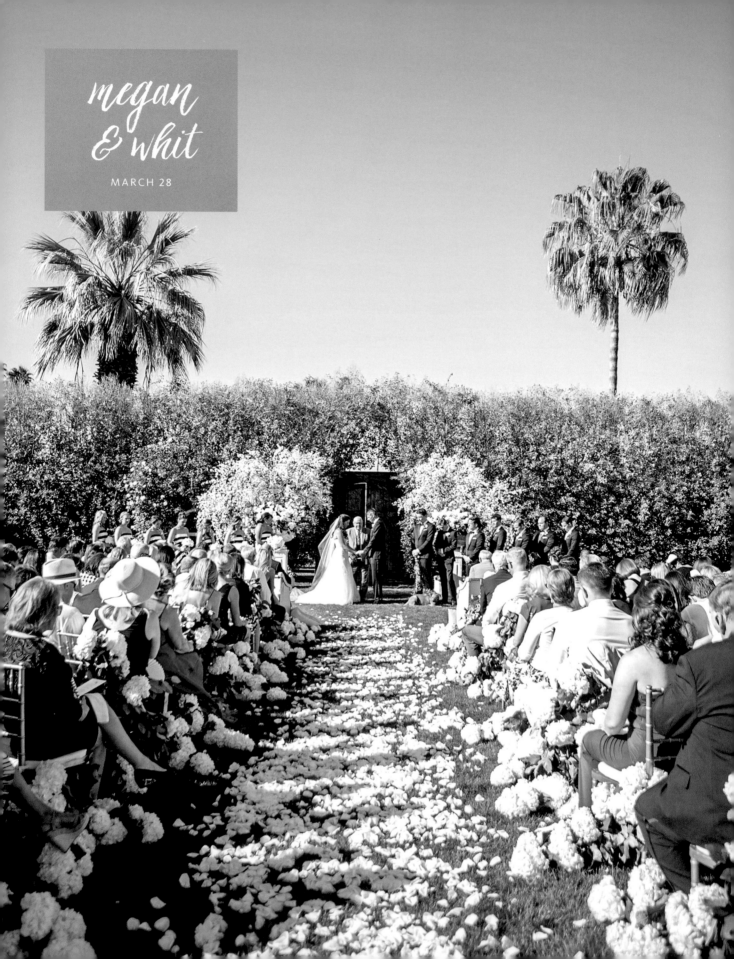

megan
& whit

MARCH 28

CLOCKWISE FROM OPPOSITE PAGE
White rose petals covered the grass, creating a ceremony aisle. • Mirrored tabletops gave the reception an unexpected layer of glamour. • The couple had fun with their stationery design, infusing witty phrases throughout. • Megan wore diamond drop earrings that complemented her strapless gown beautifully.

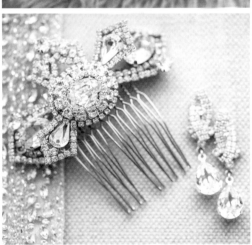

S oaring monochromatic blooms, oversize chandeliers with real sparkle, and a weekend packed with activities were just a few details that contributed to the glamour of Megan and Whit's California affair. Graphic black-and-white-striped accents and bold, high-end fashion choices were the icing on an ultra-luxe cake.

Hanging floral arrangements of white blooms
and natural greenery amped up the drama at
the reception, making the space feel "magical,"
Megan says. • The couple's dog, Aubrey, walked
Megan and Whit down the aisle. • The pair
welcomed guests with a festive bag of treats.

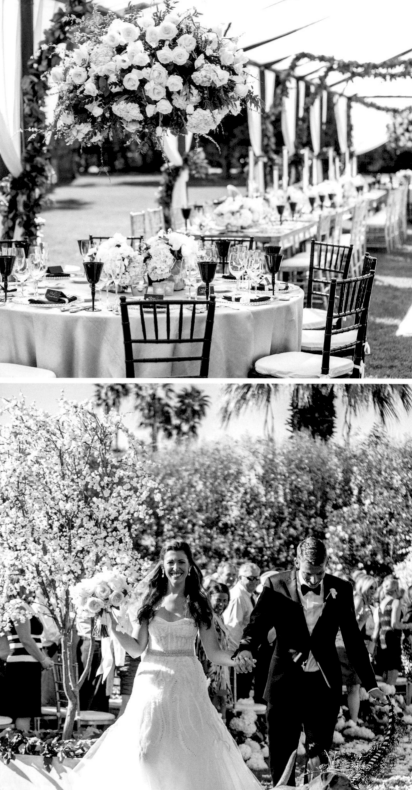

tip
DON'T FORGET TO INVITE
YOUR FURRY FRIEND! PETS
MAKE A SUPER-CUTE
(AND ÜBER-PERSONAL)
ADDITION TO ANY NUPTIALS.

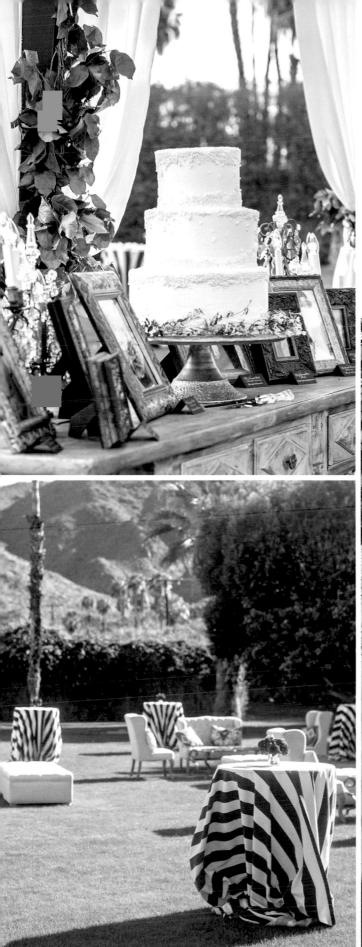

Megan and Whit aren't into sweets and were about to skip a cake altogether until their baker surprised them with a chocolate and potato chip flavor. "Who can resist that salty and sweet combo?" Megan says. • Names engraved into antique mirrors escorted guests to their seats. • The graphic black-and-white-striped cocktail-hour linens matched the bridesmaid dresses, which actually inspired the day's bold stripe motif.

CLOCKWISE FROM TOP LEFT AND OPPOSITE
Guests wrote messages to the bride and groom and slipped them into a book filled with gold-foil-embellished envelopes. • Megan and Whit sat in matching French provincial dining chairs at the reception. • An open-air tent created a dreamy indoor-outdoor vibe for the reception. • Megan's bridesmaids wore floor-length black-and-white-striped dresses, inspired by Oscar de la Renta.

"I saw this unbelievable black-and-white-striped gown by Oscar de la Renta and fell in love with it. It didn't take long for me to realize what a fabulous statement these gowns would make for my bridesmaids, and I loved the idea of incorporating black-and-white stripes throughout the wedding."

MEGAN

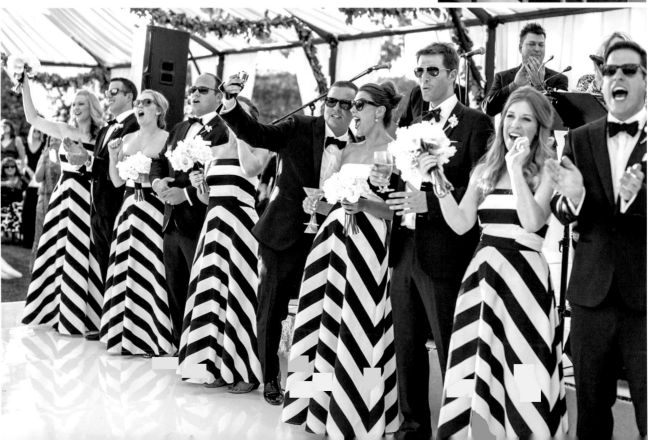

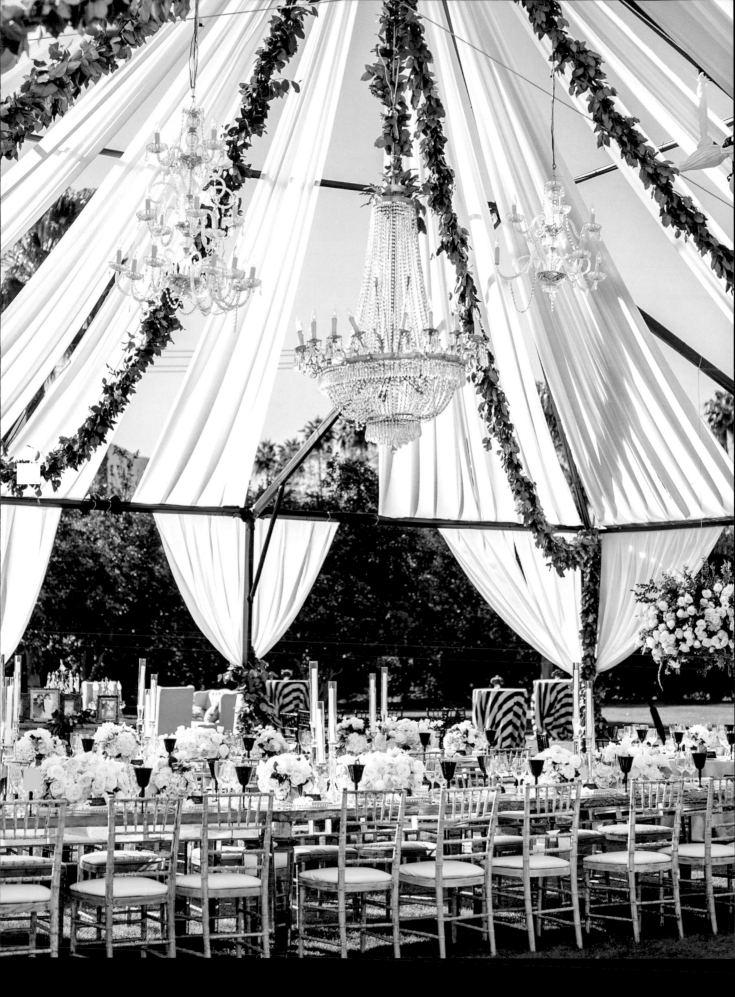

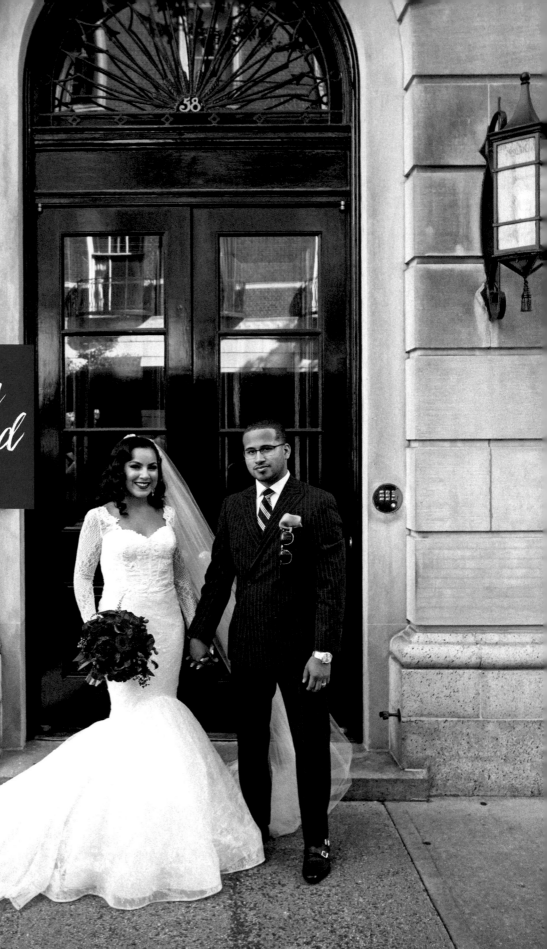

carolina
& sherrard

JUNE 11

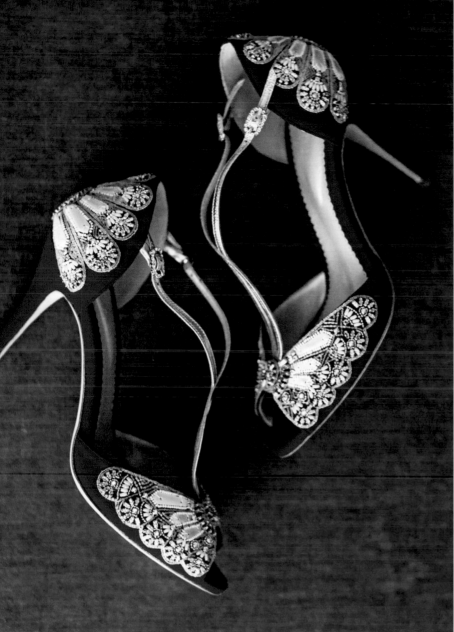

CLOCKWISE FROM OPPOSITE PAGE
Carolina searched for a while to find a wedding dress that checked all her boxes—mermaid silhouette, long sleeves, and a low back—but her persistence paid off. • The bride designed her beaded open-toe T-strap pumps herself. "It took about 10 months to complete my bespoke shoe, and it was everything I imagined and more," she says. • A gold fondant Dominican cake with dulce de leche filling was a delicious tribute to Carolina's heritage. • The bride carried a romantic all-red bouquet of peonies, roses, and calla lilies.

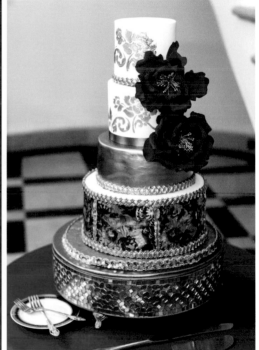

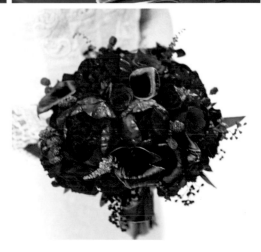

Carolina and Sherrard are both from New York City, which also happens to be where they met and fell in love. To honor the city they both cherish, the high school sweethearts planned a lavish New York City–themed wedding day full of nods to the Big Apple's rich history. For a personal touch, they paired deep shades of Sherrard's favorite color (red) with soft accents of Carolina's preferred shade (blue). Meanwhile, gilded baroque accents added to the drama and evoked the romance of old New York.

"I wanted our wedding favors to complement our theme. When I thought about what says 'New York,' I immediately thought about the caricature artists that line 42nd Street. Having someone draw our guests seemed like a lot of fun, plus the drawings were something our guests wouldn't just toss when they got home. They worked out to be a two-for-one: entertainment and favors."

CAROLINA

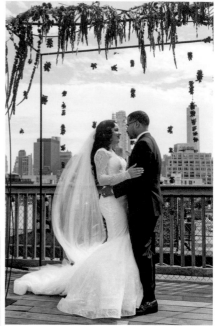

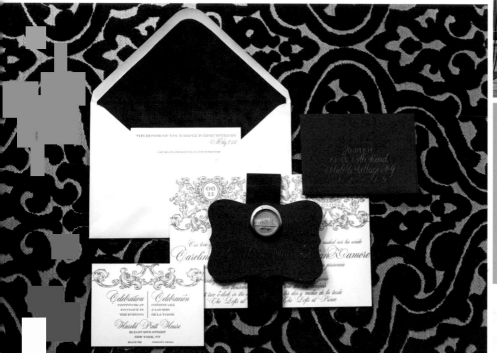

tip
INTERACTIVE ACTIVITIES DURING THE RECEPTION, LIKE A CARICATURE ARTIST OR PHOTO BOOTH, ARE TONS OF FUN, PLUS THEY PROVIDE GUESTS WITH A TAKEAWAY THEY'LL WANT TO KEEP.

CLOCKWISE FROM TOP LEFT AND OPPOSITE
The couple's ultra-luxe invitation suites were held together by a deep red belly band stamped with a vintage gold wax seal. • Carolina and Sherrard were married in a rooftop ceremony beneath a wrought-iron arbor adorned with red hanging amaranthus and orchids. • The couple decided on champagne linens to contrast the dark wood walls of their reception venue. • Carolina and Sherrard rode to and from the day's events in an antique red Buick coupe. • Arrangements of greenery and deep red blooms dotted the reception space.

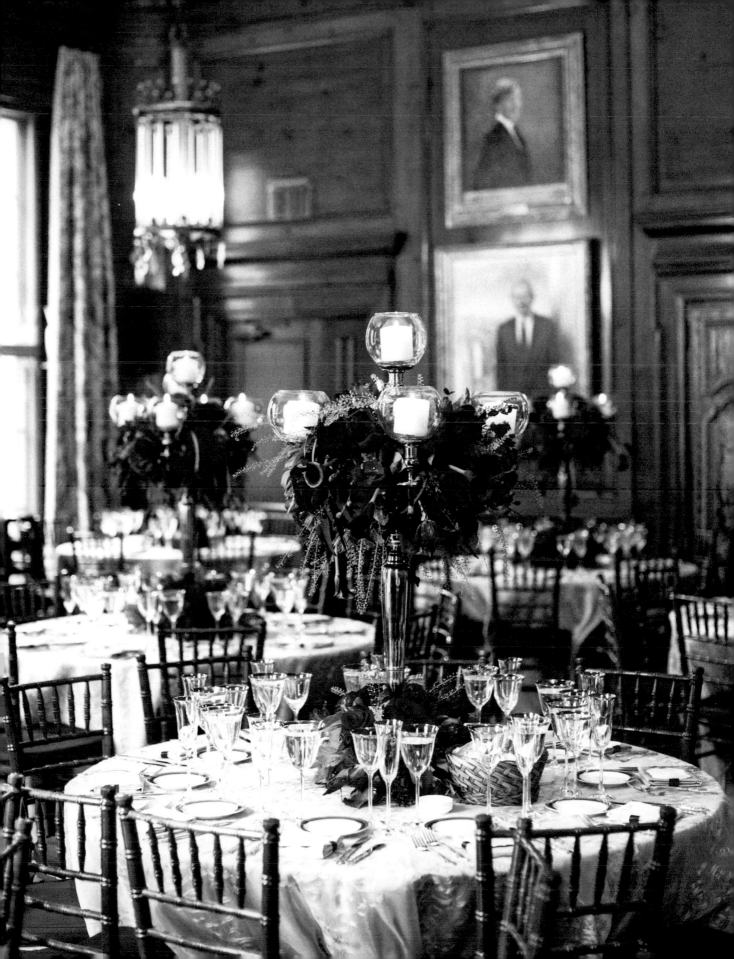

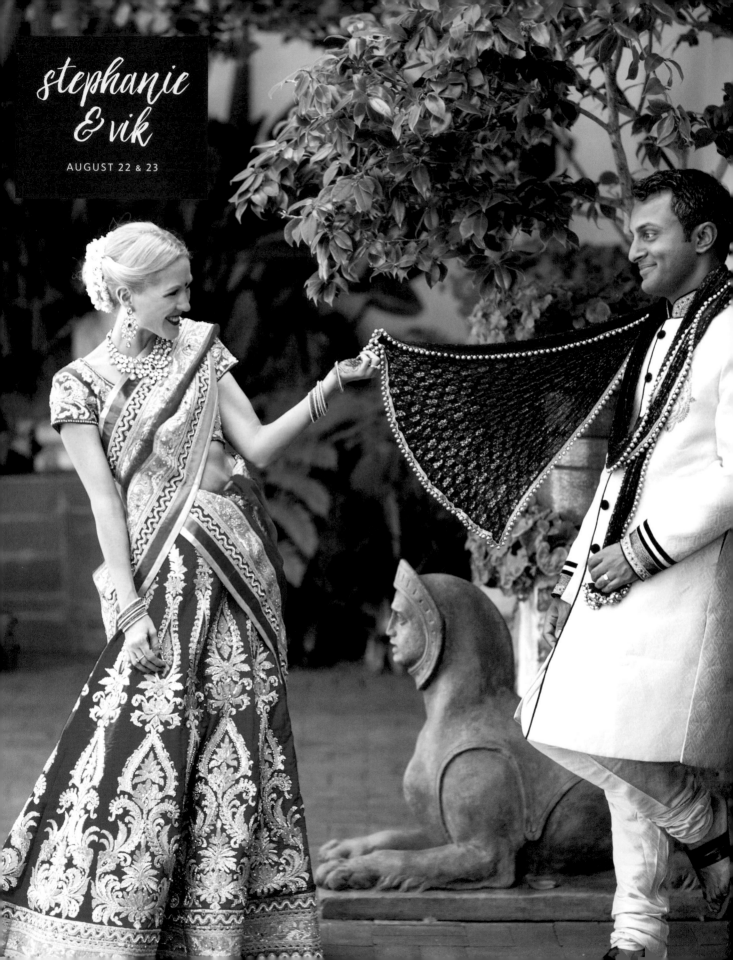

stephanie
& vik

AUGUST 22 & 23

Stephanie and Vik wanted their two-day fusion wedding to reflect not only the coming together of her Western and his Indian cultures, but the joyous merger of their families as well. A strong focus on food, drinks, and fashion (nods to their shared interests) tied it all together, as did the festive color scheme of bright red, hot pink, orange, gold, and saffron.

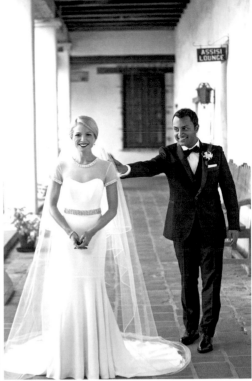

CLOCKWISE FROM OPPOSITE PAGE
Instead of a traditional nine-yard sari, Stephanie chose a hand-embroidered pink-and-orange *lehenga*. • For their Catholic ceremony, Stephanie wore an elegant fit-and-flare gown with a delicate illusion neckline and glam crystal embellishments. • They lit a unity candle to signify their two families coming together during the church ceremony. • Stephanie and her bridesmaids wore traditional henna on their hands.

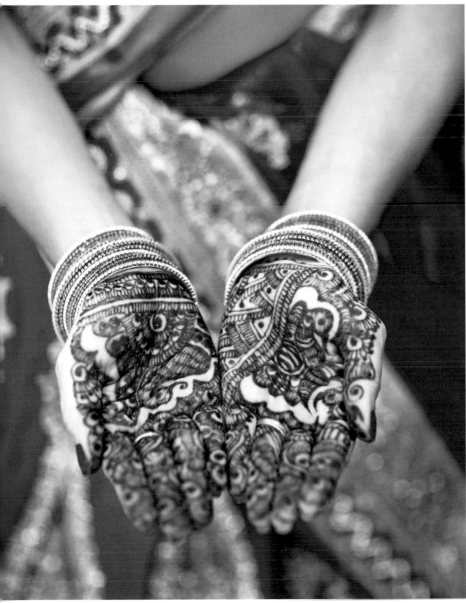

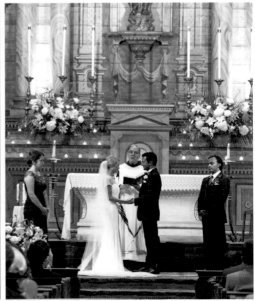

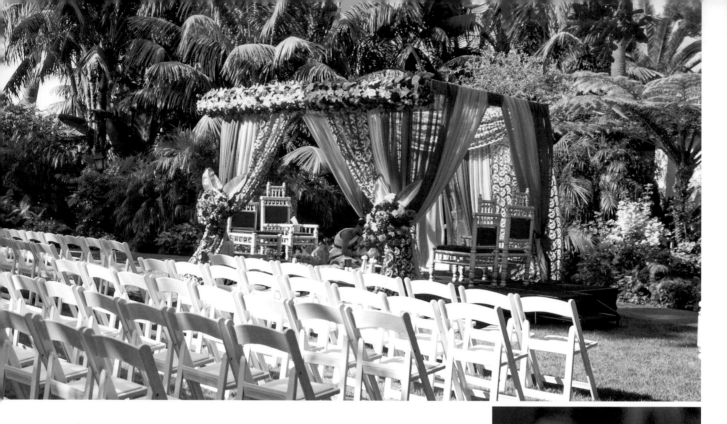

"Our theme was the coming together of our friends and family in a fusion event, since many of them had never been to an Indian or a Catholic wedding. We used traditional elements of each, with our own unique spins."

STEPHANIE

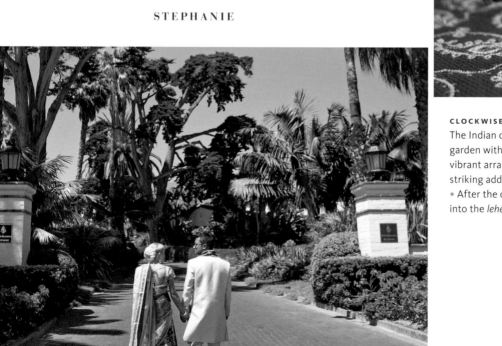

CLOCKWISE FROM TOP
The Indian ceremony took place in a lush garden with views of the ocean. • Small, vibrant arrangements were a simple yet striking addition to the reception tables. • After the ceremony, Stephanie changed into the *lehenga* she purchased in India.

Stephanie's third dress change was a custom red-and-gold sari-inspired gown she helped create with an Indian designer. • Stephanie entered the Indian ceremony on a doli carried by her uncles. • The couple drank out of intricate Hindu wedding chalices. • Vik also made a dramatic entrance thanks to a sports car.

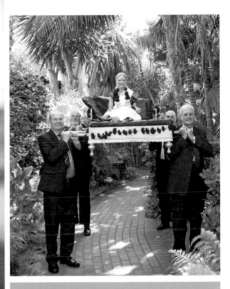

tip
COLORS CAN TELL THEIR OWN STORY. FOR A DRAMATIC EFFECT THAT LASTS, START YOUR DAY WITH SOFT HUES AND SLOWLY TRANSITION THEM INTO BOLDER, MORE VIBRANT SHADES FOR A BUILT-IN WOW FACTOR.

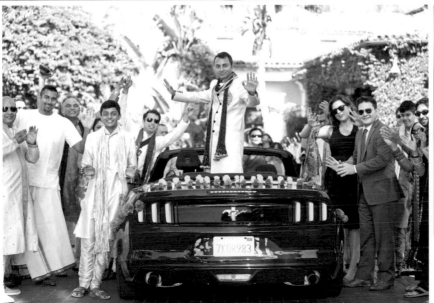

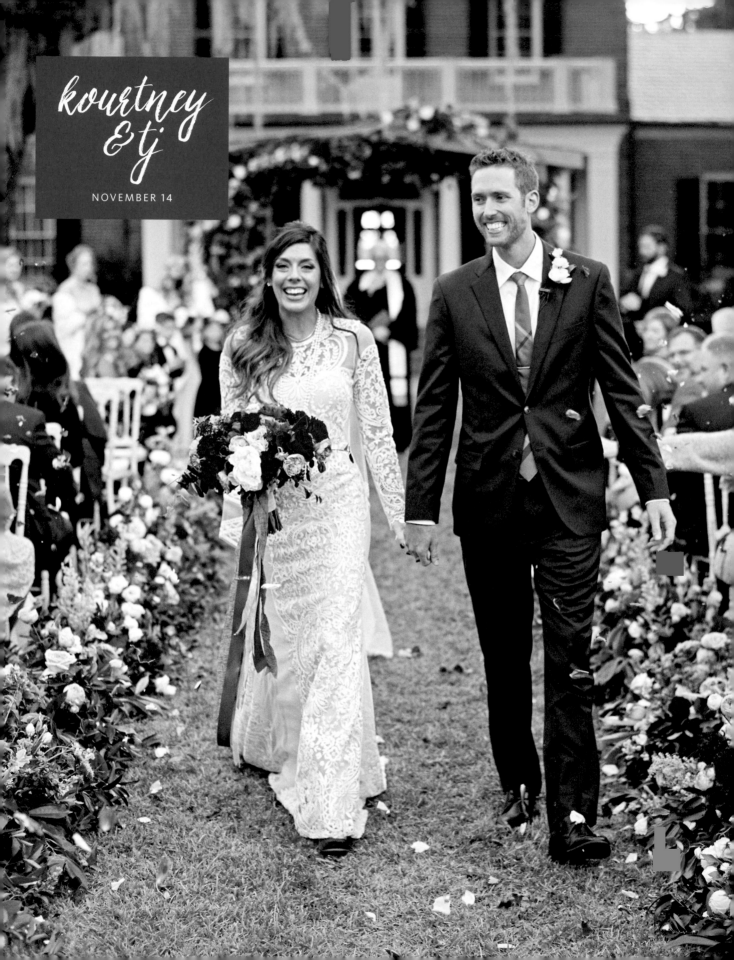

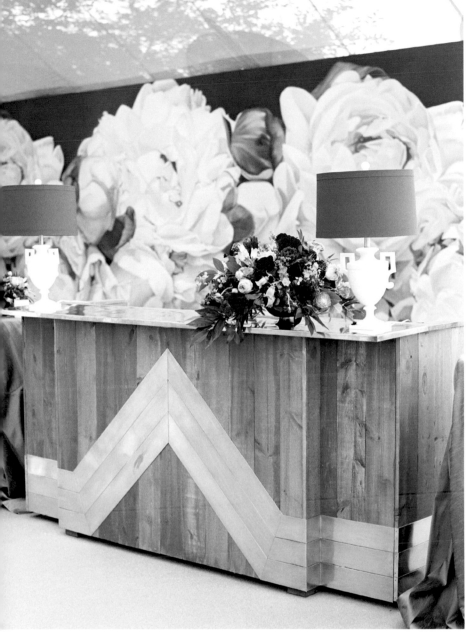

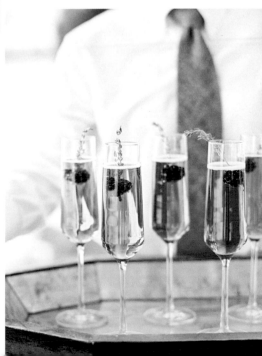

CLOCKWISE FROM OPPOSITE PAGE
The plantation house served as the backdrop for the outdoor ceremony. The two were married beneath an arbor adorned with blooms. • A gold chevron pattern added a hint of glam to the reception's wood bar. • A mix of hand-painted and sugar flowers accented the couple's fanciful four-tier pink-and-white cake. • Cocktail hour featured flutes of pink champagne garnished with blackberries and herbs.

Determined to have a Southern wedding that didn't feel like it had "been done a million times before," Kourtney and TJ were thrilled when they came across a recently restored plantation that just started hosting events. Capitalizing on the freshness of their venue, the couple went about crafting a luxurious day full of bold colors, lush florals, and a jubilant mix of patterns that evolved organically out of their mission to ensure their guests felt comfortable and enjoyed every minute of the day.

CLOCKWISE FROM RIGHT
Pink flowers lined the aisle of the outdoor ceremony. • The two flower girls wore matching velvet dresses and fresh flower crowns. • "I'm obsessed with all things flowers. If I wasn't an architect, I would have a flower shop or a farm," Kourtney says. Her love for blooms inspired the floral motif that pervaded the day's paper goods.

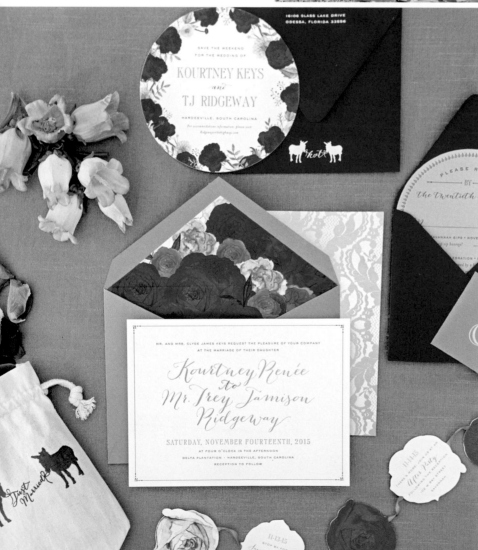

tip
IF YOUR PET CAN'T MAKE IT TO YOUR WEDDING, INCORPORATE HIM INTO THE INVITATIONS OR SOMEWHERE ELSE IN THE WEDDING DAY DESIGN. IT'S A SUBTLE (AND CUTE) WAY TO ADD YOUR PERSONAL TOUCH TO THE CELEBRATION.

OPPOSITE, CLOCKWISE FROM TOP LEFT
Shelves topped with knickknacks and books covered with pink paper gave the tented reception a homey, indoor feel. "We still have the pink books and hope to use them in a girl's nursery someday," Kourtney says. • A patterned dance floor beckoned guests to boogie. • Clusters of sleek, slate-colored lounge furniture, positioned around the dance floor, gave guests a comfortable place to mingle in between songs.

"We have two miniature
donkeys (Buckwheat
and BonnieSue) that
I just adore—we even
included them in
our engagement photos.
So when our stationer
sent us the proofs for
our invitation suite,
I was thrilled to see they
used them for inspiration
on the envelopes."

KOURTNEY

Your *Glam* Blueprint

Jaw-dropping details and red-carpet style make this formal celebration unforgettable. Every element is executed with an air of luxury, from the flowers to the food.

| gold | silver | white | crimson | indigo | ink |

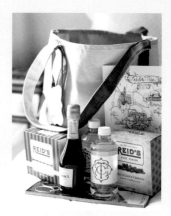

colors

Metallics and monochromatic palettes (all-white or various shades of one hue), as well as combinations ranging from sultry jewel tones to boisterous hot hues, will have a bold impact. Keep the current décor of your venue in mind: If your reception is being held in a ballroom with ornate red-and-gold wallpaper, a fuchsia and orange color scheme may clash.

paper + signage

Hint at the opulent fete to come with luxe details like thick stock and elaborate laser-cut designs or gilded foil and crystal embellishments—or all of the above. If you want to take the "less is more" approach, opt for metallic-foil textual invites with a patterned envelope liner.

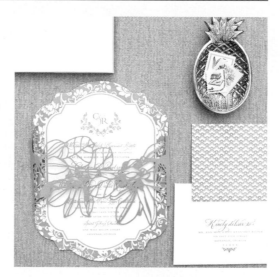

favors

- Personalized totes packed with goodies
- Chocolate truffles
- Colorful macarons

"All, everything that I understand, I understand only because I love."
—Leo Tolstoy

menu

Before sitting down to a candlelit dinner, host a cocktail hour with your own signature drink or a new spin on a classic, like an updated gimlet or an old-fashioned with a twist. These cocktails are the definition of sophistication and allow for personalization through presentation and garnishes. Pass inventive pairings in bite-size form. If you're going all out, a seated four-to-six-course meal is sure to impress. (Four courses are more complementary to a cocktail hour with appetizers; five are traditional; while six becomes a contemporary style consisting of more plates but smaller servings.) A statement-making cake is the pièce de résistance.

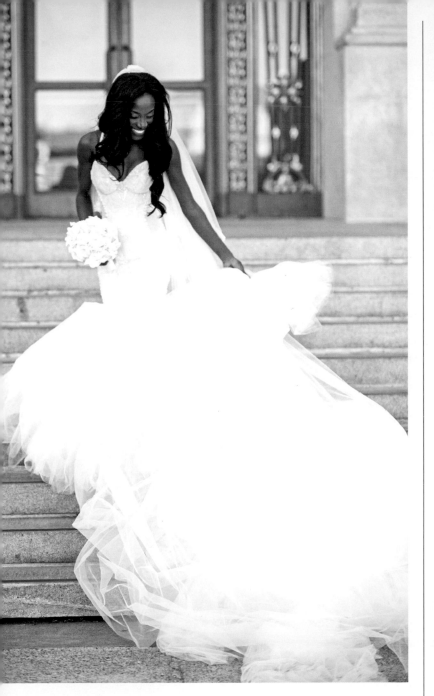

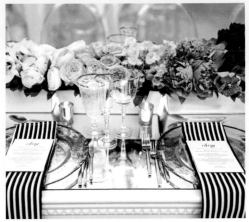

flowers

Arrangements that feature variations of one stem, like Juliet garden roses, spray roses, and English roses, are aesthetically interesting but still feel cohesive and luxe. Play around with different centerpiece styles to evoke extra drama—trade out a few low arrangements for tall, nonfloral structures such as curly willow or manzanita branches. Or add a lighting element to your table décor like candelabras.

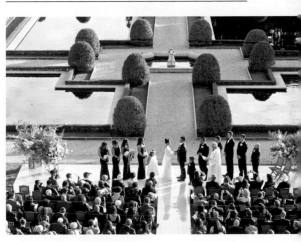

attire

HERS:
- Red-carpet-inspired silhouette
- Curve-hugging, mermaid-style gown
- Sparkly accessories like diamond drop earrings

HIS:
- A formal tuxedo
- A velvet dinner jacket
- Luxe loafers or smoking slippers

venues

Opulence and glamour are synonymous—look for a venue that has bold style. Most ballrooms have ornate architectural elements, such as crown molding or impressive uplighting, both of which give instant ambience. Other venues to consider include the atrium of an exquisite art museum, a grand estate, or a historic mansion. If you want to wed alfresco, search for an equally grand outdoor space with views to match, like a gorgeous beachfront or a well-manicured garden.

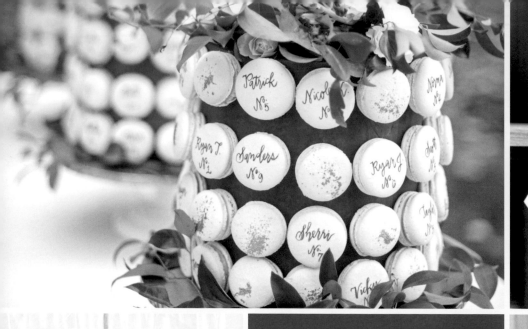

Table
03

SHANNON MCSHAY
KRISTI MCSHAY
JIM STRICKLIN
LAURIE STRICKLIN
LORI HEATHERSHAW
TODD HEATHERSHAW
MELISA COLE
TERRY COLE
MALCOM GRIEF
KATE GRIEF

Please be Seated

Escort Cards

MR. JASON RICKELS AND
MS. SARAH GOLDFINE

Silverado

Table 1

MR. RYAN
SWIGLER

Granite Chief

Table 10

table 8

sebastian rodriguez

claire olszewski

jeffrey rubin

mark o'halloran

amanda o'halloran

audrey lubin

jillian mallis

andrew klein

samantha kaplan

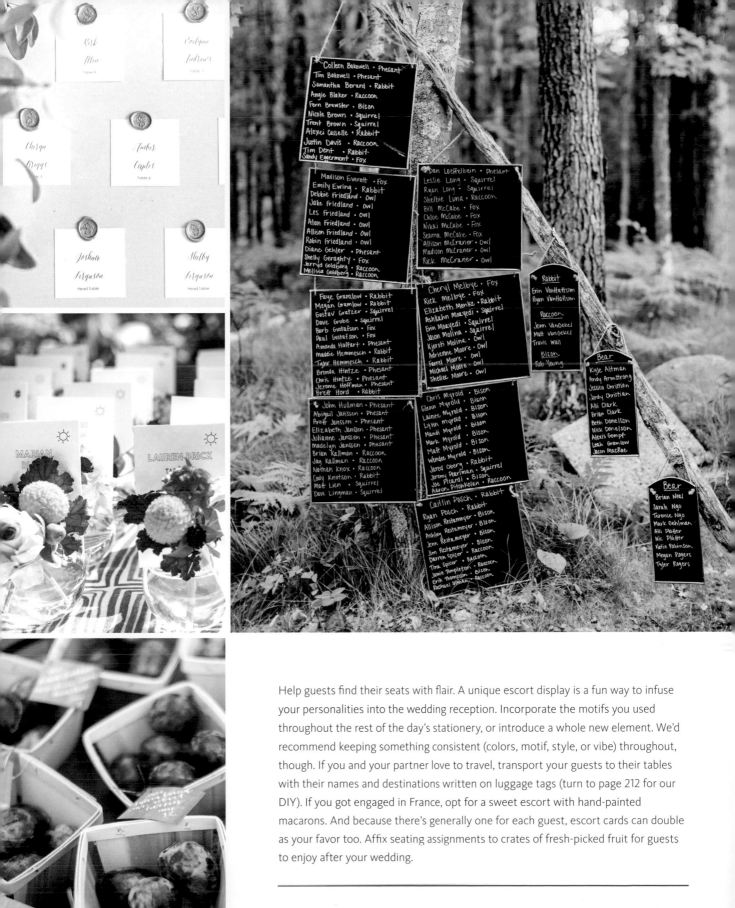

Help guests find their seats with flair. A unique escort display is a fun way to infuse your personalities into the wedding reception. Incorporate the motifs you used throughout the rest of the day's stationery, or introduce a whole new element. We'd recommend keeping something consistent (colors, motif, style, or vibe) throughout, though. If you and your partner love to travel, transport your guests to their tables with their names and destinations written on luggage tags (turn to page 212 for our DIY). If you got engaged in France, opt for a sweet escort with hand-painted macarons. And because there's generally one for each guest, escort cards can double as your favor too. Affix seating assignments to crates of fresh-picked fruit for guests to enjoy after your wedding.

modern

You appreciate clean lines, simplicity, and stylish twists on tradition. Perhaps you're an architect or an artist, or you just find yourself attracted to a pared-down design. Whatever the reason, keep in mind that sleek, minimalist styles and monochromatic floral arrangements are just the beginning of this polished affair.

BARBARA IVERSON

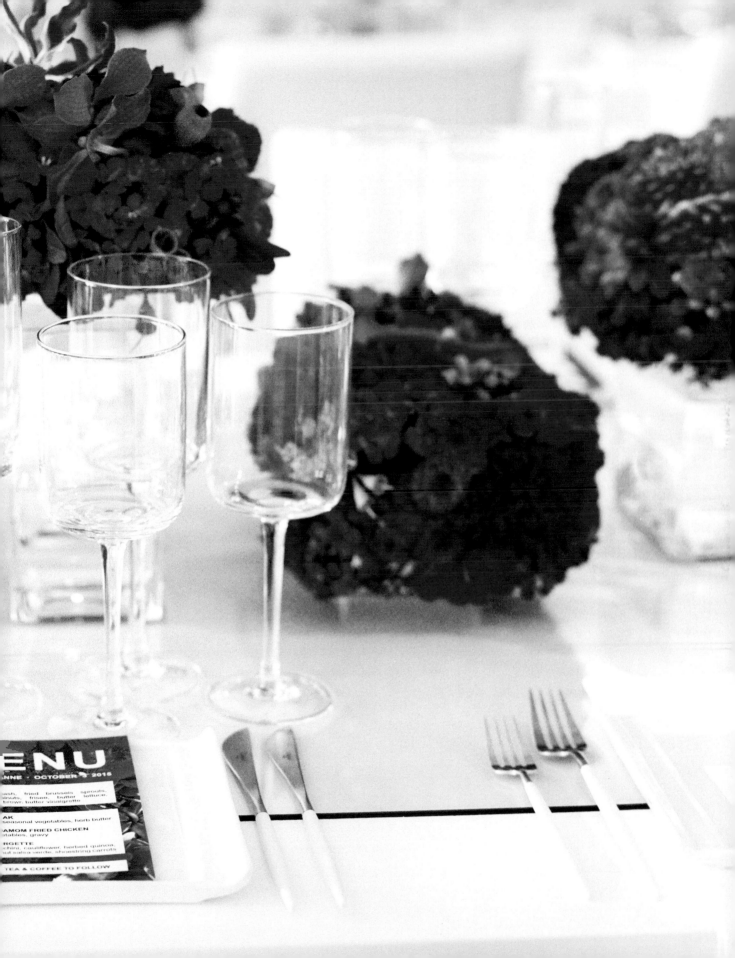

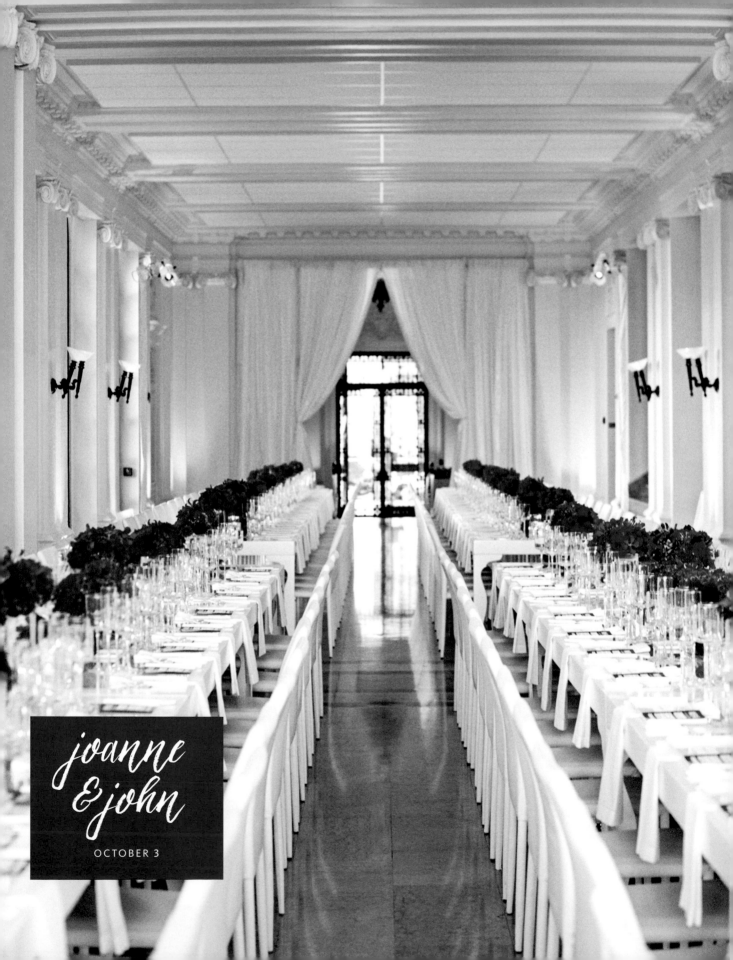

joanne
& john

OCTOBER 3

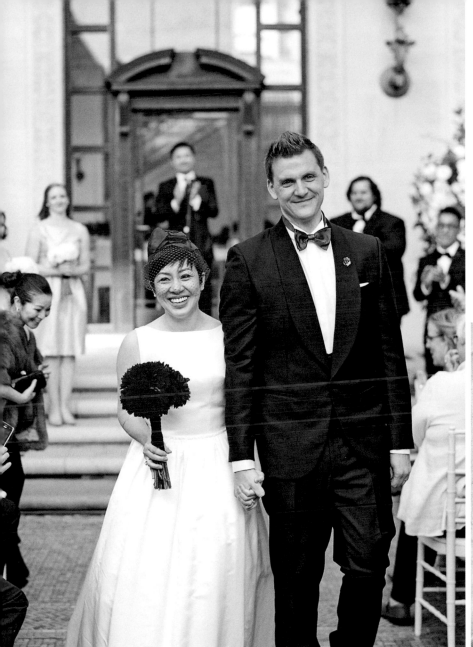

CLOCKWISE FROM OPPOSITE PAGE
The florals were meant to look more like sculptural elements than traditional centerpieces—each one was placed on glass so it appeared to be floating. • Joanne's fuchsia headband was a symbolic gesture to the Chinese tradition of a bride wearing red on her wedding day. • "We wanted something minimal that got the message 'We're getting married!' across." Joanne says of the fuss-free invites John designed. • Passed hors d'oeuvres at the cocktail hour included mini steak tartare and pumpkin and sage flatbread.

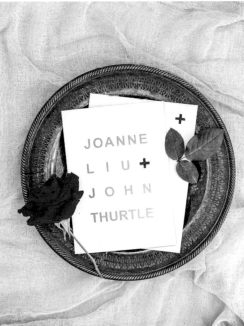

I nstead of letting their classic venue determine their day's design, Joanne and John "rebelled" against it. The couple contrasted the historic San Francisco estate with a contemporary, cutting-edge aesthetic, utilizing minimalist décor and vivid splashes of fuchsia from an abundance of structured monochromatic floral arrangements. The result was unexpected yet controlled and 100 percent them.

"The setting at the Flood Mansion is very specific, but we didn't want a classic wedding style that reflected the design of the space. Instead, it was important to us to use the structure as a foundation to juxtapose something contemporary and a bit cutting edge."

JOANNE

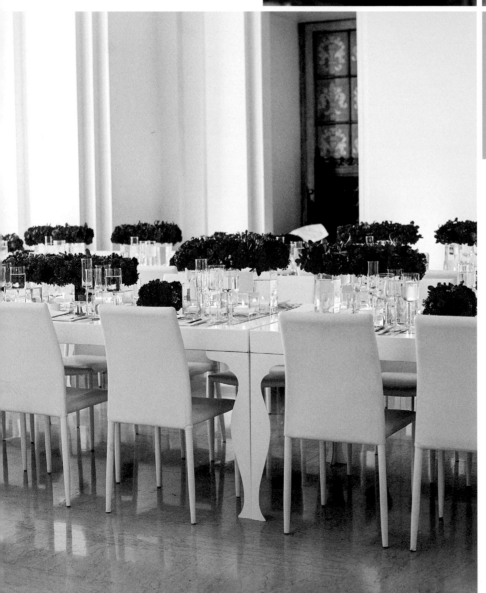

tip
SWAP OUT A TRADITIONAL VEIL WITH A FUN HAIR ACCESSORY FOR A LOOK THAT'S ALL YOUR OWN.

CLOCKWISE FROM TOP LEFT AND OPPOSITE
The couple served his and hers signature sips during cocktail hour. • Joanne subtly infused elements of Chinese tradition into the wedding day. • The bride changed into a short, white cape dress with a crystal-embellished edge that matched her shoes to add a bit of fun and sparkle. • "We wanted to use color and texture to make everything pop, so we went with really dense and brightly colored flowers that became the main focus of the reception," Joanne says.

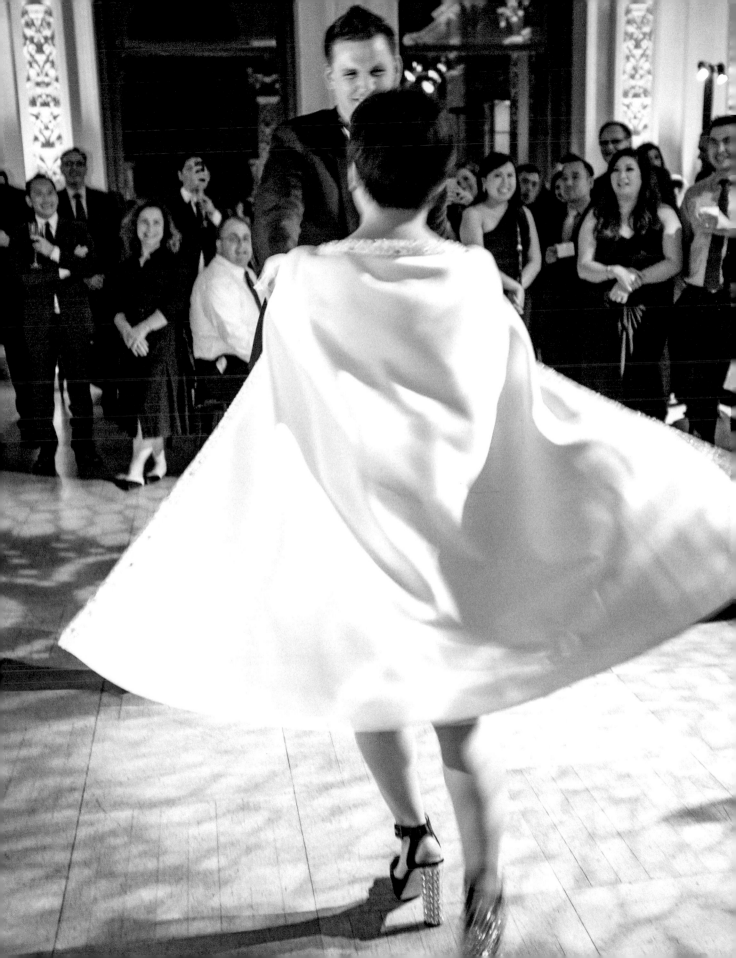

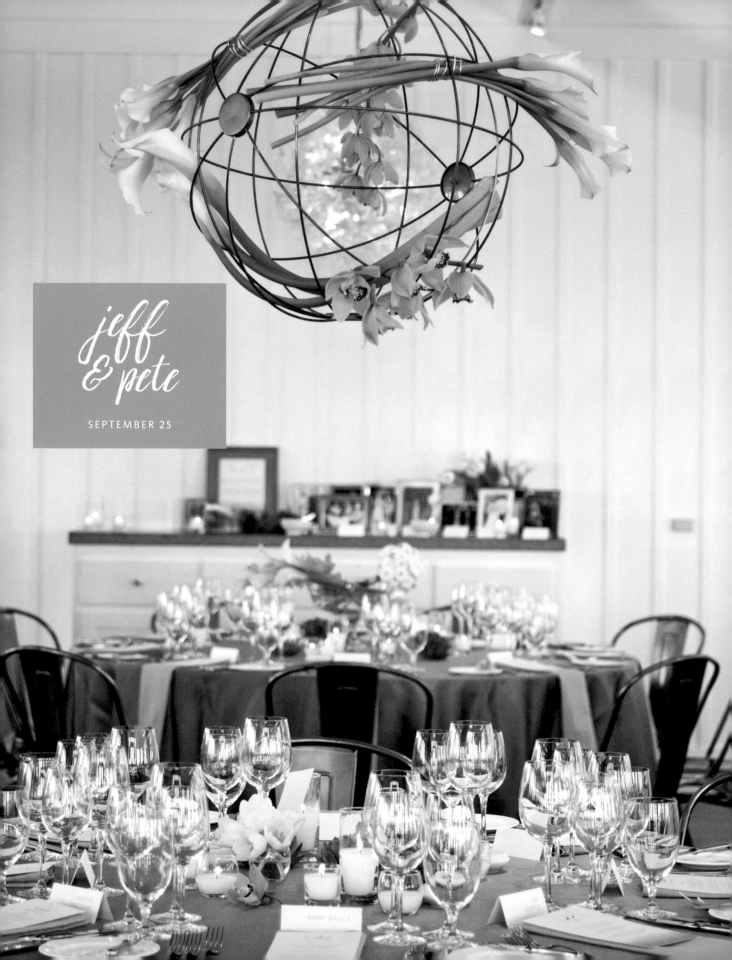

jeff
&pete

SEPTEMBER 25

It just felt right for oenophiles Jeff (right) and Pete to celebrate their marriage at a Napa Valley vineyard. The pair crafted an intimate, modern affair reflective of their own personal style, tied together with a sleek gray and crisp chartreuse palette. Polished, architectural floral arrangements juxtaposed with the farmhouse feel of their venue to create a stunning yet relaxed vibe that represented their style.

RSVP
SCHEDULE

JEFF HARMS +
PETE MACLEAN
REQUEST THE PLEASURE OF YOUR
COMPANY AT THE CELEBRATION
OF THEIR UNION

FRIDAY, THE TWENTYFIFTH OF SEPTEMBER
TWO THOUSAND AND FIFTEEN
HALF PAST THREE O'CLOCK IN THE AFTERNOON

THE APPLE ORCHARD AT THE CARNEROS INN
4048 SONOMA HIGHWAY
NAPA, CALIFORNIA

COCKTAIL RECEPTION

CLOCKWISE FROM OPPOSITE PAGE
Steel orbs woven with modern stems were suspended from the ceiling at the reception. • The grooms decided against ties, keeping with the relaxed Napa vibe. • A contemporary font and a subtle pop of chartreuse gave the invitations a modern feel. • Escort cards were arranged in split peas.

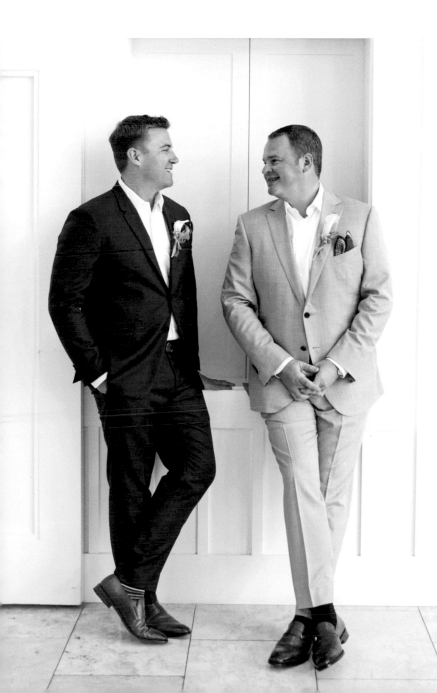

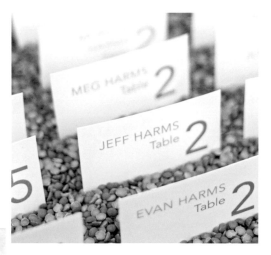

MEG HARMS
Table 2

JEFF HARMS
Table 2

EVAN HARMS
Table 2

5

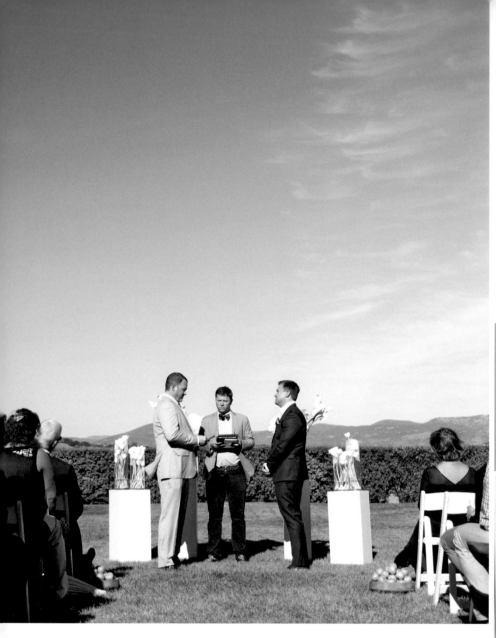

The ceremony took place in an apple orchard.
The couple lined the aisle with buckets of
fresh Granny Smith apples. • Tables were
topped with small, all-white arrangements
of mono-botanical blooms in clear glass
vases. • The couple served a classic vanilla
buttercream cake accented with gray bands
and fresh orchids.

tip
CONSIDER USING FRESH
PRODUCE AS A COST-
EFFECTIVE AND UNIQUE
SUBSTITUTE FOR FLOWERS.

*"We didn't have a religious ceremony, but
we did have a string quartet. Much like
the vibe of our wedding, we wanted a
modern twist with a classic feel. Pete and
I walked in to the string quartet playing
'Marry You' by Bruno Mars and our
recession was to 'Latch' by Sam Smith.
Not only are these songs that we love,
they were so fun to hear in a different way."*

JEFF

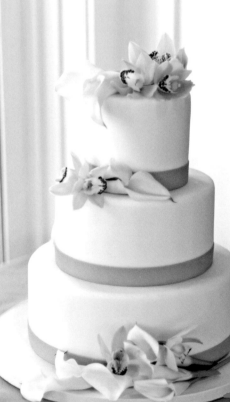

10

JEFFREY
WONDRELY

JEFF+PETE

MENU

HEIRLOOM TOMATO SALAD
Grilled Bread, Pistou, Burrata, Salsa, Arugula,
Frisée, Cucumber, Tomato Jam
Paired with - Verget Julienne's Vineyard
Sauvignon Blanc, Napa Valley

LOBSTER RISOTTO
Lemon Agrumato, Watercress, Maine Lobster
Paired with - Rhys Pinot Noir, Sonoma

CHOICE OF

ALASKAN HALIBUT

missy
& tom

AUGUST 27

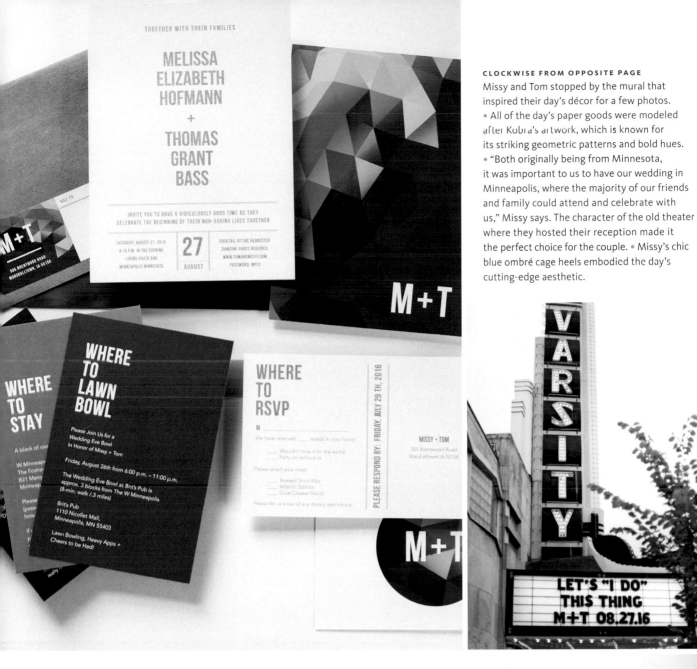

TOGETHER WITH THEIR FAMILIES

MELISSA ELIZABETH HOFMANN
+
THOMAS GRANT BASS

INVITE YOU TO HAVE A RIDICULOUSLY GOOD TIME AS THEY
CELEBRATE THE BEGINNING OF THEIR NON-BORING LIVES TOGETHER

SATURDAY, AUGUST 27, 2016 COCKTAIL ATTIRE REQUESTED
4:15 P.M. IN THE EVENING DANCING SHOES REQUIRED
LORING PASTA BAR **27** WWW.TOMANDMISSY.COM
MINNEAPOLIS MINNESOTA AUGUST PASSWORD: MPLS

M+T

505 Brentwood Road
Marshalltown, IA 50158

WHERE TO STAY

A block of roo

W Minneapo
The Foshay
821 Marq
Minneap

Pleas
(pass
hote

If
P

WHERE TO LAWN BOWL

Please Join Us for a
Wedding Eve Bowl
In Honor of Missy + Tom

Friday, August 26th from 6:00 p.m. – 11:00 p.m.

The Wedding Eve Bowl at Brit's Pub is
approx. 3 blocks from The W Minneapolis
(8-min. walk /.3 miles)

Brit's Pub
1110 Nicollet Mall,
Minneapolis, MN 55403

Lawn Bowling, Heavy Apps +
Cheers to be Had!

WHERE TO RSVP

M ____
We have reserved _____ seat(s) in your honor.

____ Wouldn't miss it for the world
____ Party on without us

Please select your meal:

____ Braised Short Ribs
____ Atlantic Salmon
____ Goat Cheese Ravioli

Please let us know of any dietary restrictions.

PLEASE RESPOND BY: FRIDAY, JULY 29 TH, 2016

MISSY + TOM
505 Brentwood Road
Marshalltown IA 50158

M+T

CLOCKWISE FROM OPPOSITE PAGE
Missy and Tom stopped by the mural that
inspired their day's décor for a few photos.
• All of the day's paper goods were modeled
after Kobra's artwork, which is known for
its striking geometric patterns and bold hues.
• "Both originally being from Minnesota,
it was important to us to have our wedding in
Minneapolis, where the majority of our friends
and family could attend and celebrate with
us," Missy says. The character of the old theater
where they hosted their reception made it
the perfect choice for the couple. • Missy's chic
blue ombré cage heels embodied the day's
cutting-edge aesthetic.

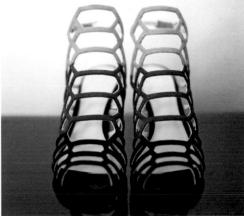

Minnesota natives Missy and Tom drew design inspiration for their
wedding from the work of Brazilian artist Eduardo Kobra,
particularly the colorful kaleidoscope motif of a Bob Dylan mural he designed in
downtown Minneapolis. They used bright and playful pops of cobalt blue, hot pink,
yellow, lime green, and orange to bring Kobra's work—and their vision—to life.

REAL WEDDINGS **129**

"We wanted to make our unity ceremony unique to us. The thing that united us from the beginning was our love for dressing up in costumes (Halloween, holiday parties). We both took pieces from three of our favorite costumes and put each piece on during the ceremony. We asked our guests if they were a part of this particular costume evening to blow on the noisemakers we handed out. It was a fun way to include them on our trip down memory lane."

MISSY

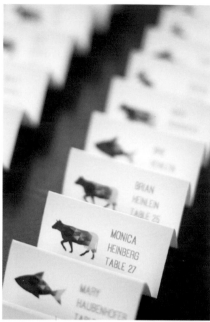

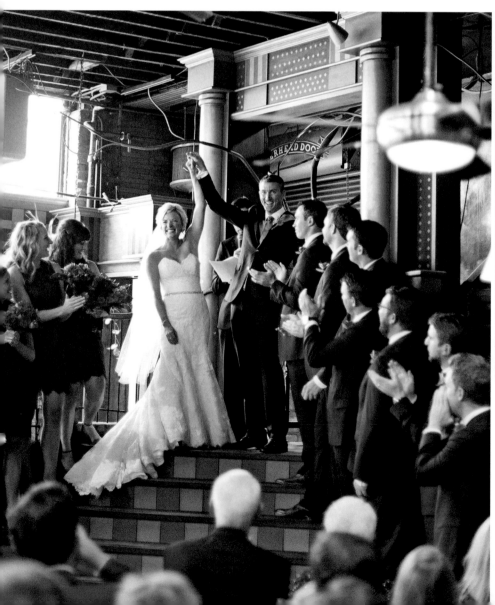

CLOCKWISE FROM TOP
Tented escort cards include colorful illustrations representing each guest's meal choice. • A sans serif font gave Missy and Tom's monogram a modern edge. • A tiled staircase served as the stage for the couple's ceremony.

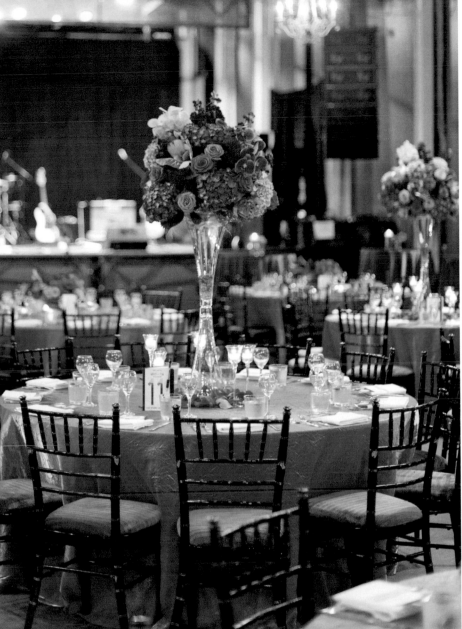

tip
WORKS OF ART CAN PROVIDE
ENDLESS INSPIRATION
FOR YOUR DAY'S DESIGN.
DON'T FORGET TO REFERENCE
THE ORIGINAL.

CLOCKWISE FROM TOP LEFT
Tall, clear glass centerpieces didn't block guests' views—everyone had a great seat for the festivities. • The bridesmaids were given their choice of shoes—as long as they were fuchsia. "I wanted them to have a fun and colorful outfit," Missy says. • The couple's monogram even made its way onto the dance floor. • Missy wore a fit-and-flare gown with a lace overlay, while Iom opted for a slim-fitting custom navy suit with their wedding date embroidered inside the jacket.

Your *Modern* Blueprint

Exquisite simplicity and sophistication sums up this wedding style. The details are thoughtfully chosen, but presented in a spirited way.

white	gray	amethyst	chartreuse	fuchsia	peacock blue

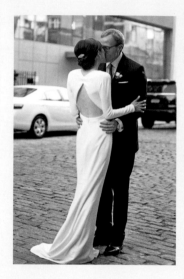

colors

Less is generally more when it comes to modern color palettes—but don't shy away from color altogether. Identify one or two dominant hues and highlight them with stark white and black spaces, or choose two complementary primary colors—like yellow and violet, black and white, or blue and orange—and go from there. If you opt for a more colorful soiree, mix in shades of white and gray to tone down vibrant hues for a clean look and feel.

paper + signage

Think graphic. The defining characteristics of modern wedding stationery are the use of white space, clean lines, and bold fonts. Work with your stationer to play with the placement and sizing of your text, and don't be afraid to break a few rules. Add some color into the mix or highlight a motif that complements the design.

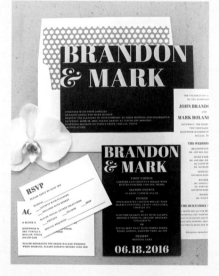

attire

HERS:
- Simple sheath
- Architectural-inspired gown
- Pared-down accessories

HIS:
- Slim-cut suit
- Modern tuxedo
- Tie clip and custom cuff links

menu

Choose a signature cocktail and turn up the volume on the presentation—modern glassware elevates even the simplest sips. Your food should feel in line with your theme too. Avoid messy foods and opt for passed bite-size delicacies that are both delicious and Instagram worthy. Finish the meal with decadent passed truffles and a statement cake.

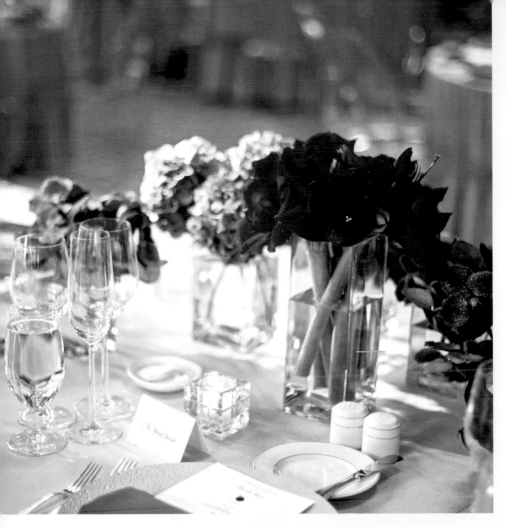

flowers

Choose monochromatic, sculptural arrangements (like orchids and calla lilies) for a sleek look. Or opt for tropical leaves or grasses in structured bunches. Greenery adds instant texture to tables and arrangements while keeping the color scheme straightforward.

—

"To get the full value of joy you must have someone to divide it with."
—Mark Twain

—

venues

It's no surprise that art museums lend themselves so beautifully to modern weddings. Their clean lines, unique architecture, and endless white spaces provide couples an empty canvas to paint their vision. Industrial loft spaces, warehouses, and galleries are also excellent backdrops.

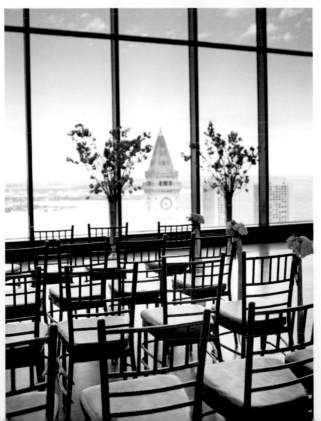

favors

• Custom magnet
• Geometric picture frame
• Luggage tag

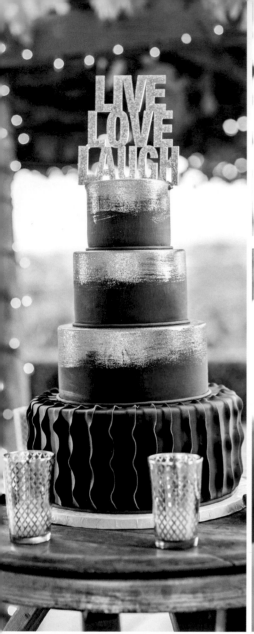

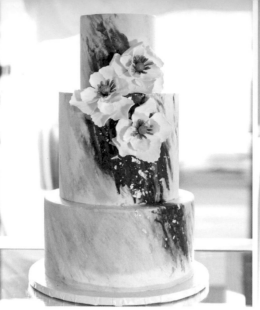

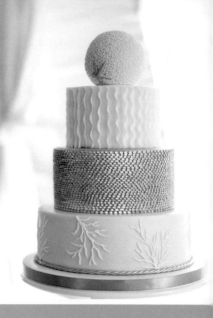

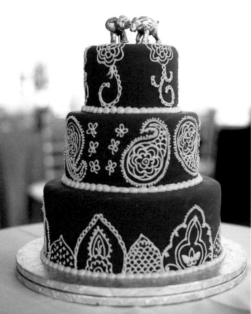

Cakes

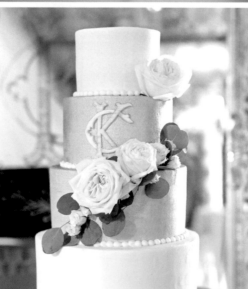

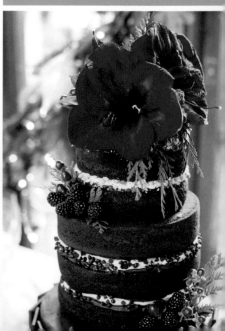

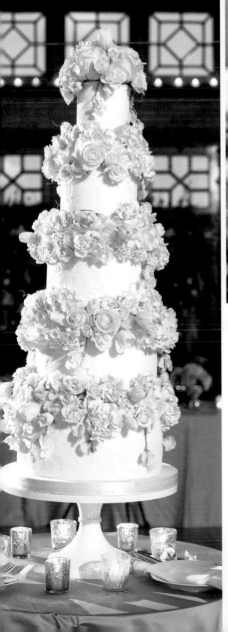

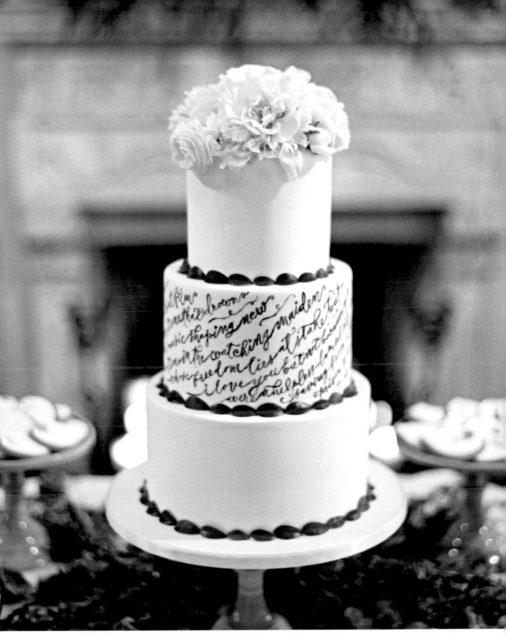

Leave your guests with a taste of your relationship—literally and figuratively—by infusing your wedding cake with some serious "you" flavor. Think outside the box on this one. Consider including your vows or a few lines of your first dance song on the middle tier. Or pay tribute to the place you met. If it was in college, show your school pride with a topper that nods to your alma mater. If you met in a city, decorate a tier with its skyline or one of its iconic bridges. And if you each have a different favorite cake flavor you like, why not alternate the layers between your preferences? Not a fan of traditional cake? Scrap it altogether and serve whatever treat the two of you prefer—just keep in mind you'll miss out on cake-cutting pics. Bottom line, the possibilities are endless, and really delicious.

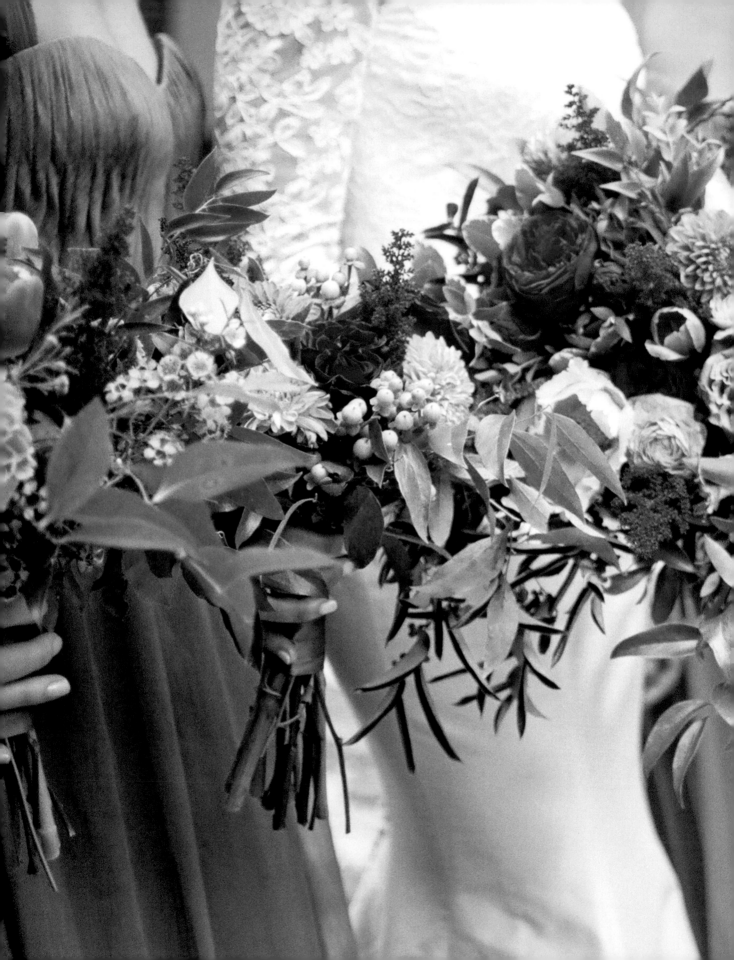

romantic

Whether it's a winter spectacle in a grand ballroom or a beach bash in
Mexico, all romantic weddings share the same depth and drama.
With lush blooms and an intimate ambience, these nuptials tap into
the feelings evoked by your favorite love stories (like your own).

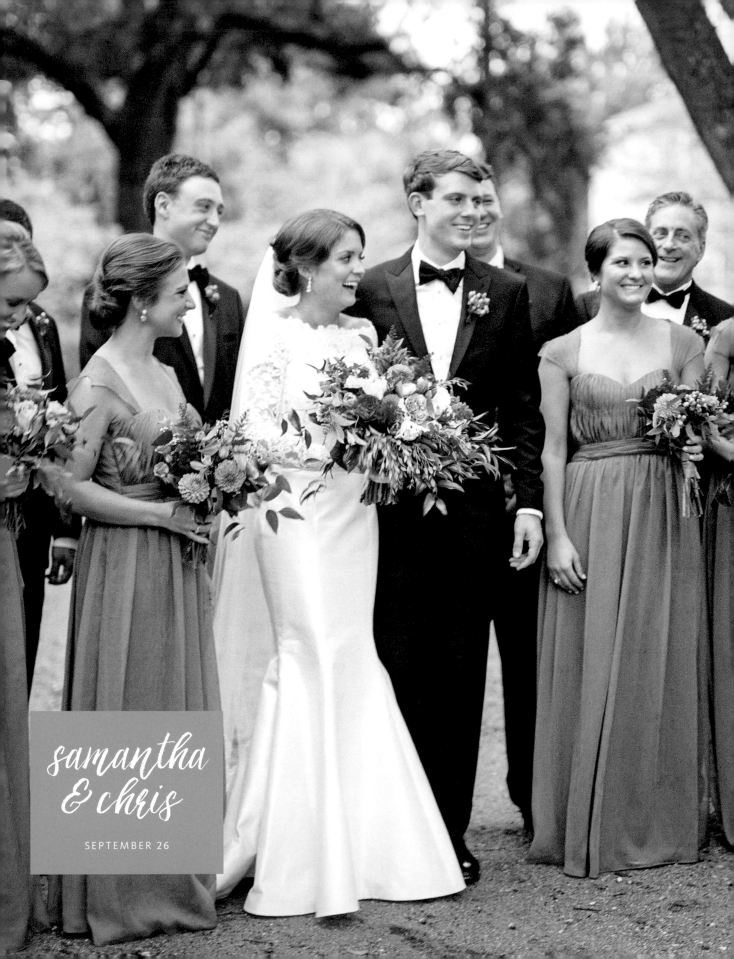

samantha
& chris

SEPTEMBER 26

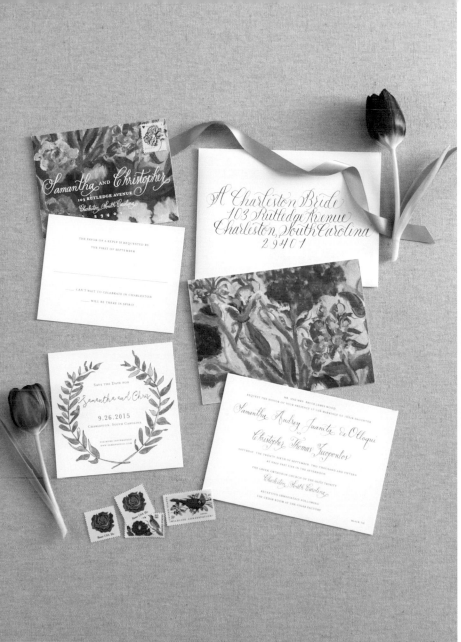

CLOCKWISE FROM OPPOSITE PAGE
Samantha wore a classic silk shantung fit-and-flare gown. • The couple's custom stationery suite was created from a section of one of the bride's grandmother's many flower paintings. • Garlands of greenery adorned the wrought-iron railings that led to the church. • The couple accessorized the brick columns flanking the path to the church in wreaths made of lemon leaves accented with fresh lemons.

S amantha and Chris never expected to find their wedding inspiration in her grandmother's paintings, but with the help of their stationer, they were able to draw from a family treasure to personalize their day. A neutral backdrop allowed the couple's bold florals—modeled after the painting, of course—to really shine.

CLOCKWISE FROM RIGHT
The painting that inspired the day's décor was displayed at the reception along with a sign explaining the connection. • A pineapple lover, Samantha included pineapple "vase" centerpieces at the cocktail hour—they were one of her favorite details. • Colorful patterned chairs were arranged in conversation clusters to allow guests a comfortable place to relax between trips to the dance floor.

tip
HAVE A CONVERSATION ABOUT THINGS THAT ARE IMPORTANT TO YOU EARLY IN THE PLANNING PROCESS. YOU NEVER KNOW WHAT CAN END UP INSPIRING YOUR WHOLE DAY.

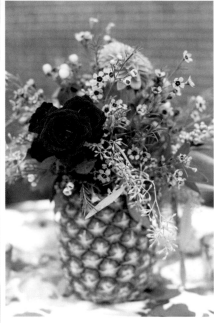

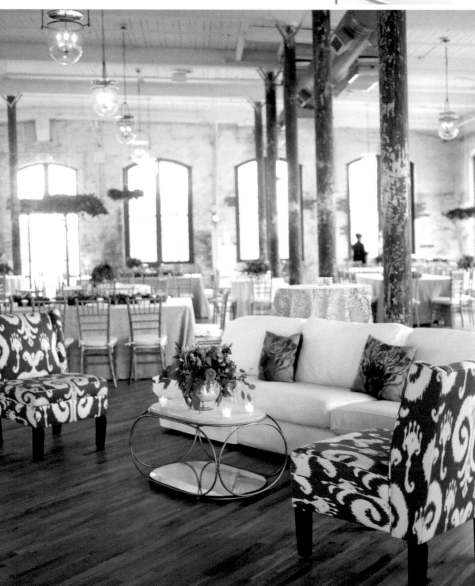

"As we were discussing personal elements and our story, our stationer remembered me mentioning my awe-inspiring grandmother and that she was still oil painting at 90 years old. Our wedding inspiration ended up being centered on one of her paintings. It was so special."

SAMANTHA

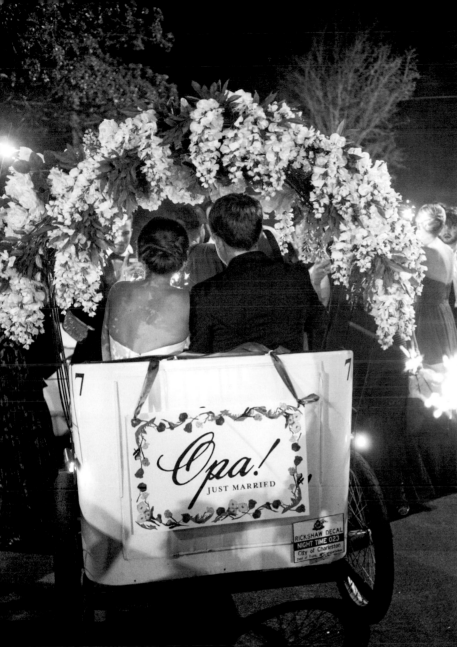

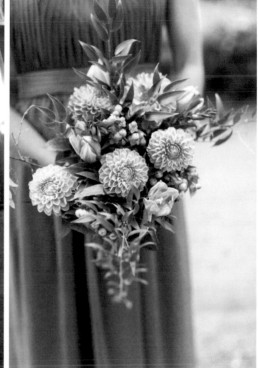

CLOCKWISE FROM TOP LEFT
Samantha and Chris exited the reception in a rickshaw decorated with an "Opa" sign—a nod to Chris's Greek heritage. • Cookies frosted with two different geometric patterns supplemented the wedding cake. • Each of the bridesmaids carried a monochromatic bouquet of dahlias and berries in a different color. • Little gilded elephants (the bride's favorite animal) sat on each place setting. • Bread bowls filled with Greek olives sat on the bar for guests to snack on.

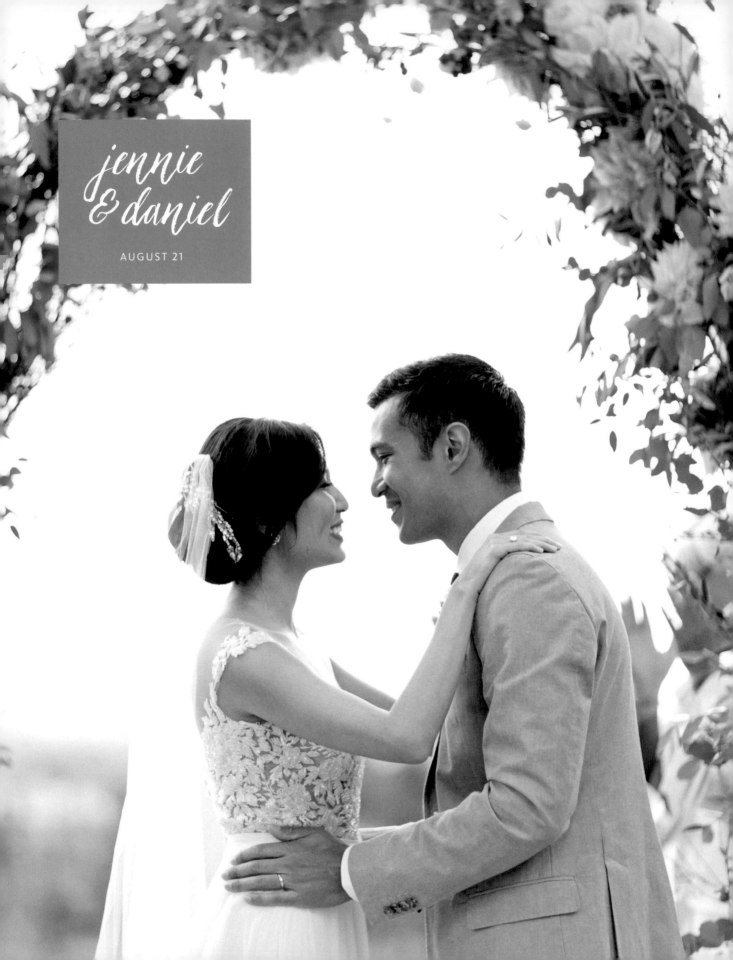

jennie
& daniel

AUGUST 21

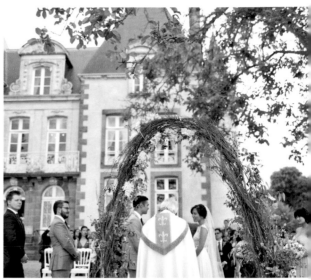

For the ceremony, Jennie wore a dress with a sheer, floral-embroidered bodice and a flowy chiffon skirt. "It felt very appropriate for a French countryside wedding, since it was soft and romantic but also a little risqué," Jennie says. • Fresh berries and figs gave the floral arrangements a more rustic vibe. • Jennie and Daniel were married beneath an arch of branches, greenery, and blooms in the shadow of the historic chateau. • Vintage coupes filled with fresh blooms and berries decorated reception tables.

New York City–based Jennie and Daniel couldn't think of anywhere more romantic, and fitting, for their nuptials than their favorite vacation spot: the gorgeous French countryside. A historic chateau set the stage for their dreamy affair brought to life by soft neutrals, charming vintage accents, and untamed florals. The only thing that rivaled the enchanting setting were the four stunning gowns Jennie wore.

"Because I'm a fashion editor, I went a little crazy with the wedding dresses and wore four in total that day. Everyone said not to do it, but it felt right for me and I'm glad I did."

JENNIE

tip
CUSTOM CALLIGRAPHY
IS THE ULTIMATE
ROMANTIC TOUCH.

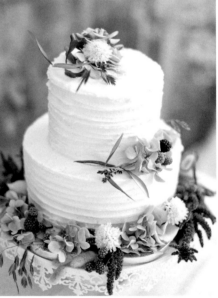

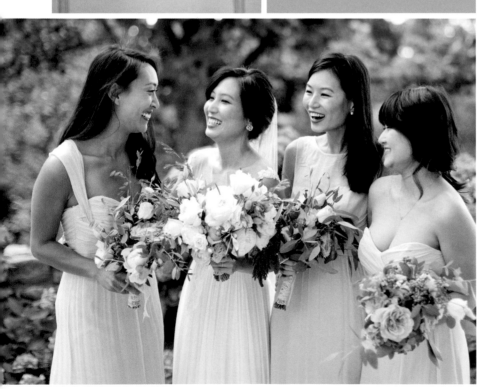

CLOCKWISE FROM TOP LEFT AND OPPOSITE
At the end of the night, Jennie changed into a short beaded-fringe dress. "I wanted it to be a serious dance party, so I needed a serious dance dress. It was so fun to wear," she says. • The couple always carries small notebooks for jotting down ideas. The escort cards paid homage, with guests' names calligraphed on them. • Jennie's second dress was a strapless pink ombré mermaid-style gown. • Jennie's bridesmaids wore floor-length gray chiffon dresses. • Jennie and Daniel decided on a honey-apple wedding cake because it's local to the region.

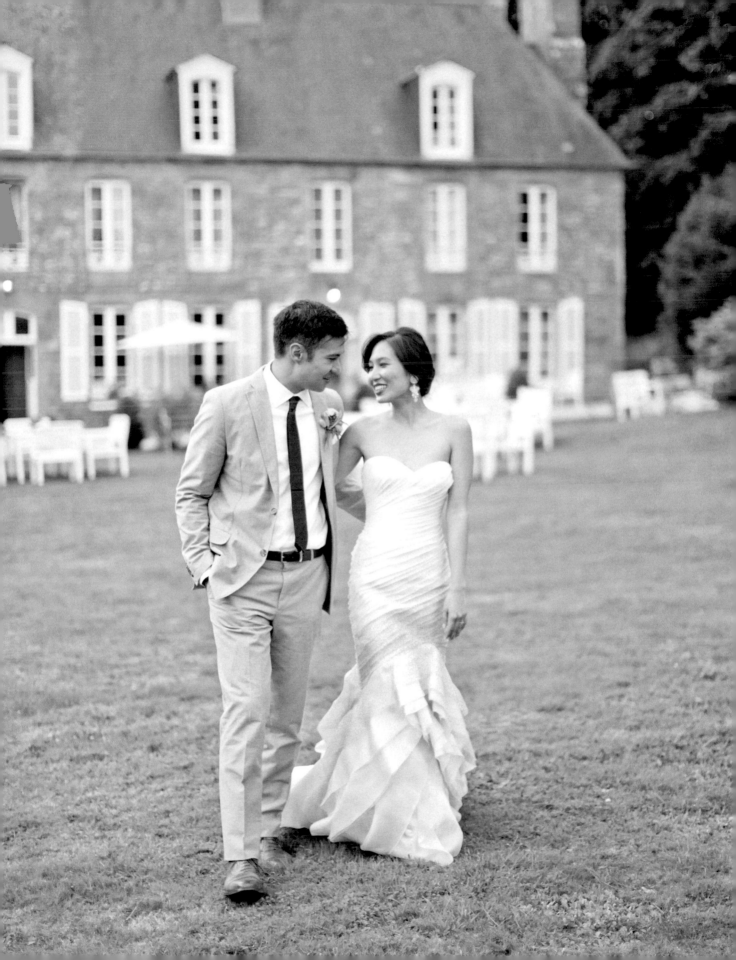

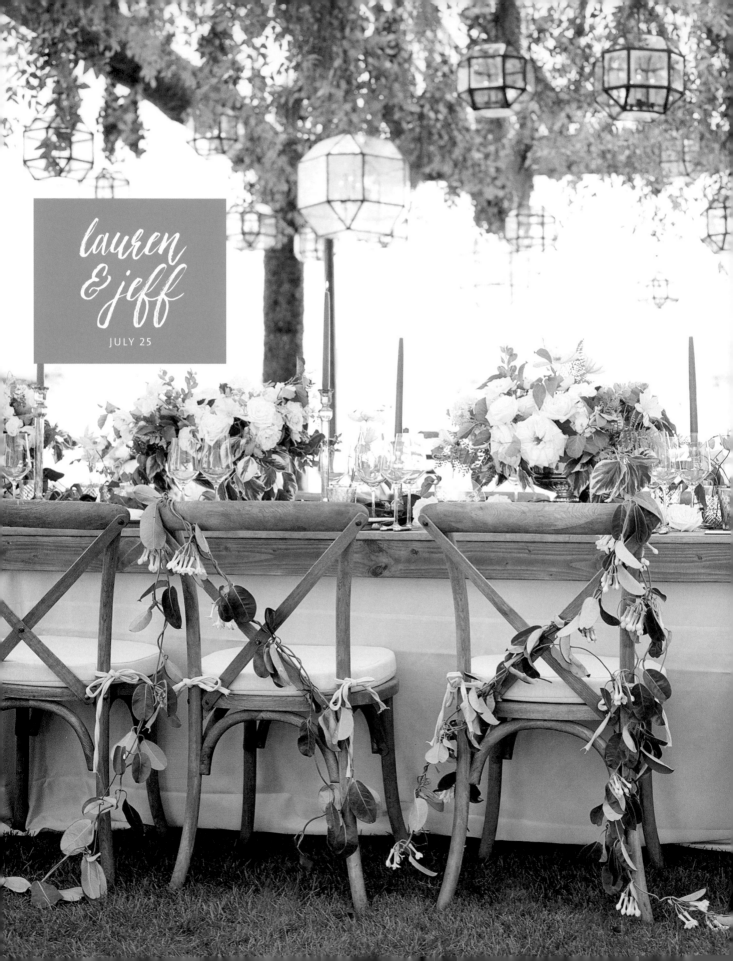

lauren
& jeff

JULY 25

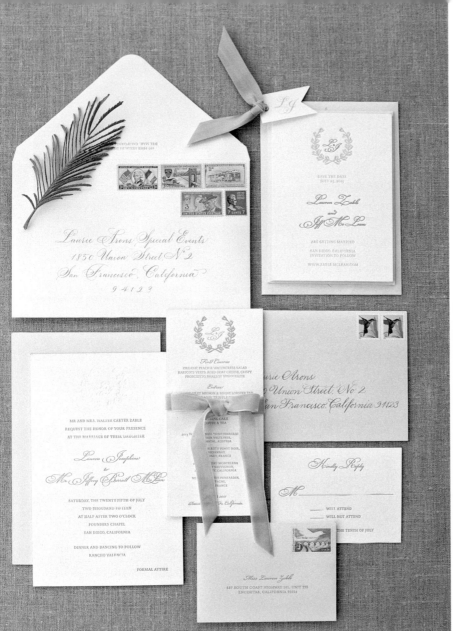

CLOCKWISE FROM OPPOSITE PAGE
Lauren and Jeff dined in wood cross-back chairs accented with garlands of fresh greenery. • The elegant invitation suite featured pale blue accents and the couple's bespoke monogram. • Jeff wore a custom dark gray tuxedo and Lauren donned a lace sheath. • He proposed with a stunning emerald-cut diamond in a double halo setting.

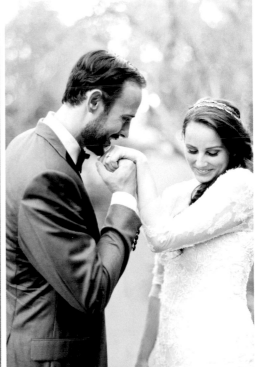

Lauren always envisioned marrying Jeff in an all-white affair, until a pale blue invitation suite she came across during the planning process inspired her to incorporate pops of the soft hue into the day's color scheme. This seemingly small touch added even more romance to the day's stunning décor.

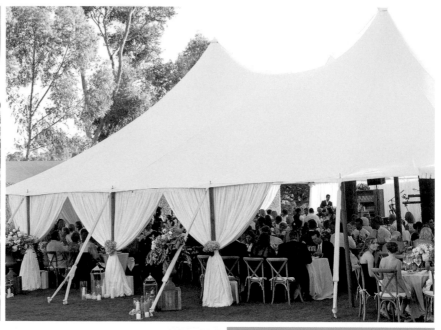

tip
LOOK TO YOUR VENUE FOR
FAVOR IDEAS. OLIVE OIL
FROM AN OLIVE GROVE ON
THE PROPERTY, FOR EXAMPLE,
WILL OFFER GUESTS A
LASTING TASTE OF YOUR
WEDDING.

CLOCKWISE FROM TOP LEFT
Lush arrangements in vintage metal
goblets topped reception tables. • The
couple hosted a sit-down dinner with a
menu of drinks crafted to reflect family and
close friends. • Ribbons were a romantic
addition to Lauren's bouquet. • The couple
opted for an unfrosted chocolate cake
decorated with fresh blooms.

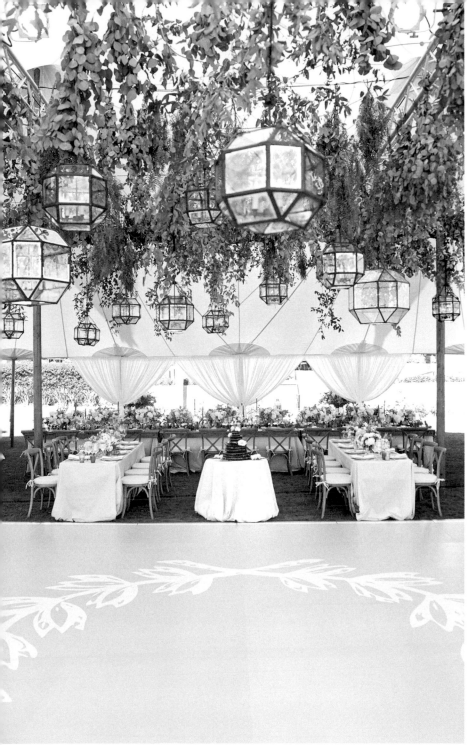

CLOCKWISE FROM TOP LEFT
Cascades of fresh greenery and round oversize lanterns hanging from the tent's ceiling blurred the lines between inside and out. • The couple's laurel monogram was projected onto the white dance floor for a personal touch during the reception. • After the ceremony, Lauren traded her cathedral-length veil for an ethereal crystal headpiece. • The couple sent guests home with olive oil made from the property's olive groves.

"I wanted to include family members from Jeff's side of the family, and we're both close with his two cousins, so instead of flower girls, I asked the girls to be junior bridesmaids."

LAUREN

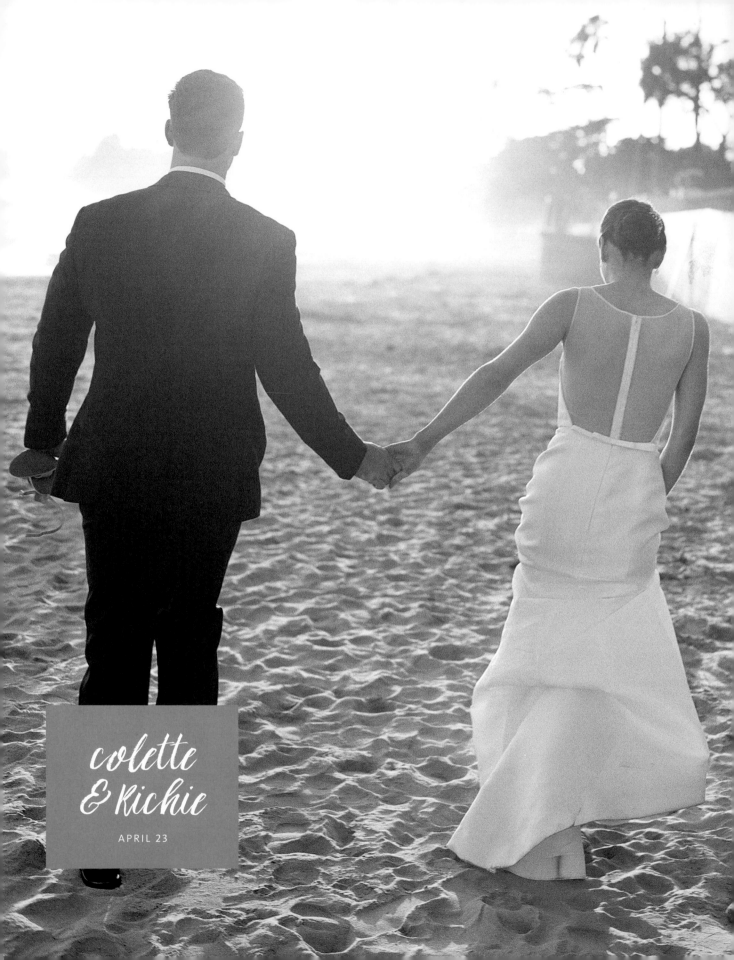

colette
& Richie

APRIL 23

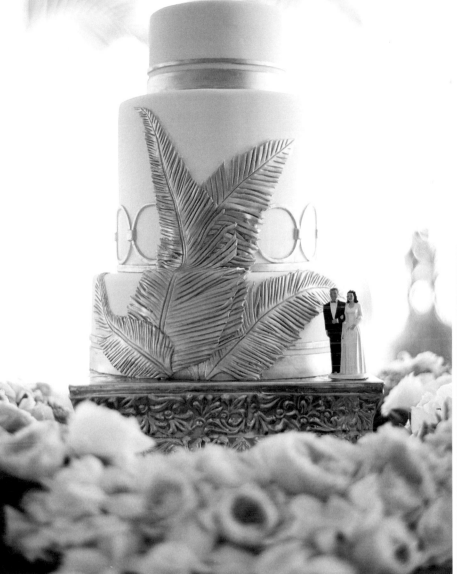

CLOCKWISE FROM OPPOSITE PAGE
Colette donned a sophisticated silk gown with an enchanting illusion back and subtle train. • The couple's cake was decorated with a gold palm motif and Colette's grandparents' cake topper. • Seating assignments were hand-calligraphed on round pearlescent shells and displayed in sand. • The bride added a lace bolero to her look for the church ceremony.

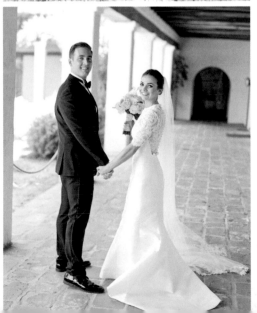

Colette and Richie wanted their "tropical vintage" theme to evoke romantic images of old-Hollywood movie stars vacationing on the beach. Understated metallics and a neutral color scheme, inspired by the natural flagstone flooring of the terrace where they hosted their alfresco reception, helped create a celebration worthy of the stunning beachside setting.

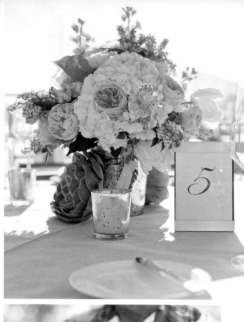

"Santa Barbara is a special place to me and Richie because it's where we met, went to school, and, of course, fell in love. We really couldn't imagine being married anywhere else."

COLETTE

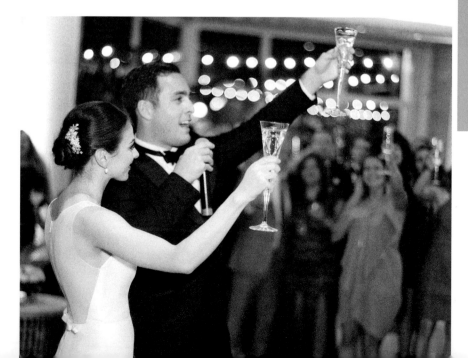

CLOCKWISE FROM TOP LEFT AND OPPOSITE
The bride's family crest was used on the silver-and-copper wedding invitations. • Shades of coral nodded to the beach setting without feeling overly nautical. • A traditional Hawaiian band was a nod to the couple's favorite vacation spot. • A metallic brocade linen topped the long head table. • The groom gave a toast just before cutting the cake. "All our guests circled around us," Colette says.

tip
COCKTAIL HOUR IS THE PERFECT OPPORTUNITY TO SHARE YOUR PERSONAL MUSICAL TASTES—THE ONES THAT MAY NOT FIT INTO YOUR CEREMONY OR RECEPTION—WITH YOUR GUESTS.

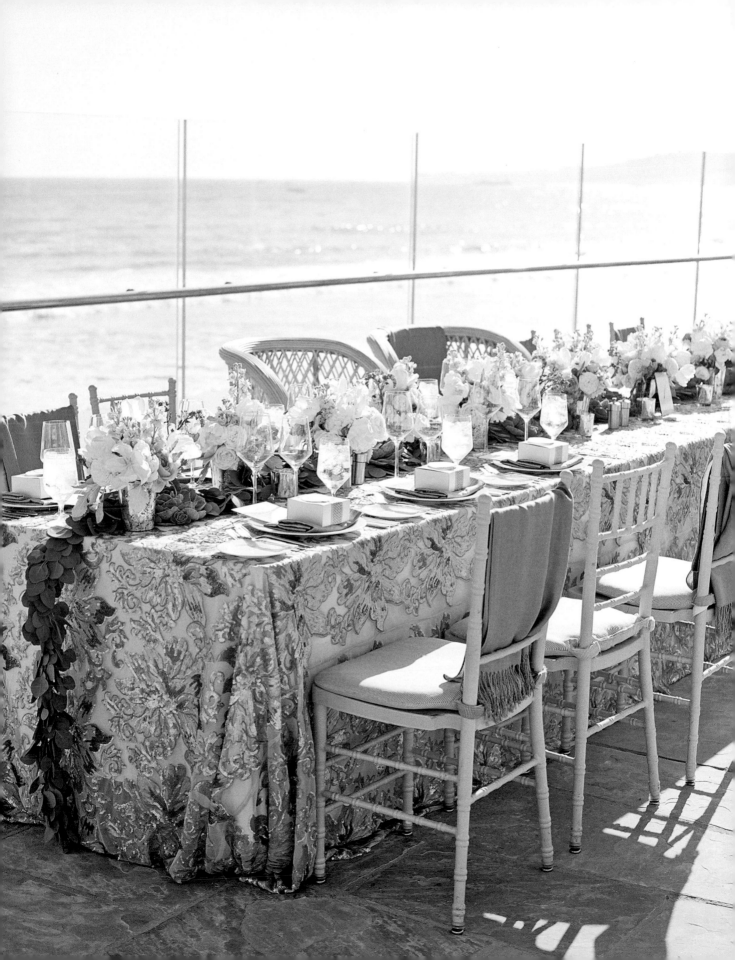

lauren & andrew

OCTOBER 24

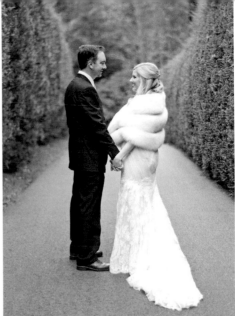

auren loves color, so she knew she had to have plenty of it for her charming "Anthroplogie meets Great Gatsby" wedding. The first thing she and Andrew decided on was their custom watercolor floral crest, which ended up setting the tone for the day's décor and palette, and was used throughout the design. Lush greenery and warm candlelight completed the romantic atmosphere.

CLOCKWISE FROM OPPOSITE PAGE
Lauren and Andrew made their getaway in a 1950 Riley convertible adorned with a garland of greenery. • Lauren added a glam fur stole to complete her look. • The couple's four-tier cake was frosted with fondant ruffles. • The reception tables were a mix of bare farm tables and rounds draped in soft linens. Tapered red candlesticks added ambience.

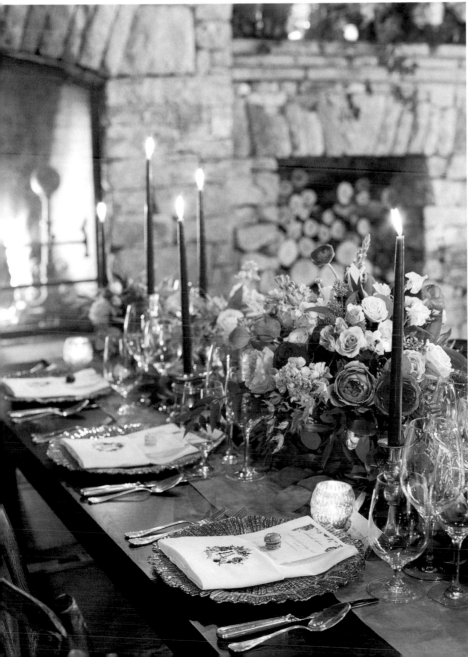

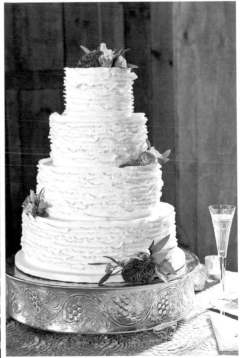

"I loved my paper goods—they were one of my favorite parts of the wedding. Our custom watercolor crest was embroidered on linen napkins, printed on fabric and made into pillows, and even used as wrapping paper for bridesmaid gifts."

LAUREN

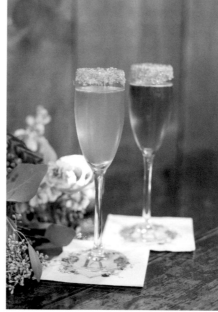

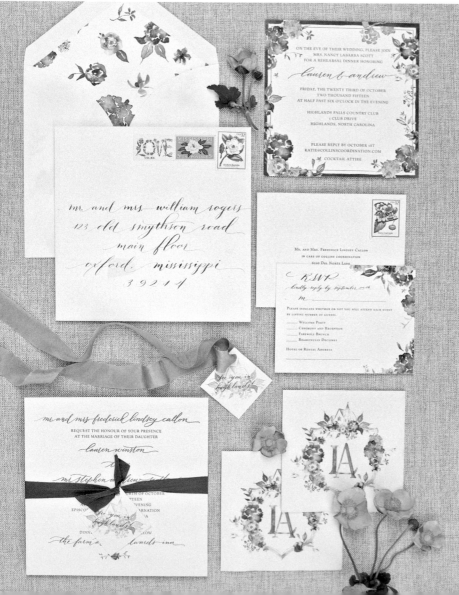

tip

TALL, VINTAGE CANDLESTICKS ARE A GREAT WAY TO ADD ROMANCE—AND LIGHT—TO AN AFFAIR.

CLOCKWISE FROM TOP LEFT AND OPPOSITE
Sugar-rimmed flutes of bubbly greeted guests. • The groomsmen wore hypericum berry and rose boutonnieres. • The raw beams of the farmhouse were softened with florals. • The oldest flower girls pushed the youngest in a vintage stroller Lauren played with as a child. • "The stationery was the focal point of the décor. Pretty much everything stemmed from there," Lauren says.

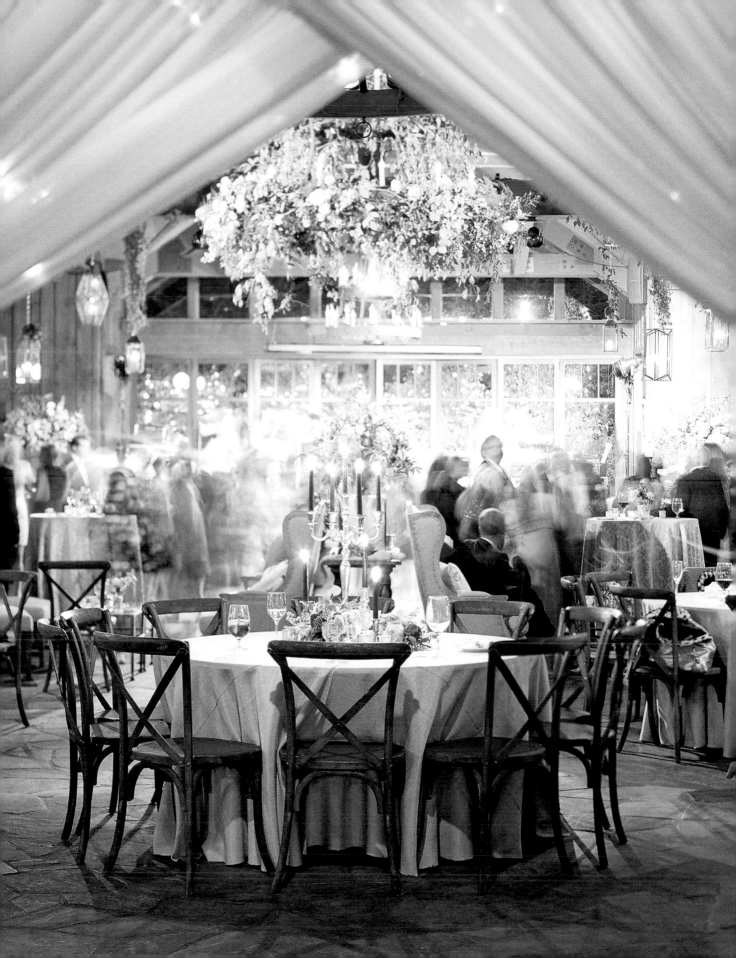

Your *Romantic* Blueprint

Barely there color palettes, candlelight, and ethereal details (lace gowns, floral walls, rosé champagne) are hallmarks of this charming affair.

| cream | blush | apricot | rose gold | pale blue | mint |

colors

Stick to sophisticated shades, like soft blush, cream, and hints of gold. Or choose a mix of metallics with strong pops of color, like deep purple or mint green. A variegated spectrum of purple and pink is cheery yet still romantic.

menu

Pass signature sips garnished with edible flowers or mint sprigs on antique silver trays. Keep cocktail bites small and savory, bursting with flavor. Then, delight guests with a multiple-course meal served family-style—upscale comfort foods or unique culinary pairings are sure to impress. Opt for a naked cake garnished with fresh flowers and fruits, or choose a delicately frosted buttercream confection.

favors

- Book of poems
- Jar of honey
- Bottle of wine or champagne

"If you live to be a hundred, I want to live to be a hundred minus one day so I never have to live without you."
—A. A. Milne

venues

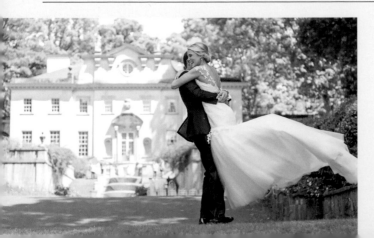

Think dreamy and exotic, like a botanical garden, or live out your own real-life fairy tale at a castle or a Gatsby-style mansion. Look for a venue that has cozy spaces within it to really get that romantic vibe.

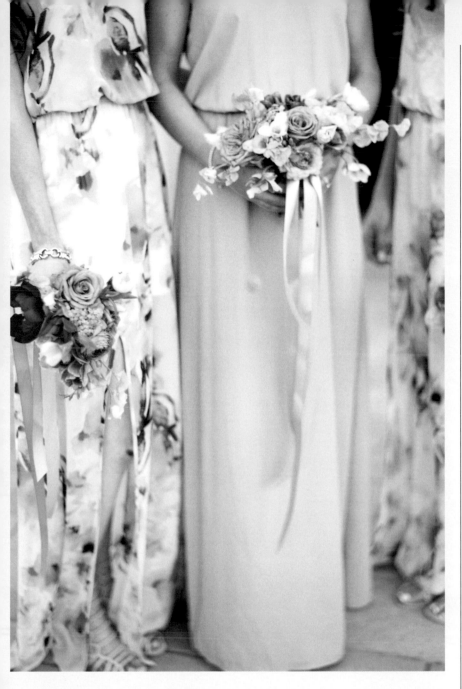

flowers

Create an intimate ambience with a mix of florals and candlelight. Big-headed blooms like peonies and garden roses will give volume and fragrance to arrangements, while cascading table garlands and lush vines add a carefree touch to the décor. Pillar candles in mercury glass hurricanes will help set an amorous mood.

paper + signage

Work with your stationer to come up with an illustration—of the two of you, your pet, your dress—or a timeless quote that you can use to tie your paper goods together. Roses, hearts, and poetry are popular motifs to set a romantic stage.

attire

HERS:
- Flowing gown with hint of drama or sweetness
- Ball-gown skirt
- Jeweled belt

HIS:
- Suit with matching vest
- Blush tie and matching pocket square
- Floral boutonniere

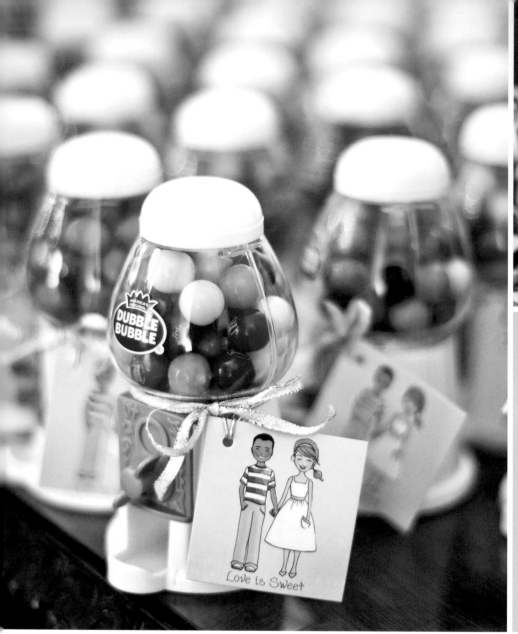

Love is Sweet

Guest Gifts

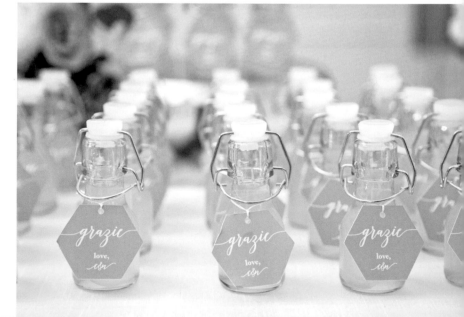

grazie
love,

Your guests came from near and far to celebrate with you, so thank them with a thoughtful gift. For out-of-town guests, welcome bags filled with local goodies and a personalized map of your favorite spots and activities are a generous way to show your appreciation for their time, effort, and expense. Or set up a gifting lounge where you can welcome guests in person and let them choose their goodies. The end of the night offers plenty of gift-giving opportunities as well. If you're planning to have a photo booth, provide custom frames so guests can take home a reminder of your epic bash. Food favors, especially ones inspired by your locale, won't be left behind. Or greet your loved ones with a morning-after breakfast basket (turn to page 224 for our DIY) filled with homemade granola, coffee, and fruit.

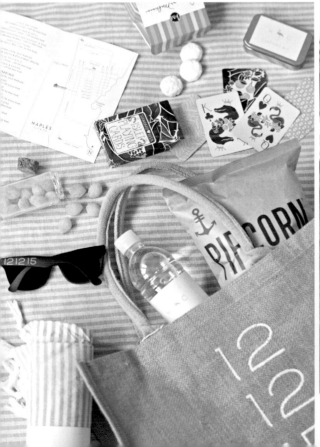

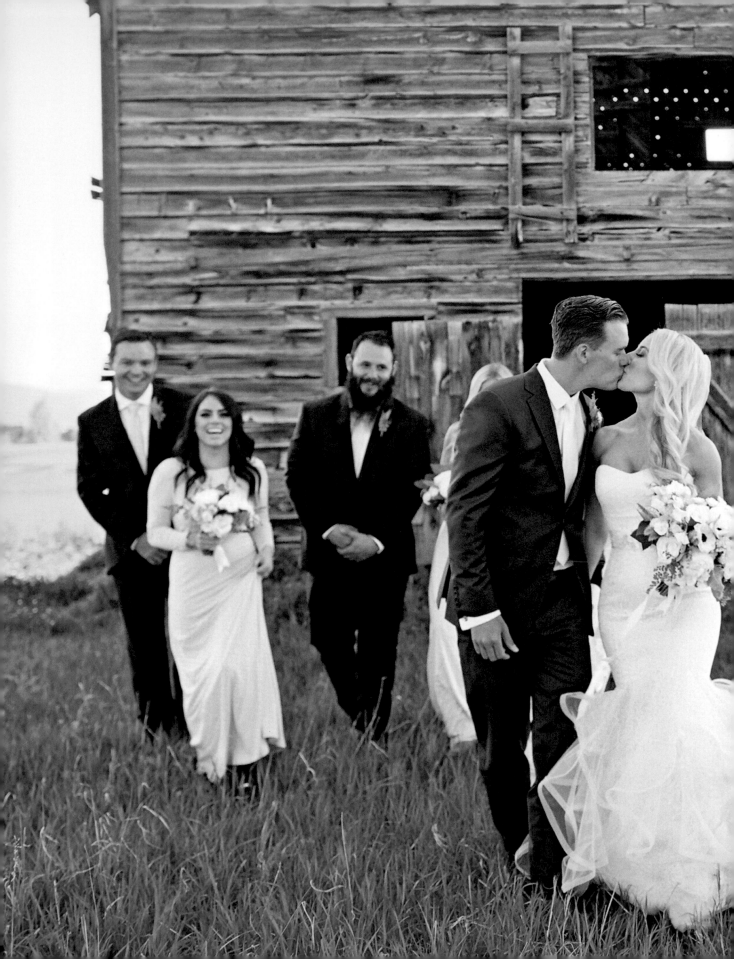

rustic

Down to earth, natural, and outdoorsy, but still sophisticated—that's exactly what a rustic wedding should feel like. If you prefer the raw charm of Mother Nature with an air of refinement to the frilly and feminine, this wedding style is for you. Remember, a rustic wedding is so much more than barns, mason jars, and string lights—it's a celebration of homespun comfort and organic beauty.

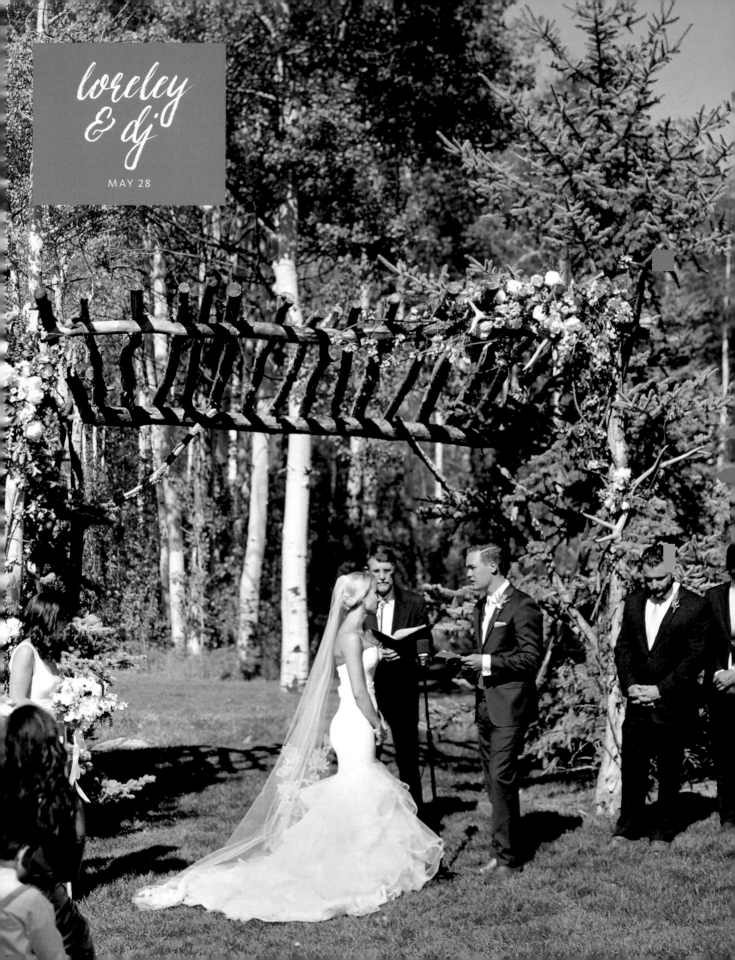

loreley & dj

MAY 28

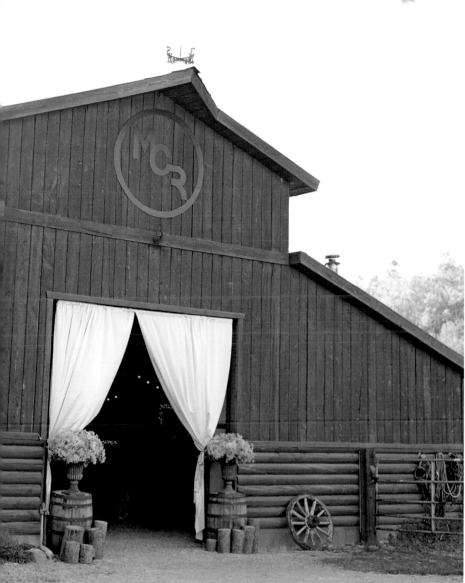

CLOCKWISE FROM OPPOSITE PAGE
The couple said "I do" beneath a rustic arbor made of logs, which they decorated with blush and ivory blooms and elk antlers. • DJ's sister also had her wedding reception in the same barn a few years earlier. • The ceremony programs included the couple's custom elk antler monogram. • Loreley's nude cutout boots had a cute cowboy flair and kept her comfortable as she danced the night away.

Loreley describes her and DJ's vision for their Idaho wedding day as "glamorous with Western flair." In the shadow of the Grand Tetons, the pair crafted an effortlessly stylish affair that highlighted the vast beauty of their surroundings as well as their fun personalities. Elk antler accents and rustic wood details were softened by feminine flowers and muted shades of blush and ivory.

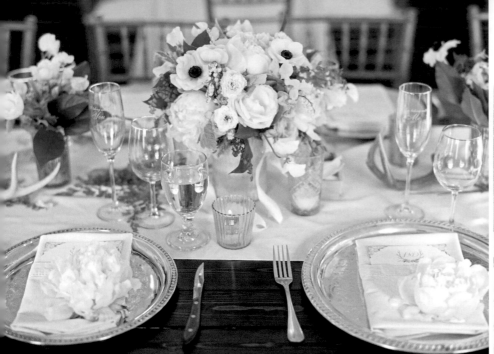

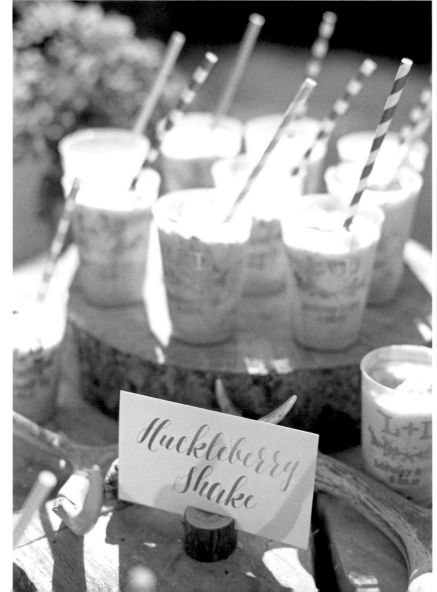

Huckleberry Shake

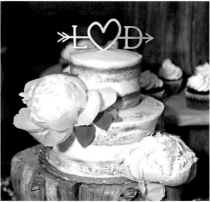

tip
INCORPORATE YOUR
FAVORITE YARD GAMES INTO
THE COCKTAIL HOUR TO KEEP
GUESTS ENTERTAINED WHILE
THEY WAIT FOR THE REAL
PARTY TO START.

CLOCKWISE FROM TOP LEFT
The couple's florist let them use her
grandmother's vintage silver chargers
for the place settings. • Yard games
entertained guests during cocktail hour.
• In addition to a sprawling dessert bar,
the couple served a small naked cake
adorned with giant white peonies. • During
the ceremony, Loreley and DJ offered up
huckleberry (an Idaho staple) milk shakes
in personalized cups with paper straws.

CLOCKWISE FROM TOP LEFT
Photos of Loreley and DJ in heart-shaped wood frames decorated a table. • "My absolute favorite part of the wedding décor was a gift DJ and I received from his sister and brother-in-law the day before the wedding: matching personalized denim jackets," Loreley says. • Guests enjoyed barbecue Gouda quesadillas during the cocktail hour.

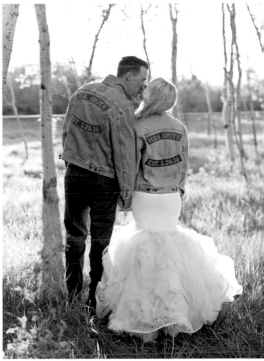

"The escort cards were a fun DIY project we took on together. DJ is an avid fly-fisherman, and we knew we wanted to incorporate this on our day. DJ tied over 80 flies himself, and we attached them to miniature wood picture frames that served as our guest's escort cards and also their favors. We named the tables after the famous fly-fishing rivers in the area that are also some of DJ's favorite spots. The sign on the escort card table read, 'Find your fly, find your river, have a seat, and enjoy some dinner!'"

LORELEY

kaitlyn
& kris

DECEMBER 5

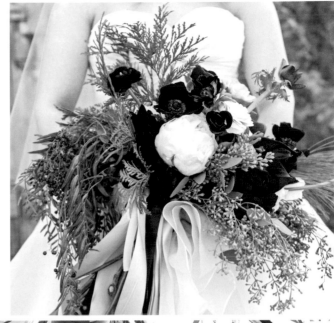

E ver since she was a little girl, Kaitlyn dreamed of having a winter wedding. For their intimate nuptials, she and Kris added seasonal touches (pinecones, birch trees, and candles) to Christmas classics (wreaths, string lights, and shades of red) to create their cozy wonderland.

CLOCKWISE FROM OPPOSITE PAGE
String lights created a romantic ambience. • Champagne- and maroon-colored ribbons added even more drama to Kaitlyn's oversize bouquet. • The ceremony took place in the venue's greenhouse, which they decorated with a backdrop of hanging greenery. • Chris wore a seasonal boutonniere of pine branches and mini pinecones on his wool blazer.

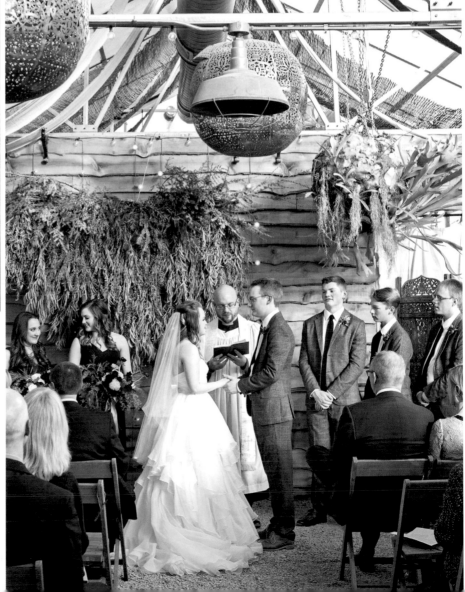

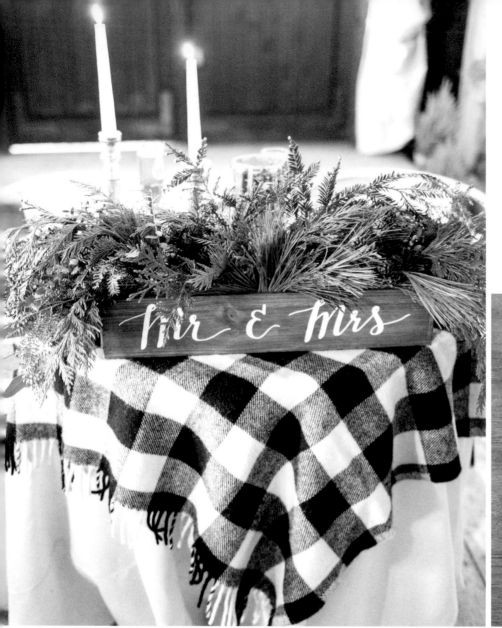

CLOCKWISE FROM TOP LEFT
The bride painted a "Mr. and Mrs." planter for their sweetheart table. • Each ceremony program came wrapped with a piece of twine and a sprig of winter greenery. • Kaitlyn wanted to do something charming and country for the favors, so she enlisted the help of her family to make little jars of blackberry jam. Her dad picked all of the berries, and her mom and brother made the jam.

"So many little pieces at our wedding had stories and meaning behind them. One of the cake platters was handmade by my great-grandmother, the flannel blanket on our sweetheart table was a Valentine's Day present from my parents, and some of the pinecones we used were cedar rose heads given to me by my aunt. The details of our day told smaller stories about who we are and where we come from."

KAITLYN

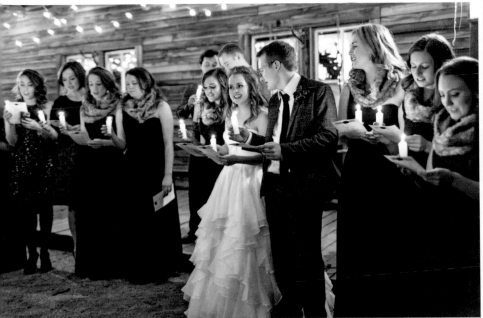

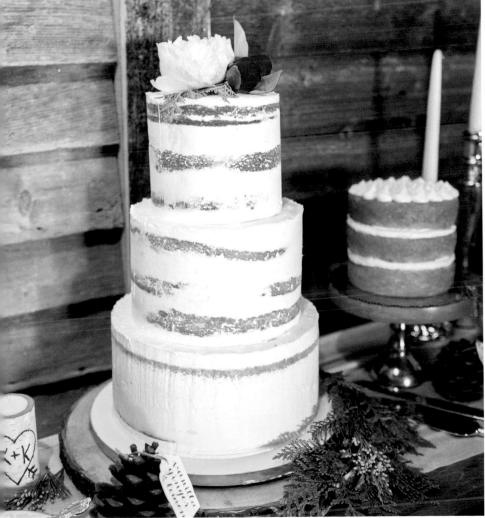

tip
USE FAMILY HEIRLOOMS AS
WEDDING DÉCOR.

CLOCKWISE FROM TOP LEFT
As a twist on a traditional send-off, the
newlyweds sang Christmas carols at the end
of the evening. • The couple incorporated
nods to family throughout the wedding. • The
bride put her calligraphy skills to work on a
wood sign that read "Baby it's cold outside."
• A spread of six different naked cakes gave
guests plenty of flavors to enjoy.

kaylin & anthony

SEPTEMBER 19

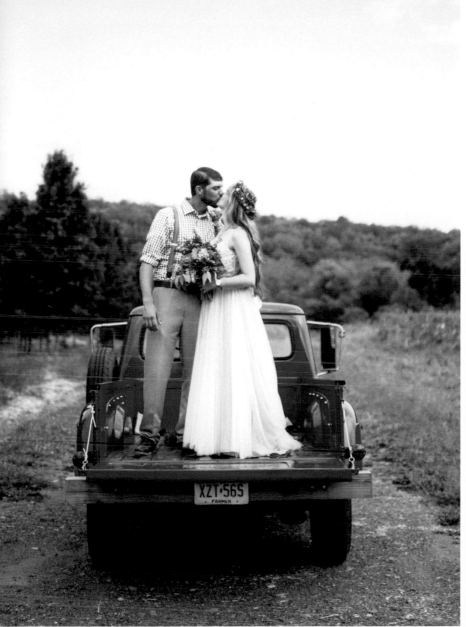

Heads of kale in Kaylin's fresh-picked bouquet were a nod to the day's setting. • Kaylin's feminine tulle and lace gown was just what she was looking for: a bit vintage, laid-back, and comfortable. • A *Fantastic Mr. Fox* pillow was a whimsical addition to the eclectic lounge furniture. • A custom invitation suite with a vegetable motif set the stage for the couple's farm wedding.

The groom's family tree farm was an easy choice of setting for Kaylin and Anthony's New Jersey wedding day. The couple decorated the rustic space with things they hold dear—vintage kitchen items, the Americana artwork of Charles Wysocki, and nods to farm life—to create a whimsical, vibrant style that was all their own. Without a specific palette in mind, a cheery color scheme of bright yellow and red evolved organically.

"The reception included a 'Marry Me Pumpkin Patch' for guests to pick their own pumpkins. The pumpkins were all grown from the seeds of the pumpkin Anthony used to propose a year earlier."

KAYLIN

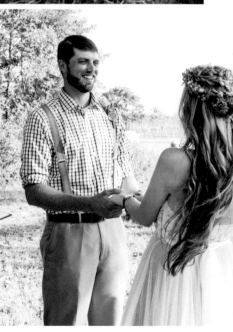

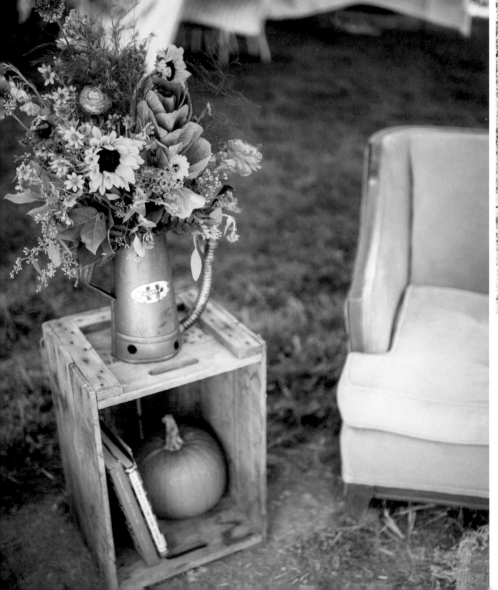

CLOCKWISE FROM TOP LEFT AND OPPOSITE
Hay bales provided authentic ceremony seating. • Assorted mugs evoked a cozy, kitchen vibe in the tented reception.
• Centerpieces included local wildflowers.
• Anthony's aunt made the naked cake, which was accented with an ivory dog and cat topper.
• The couple invited their guests to BYOP (bring your own pie). • Vintage kitchen tools and tin cans served as vessels for the couple's vibrant floral arrangements. • Anthony wore suspenders and a vintage county-fair pin in lieu of a traditional boutonniere.

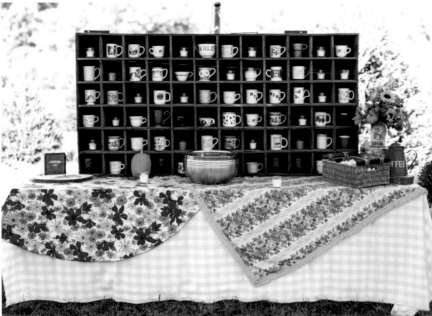

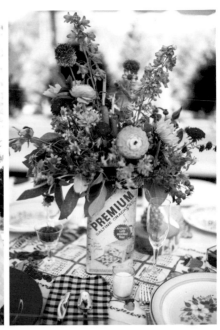

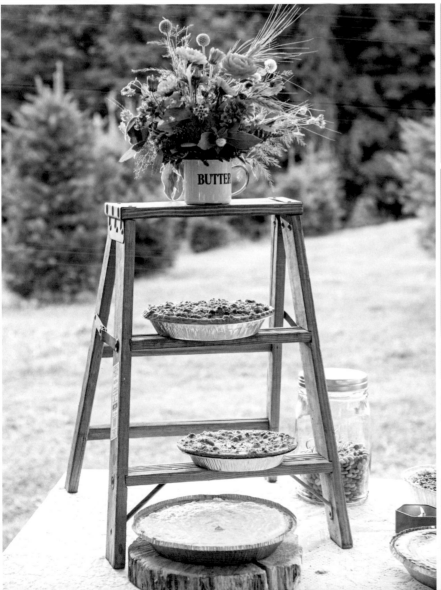

tip

BUCK TRADITION AND
SUBSTITUTE A FLORAL
BOUTONNIERE FOR
SOMETHING MORE
MEANINGFUL, LIKE AN
HEIRLOOM PIECE.

Your *Rustic* Blueprint

This laid-back celebration incorporates bucolic details, like just-picked centerpieces, comfort foods, natural colors and textures, and a vibe that feels totally welcoming.

| rust | olive | plum | bronze | beige | amber |

colors

Let the raw beauty of your wedding location take center stage—this means sticking to a color palette that highlights the setting's natural décor. Neutral, organic colors, such as shades of brown and green, will go a long way to making your day feel cohesive. Add splashes of color in your florals, stationery, or table settings.

menu

A specialty bar (whiskey, anyone?) is a fun twist on a signature cocktail. For a more casual affair, artfully display craft brews in buckets. Your food should complement your natural setting and have that farm-to-table vibe. Work with your caterer to come up with a menu based on locally sourced, in-season ingredients such as steak or wild game. Fuss-free comfort foods and barbecue are also guaranteed crowd-pleasers. Naked cakes or passed desserts (your favorite oatmeal cookies, carrot cake whoopie pies, or chocolate mousse in jars) fit perfectly with the rustic theme.

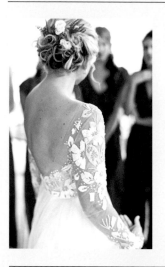

attire

HERS:
- Simple silhouette with lace details
- Short or midi hemline
- One-of-a-kind accessories

HIS:
- A suit (brown, blue, or gray)
- Swap a jacket for a vest and pair with a slim trouser
- A wooden bow tie or patterned pocket square

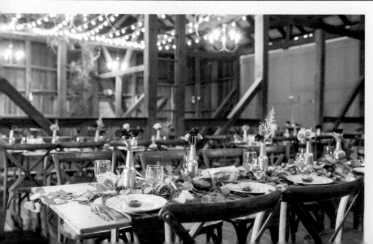

venues

An outdoor setting where nature plays a starring role in décor is ideal, like a ranch, mountaintop, farm, or lakeside resort. If you prefer to play it safe inside, choose a rustic space like a cool brewery, barnyard, or mountain lodge. If you've always imagined your perfect wedding being half indoors and half outdoors, then look to vineyards—they often have beautiful open-air spaces or patio-type decks with partial covering.

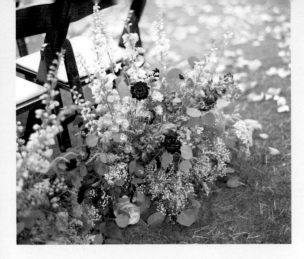

flowers

Rather than letting color dictate your flower choices, look to what's in season when you plan to wed. Stick with sturdy and textured flowers and plants that not only look the part but will also last in an outdoor environment. Dahlias, succulents, sunflowers, ranunculus, craspedia, cockscomb, and hanging amaranthus will all stay fresh from start to finish. Ask your florist to include wildflower fillers like Queen Anne's lace or thistle at varying heights to make your arrangements look like they were freshly gathered from the field. Texture is key here—incorporate natural, nonfloral accents like pussy willows, veggies, grains, or fiddlehead ferns for a unique look.

paper + signage

Choose a motif that matches your rustic setting and include it on your invitation and throughout your day-of paper—mountaintops, pinecones, trees, and so on are go-to motifs for alpine affairs, while horseshoes, stars, and cacti are perfect for ranch nuptials. Or opt for a less obvious nod to the locale. For example, print your invitations on wood-grain card stock for a subtle introduction to your theme. Western fonts are a good design option for desert and ranch weddings.

favors

- A location-inspired favor (think maple syrup for a Vermont wedding)
- Wood drink coaster
- Homemade granola or trail mix packaged in a mason jar

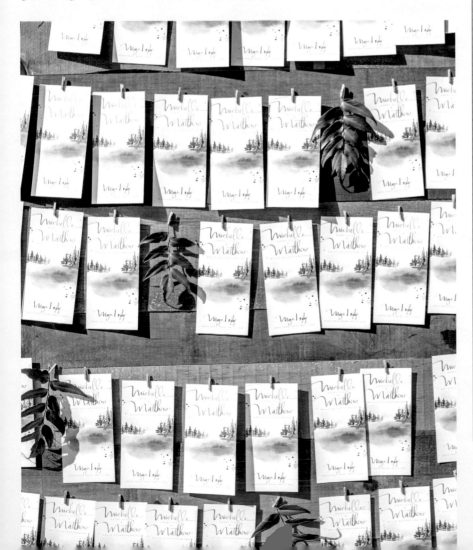

"I swear I couldn't love you more than I do right now, and yet I know I will tomorrow."
—Leo Christopher

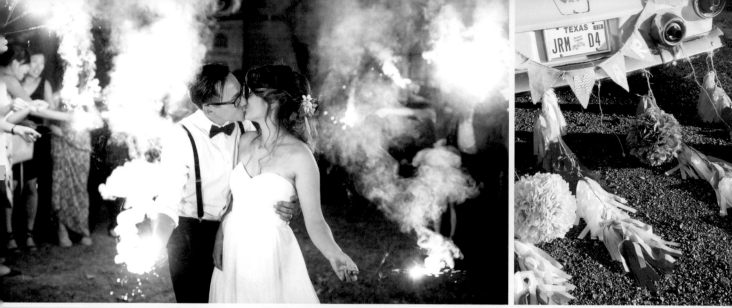

Exits

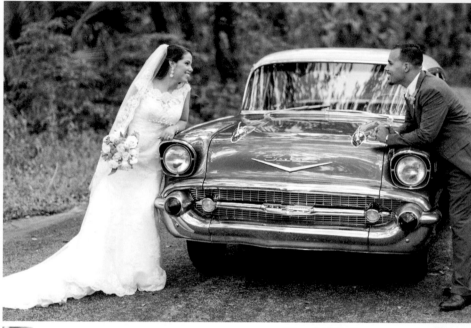

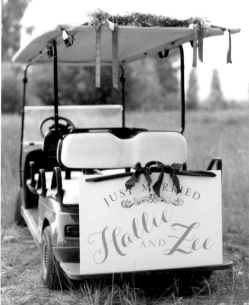

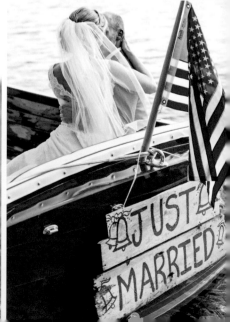

It's time for your grand finale. Encourage guests to send you on your married way in style by providing something unique for them to toss during your exit, like mini paper airplanes, flower petals (turn to page 211 for our DIY), confetti, or bubbles. Interactive exits are fun for everyone, and they also provide some beautiful group photos with lots of energy. If making a mess isn't exactly your thing, end the night with sparks—either with a sparkler exit or a surprise fireworks show.

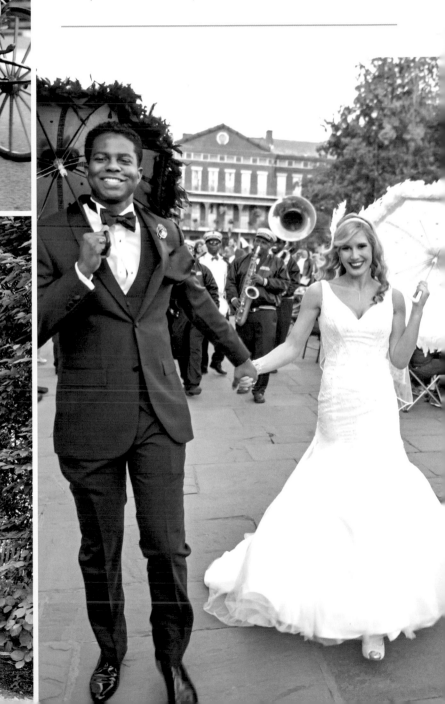

CRAFTS

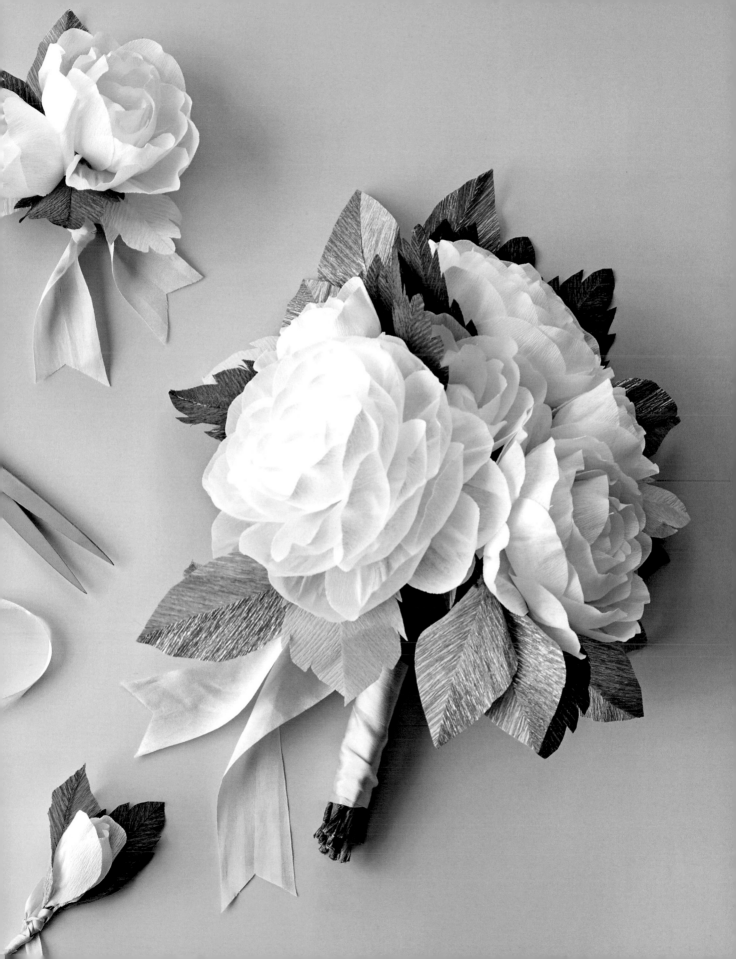

One of the best ways to personalize your wedding is to create an element yourself. You don't have to be an expert crafter to pull off a winning project—a simple detail goes a long way. Maybe it's an invitation envelope liner cut from patterned paper you love, or a hand-stamped favor tag. If you're a seasoned expert, however, then you might enjoy taking on a few DIY challenges.

When deciding what kind of project to tackle, or whether to do one at all, consider your abilities and what element of your wedding day you're most excited about. Maybe you love to doodle and have always imagined a handwritten save-the-date postcard for your nuptials. Or perhaps you and your fiancé love photo booths, so an arsenal of fun, curated props is high on your wish list. Once you've settled on a project or two, make a timeline of to-dos. Knock out anything you can do in advance—you'll feel better checking it off your list, and if you stumble along the way, there will be time to troubleshoot.

A word of caution: Some things are best left to the pros. It's doable to assemble a hundred favors well before your wedding day, but much harder to arrange a dozen centerpieces while getting ready for the party you've spent months planning. Choose projects you can make ahead and enlist help with day-of setup from trusted family and wedding attendants (you probably won't have time to arrange the escort card display). Just be wary of outsourcing any big tasks to friends—a wedding cake disaster is not an easy fix.

We teamed up with crafter **Lia Griffith** to create 20 projects guaranteed to bring your wedding day to life. From décor to gifts and signage, put your mark on the day with one of these easy DIYs. Follow our instructions to the letter or use them as loose guidelines or inspiration for your own spin on an extra-special element of your wedding day.

Turn the page for our favorite craft supplies and resources.

YOUR DIY TOOLBOX

We've said it before, but it's worth repeating: Staying organized is the key to wedding planning success. Assemble your supplies before tackling any DIY projects. Many projects will require a unique material or two, like wood-carving instruments or gold foil. But there are some basics you will reach for over and over again. Here are a few of our go-tos.

CHALKBOARD PAINT: Give just about anything instant sign potential with a coat of chalkboard paint. The black color is a classic and modern hue—even if you don't write anything in actual chalk.

ERASER: Everyone makes mistakes—a big eraser can help clean up pencil guidelines quickly.

FLORAL WIRE: If you plan on making any paper flowers (or playing with the real variety), keep some floral wire on hand.

GLUE DOTS: These no-mess glue stickers are great for paper projects, like escort cards and program assembly.

GLUE GUN AND GLUE STICKS: Hot glue can affix just about anything from paper projects to fabric and beyond. It dries quickly too. Look for a gun with a low-temperature option for more delicate projects, and have backup glue sticks at the ready.

HOLE PUNCH: If you plan to hang tags or assemble any bunting or garland, a hole punch will be essential.

INK PADS: Stamping is one of the easiest ways to personalize a project. Grab a couple of ink pads in colors that coordinate with your palette—metallics look extra luxe.

PAINTBRUSHES: Load up on various paintbrush sizes—small tips for detailed work and bigger brushes for large-scale painting.

PENS: Invest in a nice pen—your handwriting will look better, we promise. Choose a couple of metallics, which can write on opaque paper, and some ink in your wedding colors (just think about readability).

PENCILS: Make guidelines or sketch ideas with a pencil. You can always erase!

RULER: A basic ruler is perfect for making small measurements (think envelope liners), and provides a straight edge for cutting.

SCISSORS: Upgrade your scissors if you haven't lately—a good cut is essential for most projects. If you plan on cutting a lot of fabric or ribbon, invest in two sets of shears (one for paper, one for fabric) to keep your blades extra sharp.

STICKERS: Store a few sheets of fun, decorative stickers in your toolbox—they can instantly elevate a wrapped gift or homemade thank-you card.

WASHI TAPE: This easily removable decorative tape is perfect for so many projects—it can even double as painter's tape in a pinch. Look for rolls in your wedding colors, or opt for a fun pattern.

CRAFT KNIFE: This supersharp blade will give you a perfect cut every time. Consider picking up a cutting mat to protect your work surface (and the blade) from damage.

OUR FAVORITE DIY RESOURCES

Sometimes the only thing standing between you and that adorable wedding craft are mini hanging glass orbs or swing-top bottles. We know exactly where you can get those—in bulk—and everything else on your list. Here are our favorite places to stock up.

General Stores

JO-ANN FABRIC AND CRAFT STORES: This store is best experienced in person (they have locations all over the US), but its website offers up a range of online-only treasures, like specialty paintbrushes and party supplies. **JoAnn.com**

MICHAELS: From frames to tulle and votives, this superstore has every supply under the sun. Its website has a wedding tab so you can search for essentials. Best of all, it runs online promotions and has weekly coupons. **Michaels.com**

HOBBY LOBBY: Find modeling clay, metallic spray paint, and floral foam all in one place. If you shop online, a wide variety of rubber stamps and paper products can be shipped straight to your mailbox. **HobbyLobby.com**

Packaging

PAPER MART: This is one of those it-has-everything stores: cello bags, boxes, cartons, baskets, and every other container you could dream up, plus a wide selection of ribbon. **PaperMart.com**

SHOP SWEET LULU: Shop all the cutesy party and craft supplies—from polka-dot paper straws to glitter tape. Looking for take-home cake boxes? This is the place. **ShopSweetLulu.com**

SPECIALTY BOTTLE: Any bottle, jar, or tin you could imagine can be found here. If you're planning to make an edible favor, like jam or limoncello, this is the best place to buy containers in bulk for less. **SpecialtyBottle.com**

ULINE: Don't let the utilitarian look of this site deter you—it's full of gems for bulk packaging. Check out the padded mailers for fragile save-the-dates or the burlap pouches in all sizes for that essential rustic favor. **Uline.com**

Décor

FOR YOUR PARTY: If you're looking to put the finishing touches on a project instead of starting from scratch, this is the place for you. Premade banners, stir sticks, and custom coasters are aplenty. You can also add personalization to just about anything on the site. **ForYourParty.com**

JAMALI GARDEN: Need some silk flowers that rival the real thing? Or whimsical wood vases you just can't seem to find anywhere? Look no further. Mirrors, candles, floral supplies, and jars perfect for a confetti or candy bar can be shipped right to your doorstep. **JamaliGarden.com**

OH HAPPY DAY SHOP: This online party shop sells raw supplies like crepe paper and miniature clothespins, plus décor odds and ends (honeycomb balls, letter balloons, banners, confetti) that will turn up the volume on any celebration. **Shop.OhHappyDay.com**

RUBBER STAMPS: Create a completely custom wood-handled stamp with your wedding logo, date, or your new monogram. Choose from dozens of sizes, perfect for favor tags or save-the-date postcards. **RubberStamps.net**

THE KNOT SHOP: Of course, we had to mention our shop! It's organized by wedding theme, so whether you're interested in outfitting your venue in rustic, glam, or modern details, you can browse the selection and gather inspiration at the same time. This is the best place to find décor, personalized favors, and gifts for your wedding party. **TheKnotShop.com**

Paper

BLICK: Pens, tips, ink, kits, and parchment paper—all your calligraphy needs are met here. For any calligraphy newbie, we recommend looking into a kit. **DickBlick.com**

CHAMPION STAMP COMPANY: If you're in the market for vintage postage stamps, you'll be hard-pressed to find a selection that rivals this one. Choose from stamps in every hue of the rainbow—just expect to pay more than face value. **ChampionStamp.com**

PAPER PRESENTATION: Making place cards or tags for your favors? Need a printable label? Paper Presentation has a robust selection of sizes, shapes, and patterns that fit exactly what you're looking for, plus tons of other stationery supplies. **PaperPresentation.com**

PAPER SOURCE: Find high-quality envelopes, kraft paper, and stationery. Heart stamps, favor bags, and a few craft tools are also available. Check out its specialty papers—amazing envelope liner potential. **PaperSource.com**

ZAZZLE: If you're looking for custom postage, this is the place. Choose from a variety of wedding motifs (add your initials for a punch of personalization) or create your own custom creation. You can even designate postage amounts so your heavy envelope only needs a single stamp. **Zazzle.com**

Odds and Ends

D. BLÜMCHEN & CO: Metallic tinsel trim, crepe paper, and so much more can be found here. Blumchen specializes in old-fashioned, authentic craft supplies from places like Germany and Italy, so if you're looking to deck out a vintage wedding in DIY details, start your search here. **Blumchen.com**

M&J TRIMMING: Ribbons, trim, and lace all available at the click of a mouse—but if you really want the full trim-shopping experience, visit its store in New York City. If that's too far to travel, check out the shop's blog—it's full of bridal inspiration. **MJTrim.com**

ORIENTAL TRADING: You might think of this site as only a catchall for novelty toys and party supplies, but it has craft and art materials too. Choose from more than 30 different rolls of washi tape, glue guns, and even some packaging options, all affordably priced. **OrientalTrading.com**

SAVE ON CRAFTS: This site is a wedding crafter's dream. There's no shortage of inspiration, plus you'll find the supplies you need for escort-card holders, mercury glass votives, and charger plates. **Save-on-Crafts.com**

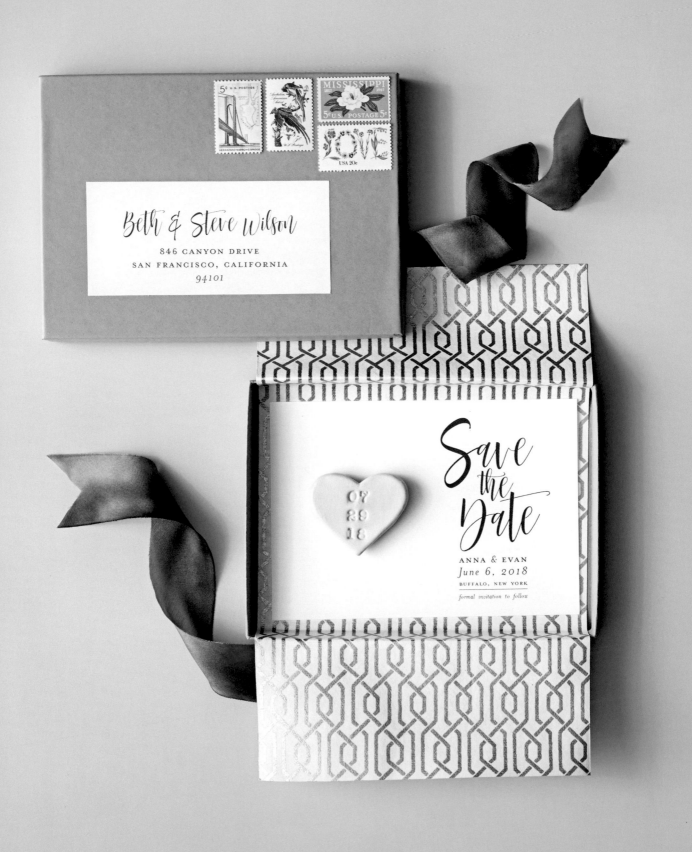

Beth & Steve Wilson
846 CANYON DRIVE
SAN FRANCISCO, CALIFORNIA
94101

Save the Date
ANNA & EVAN
June 6, 2018
BUFFALO, NEW YORK
formal invitation to follow

07
29
18

save-the-date magnet

LOOKING FOR A FRESH TAKE ON A SAVE-THE-DATE, but still want it to end up front and center on the fridge? Reimagine the magnet. A graphic clay magnet will hold up your printed announcement and live on long after your wedding day.

SUPPLIES
air dry clay
rolling pin
Craft knife or cookie cutter
 (we used a heart)
rubber stamp numbers
bowl of water
permanent craft adhesive
circular magnets

1 Roll out the clay to ¼-inch thickness on a dry work surface.

2 Cut out your shapes with a craft knife or cookie cutter.

3 Wet your fingers with water and gently smooth the edges of your shapes, front and back.

4 Press the rubber stamp numbers onto the front center of your clay shapes. Press firmly and evenly.

5 Let dry for at least 24 hours.

6 Using the permanent craft adhesive, glue the magnets to the back of the clay shapes.

expert tip
USE DOUBLE-STICK TAPE TO ATTACH YOUR MAGNETS TO YOUR PRINTED SAVE-THE-DATE CARDS. THEN POP THE CARDS IN BOX MAILERS AND AFFIX EXTRA POSTAGE (OR HAND DELIVER).

embellished invitations

TURN UP THE VOLUME ON A SIMPLE WEDDING INVITATION with an envelope liner, belly band, or ornamentation to elicit "oohs" and "aahs" from the lucky recipients. Download our envelope liner template at TheKnot.com/yourstruly.

SUPPLIES

template

patterned paper for envelope liners and belly bands

paper trimmer (or craft knife and ruler)

A7 envelopes

double-stick tape or glue dots

belly band suggestions: ribbon in satin, linen, or burlap; wood paper; twine

embellishment suggestions: paper cutouts, leather elements, monograms, herbs

1 Decide what elements or motifs are the best match for your wedding theme—like a nautical anchor or a rustic ribbon detail.

2 Download our envelope liner template. Using patterned paper, cut to fit.

3 Insert the patterned paper into an envelope, pattern side up. Using the double-stick tape or glue dots, adhere it to the envelope.

4 Cut ribbon, paper, or twine to act as a belly band for your invite. Wrap and then tie or fasten it with glue dots.

5 Add embellishments like paper cutouts or a monogram to give more style to a simple invitation.

expert tip

CLOSE YOUR ENVELOPE WITH A WAX SEAL FOR A SPECIAL TOUCH, OR USE A CUSTOM POSTAGE STAMP FOR EXTRA STYLE POINTS.

DOWNLOAD OUR EMBELLISHED INVITATIONS TEMPLATE AT THEKNOT.COM/YOURSTRULY

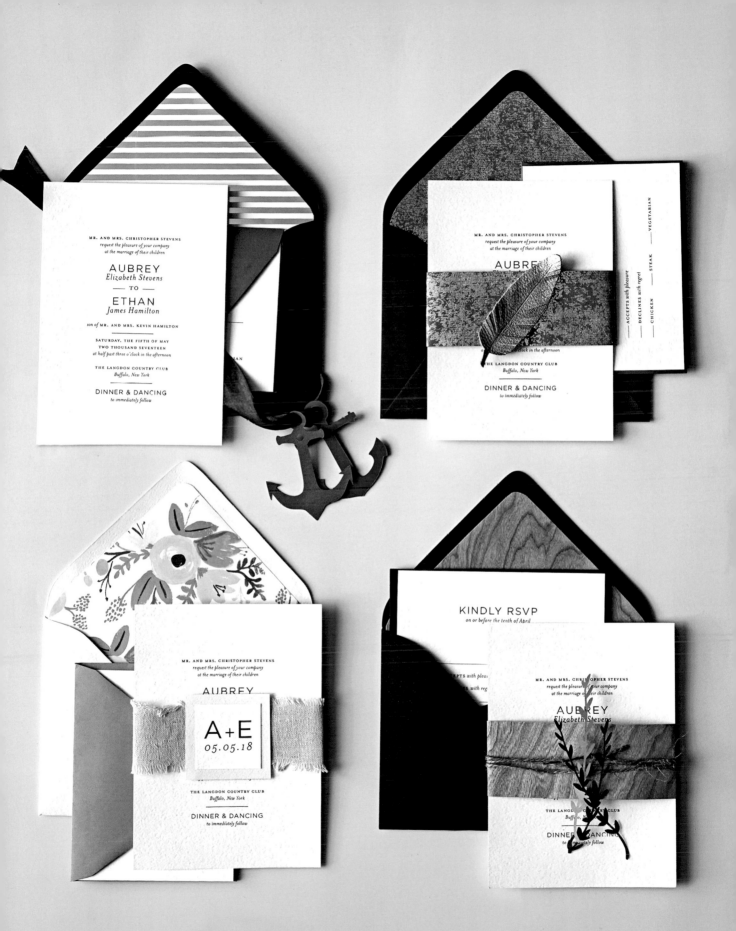

MR. AND MRS. CHRISTOPHER STEVENS
request the pleasure of your company
at the marriage of their children

AUBREY
Elizabeth Stevens
— TO —
ETHAN
James Hamilton
son of MR. AND MRS. KEVIN HAMILTON

SATURDAY, THE FIFTH OF MAY
TWO THOUSAND SEVENTEEN
at half past three o'clock in the afternoon

THE LANGDON COUNTRY CLUB
Buffalo, New York

DINNER & DANCING
to immediately follow

MR. AND MRS. CHRISTOPHER STEVENS
request the pleasure of your company
at the marriage of their children

AUBRE

THE LANGDON COUNTRY CLUB
Buffalo, New York

DINNER & DANCING
to immediately follow

ACCEPTS with pleasure

DECLINES with regret

CHICKEN

STEAK

VEGETARIAN

MR. AND MRS. CHRISTOPHER STEVENS
request the pleasure of your company
at the marriage of their children

AUBREY

A + E
05.05.18

THE LANGDON COUNTRY CLUB
Buffalo, New York

DINNER & DANCING
to immediately follow

KINDLY RSVP
on or before the tenth of April

MR. AND MRS. CHRISTOPHER STEVENS
request the pleasure of your company
at the marriage of their children

AUBREY
Elizabeth Stevens

THE LANGDON COUNTRY CLUB
Buffalo, New

DINNER & DANCING
to immediately follow

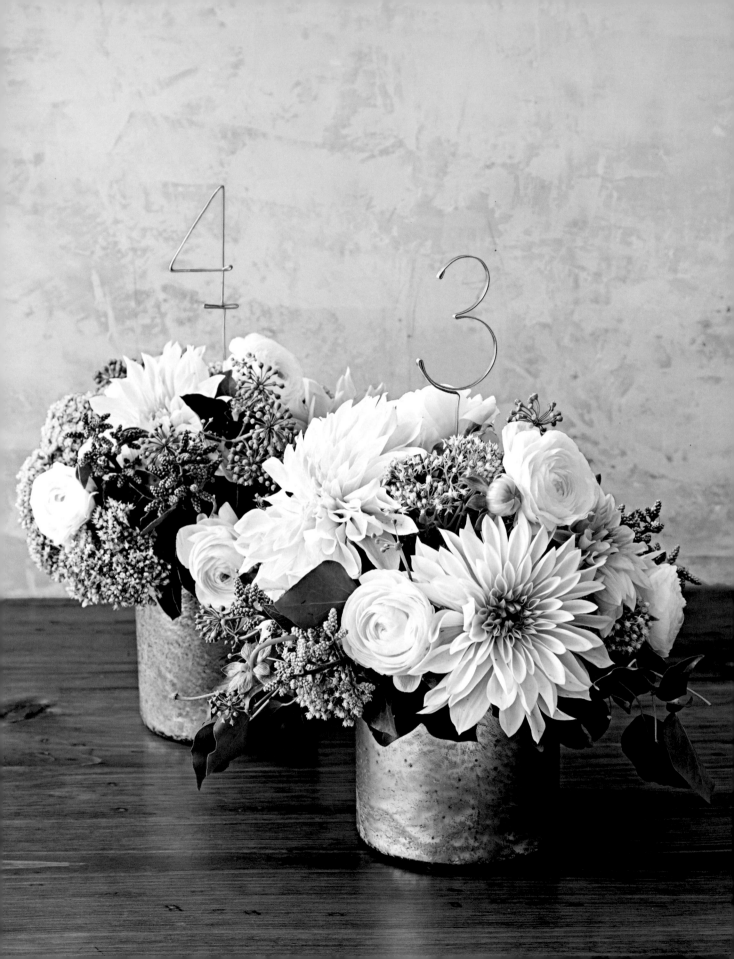

copper wire table numbers

ADD SOME LUSTER TO YOUR CENTERPIECES—and direct guests to their seats—with copper table numbers. These easy-to-fashion numerals are sure to stand out. After the wedding, you can use the relevant ones to commemorate your wedding date on a bookshelf.

SUPPLIES

printout of numbers or words in the size and font desired

ruler

wire cutters

copper wire (round or flat)

jewelry pliers

1 Print the numbers in the desired font and size to use as a guideline.

2 Cut a long piece of wire. You want a 12-inch (or more) "stem" so the numbers will be visible in your centerpieces. Depending on your style of numeral, you'll likely need another 8 to 10 inches for each digit.

3 Using the printed guideline, bend the wire with the jewelry pliers into the desired numbers.

vellum-wrapped hurricanes

LIGHTING IMPACTS THE AMBIENCE AND VIBE more than any other décor element at a wedding. Candles (even the battery-operated kind) can add an extra layer of romance, especially when styled in simple glass hurricanes. They work for any celebration and are affordable too. Download our vellum-wrapped hurricane template at TheKnot.com/yourstruly.

expert tip

ADD YOUR MONOGRAM TO THE PATTERN FOR A PERSONALIZED TOUCH. OR CUT NUMBERS INTO VELLUM PAPER AND LET THE CANDLES DOUBLE AS TABLE NUMBERS.

SUPPLIES

cutting machine (optional)

vellum paper

template (optional)

Craft knife

decorative hole punches
 (optional)

scissors

glass hurricanes

glue dots or double-stick tape

candles

1 If you have a cutting machine (like a Cricut), let it do the work for you—simply upload a pattern to your computer and insert vellum paper into the machine. If you do not own a cutting machine, download our template. Trace the designs on vellum paper. Using a craft knife, cut around the design, leaving spaces for the candlelight to shine through. You can also create a design with the decorative hole punches.

2 Once the vellum has been cut, wrap it around a glass hurricane. Secure with the glue dots or tape.

3 Add candles to the hurricanes and light them.

DOWNLOAD OUR VELLUM-WRAPPED HURRICANE TEMPLATE AT THEKNOT.COM/YOURSTRULY

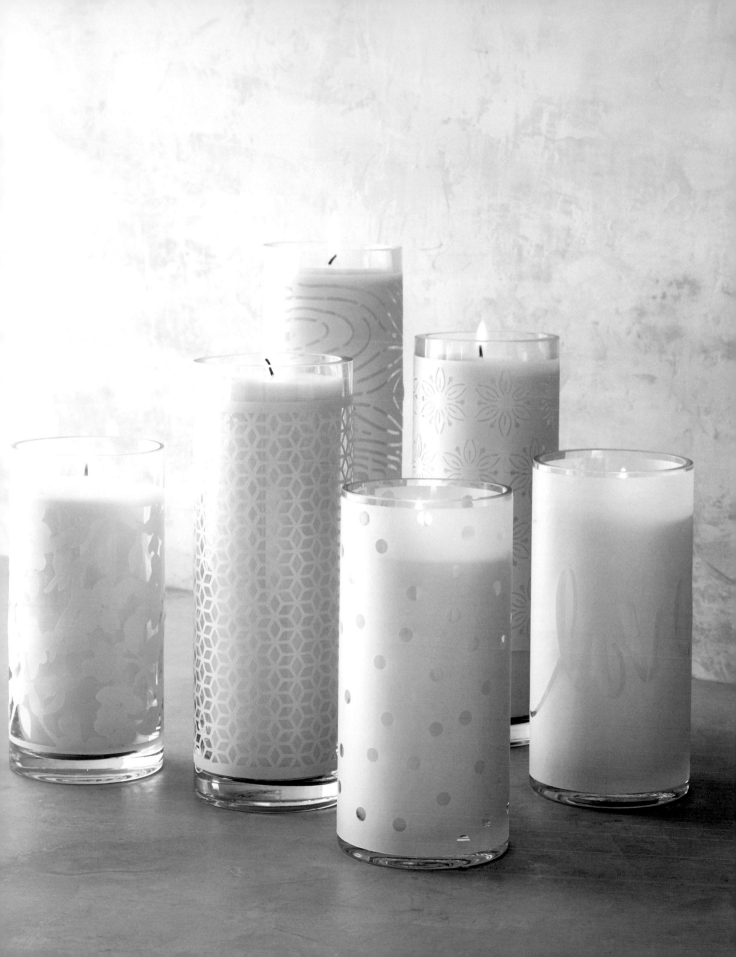

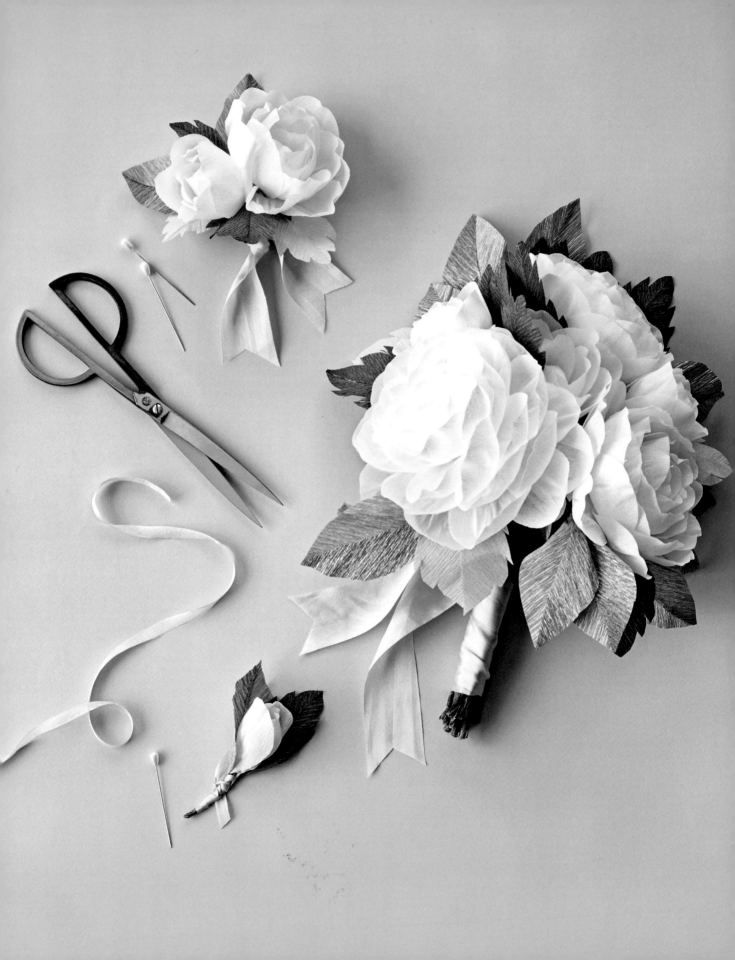

crepe paper flowers

WANT A FLOWER WITH LASTING POWER? Paper florals are a fun, totally wilt-proof addition to wedding décor. Once you've mastered the art of the flower, create a smaller stem for a boutonniere or scale the pattern for a lush bouquet. Download our crepe paper flower template at TheKnot.com/yourstruly.

SUPPLIES

template

scissors

extra-fine crepe paper
 in desired colors

½-inch foam ball

jewelry nose pliers

floral wire

hot glue gun (with low-
 temperature setting) and
 glue sticks

floral tape

1 Download and print the template.

2 Using the template, cut 30 crepe petals—10 small and 20 large.

3 Poke a small hole into the foam ball with the jewelry nose pliers.

4 Cut the wire to your desired length—short for boutonniere, longer for stems in a bouquet. Bend the tip of the floral wire to form a tiny circle, almost like a hook, to help secure the wire. Apply hot glue to the wire circle and secure it in the foam ball's hole.

5 Cover the ball with circle piece of crepe paper from template and glue it in place.

6 Gently stretch the centers of the petals to create a small cup shape.

7 Starting with the small petals, glue them around the base of the foam ball. Repeat with larger petals, alternating placement for a natural look.

8 Cut half leaf shapes horizontally, against the grain of the crepe paper. Glue two half leaf pieces together along the seam, creating a full leaf.

9 Glue the leaves to the floral wire stem.

10 Wrap all the stems with floral tape to secure them.

DOWNLOAD OUR CREPE PAPER FLOWER TEMPLATE AT THEKNOT.COM/YOURSTRULY

canvas clutch

SHOW YOUR APPRECIATION FOR THE WOMEN WHO'VE STOOD BY YOUR SIDE with a handmade gift—or carry one yourself. These personalized clutches will be a meaningful reminder of the day, and they'll definitely find use again.

SUPPLIES

fabric glue

scissors

optional embellishments: ribbon, fringe, glitter, fabric paint, embroidery threads and needles

simple fabric clutch (we used canvas, but leather would work too)

FOR THE TASSEL (OPTIONAL)

3 skeins of metallic embroidery floss

ruler

chain nose pliers

CLUTCH HOW-TO

Glue ribbons and fringe to the edges of the clutch, dip the clutch in glitter, or add a painted motif or embroidered initials. Look to your wedding colors for inspiration, or tailor the design to your besties' personalities. Finish the clutch with a tassel if desired.

TASSEL HOW-TO

1 Do not unwind the embroidery floss. Gently slide off their covers.

2 Cut one 18-inch piece of floss and one 24-inch piece of floss, keeping the skeins intact. Fold the 18-inch piece of floss in half.

3 Pass the folded floss through and around one end of all three skeins of floss; tie a square knot tightly to secure.

4 Hold the top of the knot of floss and smooth the strands.

5 Using the 24-inch piece of floss, start 1 inch down from the top of the tassel and begin wrapping the strands together tightly.

6 When you get to the end of the floss, tie a double knot and glue it to secure the knot.

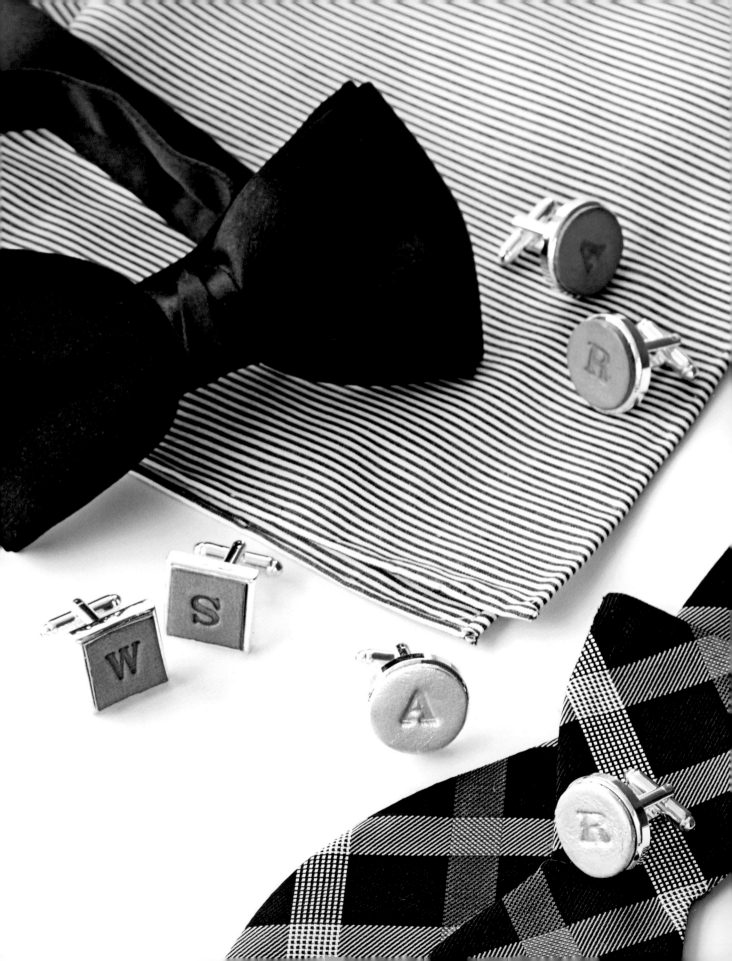

leather cuff links

ADD SOME FLAIR TO THE GROOM OR GROOMSMEN ATTIRE with a custom accessory. Rugged leather pairs with silver cuff links for a strikingly handsome keepsake.

SUPPLIES
beveled-edge cuff links
leather scraps
scissors
leather alphabet stamps
rubber hammer
permanent craft adhesive

1 Trace the faces of the cuff links onto a scrap of leather and cut them out.

2 Dab the cut leather pieces with a damp paper towel to wet them. Place them on a clean wood surface and stamp on the initials using the rubber hammer.

3 Let the leather dry. Using permanent craft adhesive, glue the leather to the face of the cuff links.

expert tip

IF YOU WANT TO ADD A HINT OF COLOR, USE A SMALL PAINTBRUSH TO FILL IN THE LETTER IMPRESSION, OR PAINT THE WHOLE PIECE OF LEATHER WITH A BOLD OR METALLIC HUE (WE CHOSE SILVER FOR ONE OF OUR SETS).

felt flower crown

MAKE ALL YOUR FLOWER GIRL'S PRINCESS DREAMS COME TRUE with this sweet floral crown—she may even think it's *her* day. Best of all, she can wear it again and again. Download our felt flower crown template at TheKnot.com/yourstruly.

SUPPLIES

template

scissors

3 to 5 shades of wool-blend felt (for the petals)

2 to 3 shades of green wool-blend felt (for the leaves)

black wool-blend felt (for the centers and fringe)

hot glue gun (with low-temp setting) and glue sticks

plastic headband

ribbon

1 Download and print the template. Cut out the petals, center pieces and fringe (it wraps around the center of the flower), and leaves from felt.

2 Roll a small scrap of felt into a ball (this will be the center of your flower). Cover with the center round and glue to secure. Wrap the fringe around the center ball and glue it in place.

3 One by one, glue the felt petals around the base of the flower center. Repeat with other colors until you have five felt flowers.

4 Glue two pieces of ribbon to both ends of the headband—these will be used to tie the crown to the flower girl's head.

5 Glue the ribbon along the underside of the headband, folding it over the ends to completely conceal the headband.

6 Glue the five flowers to the headband.

7 Add the leaves to the underside of the headband, gluing them in different directions for a natural look.

DOWNLOAD OUR FELT FLOWER CROWN TEMPLATE AT THEKNOT.COM/YOURSTRULY

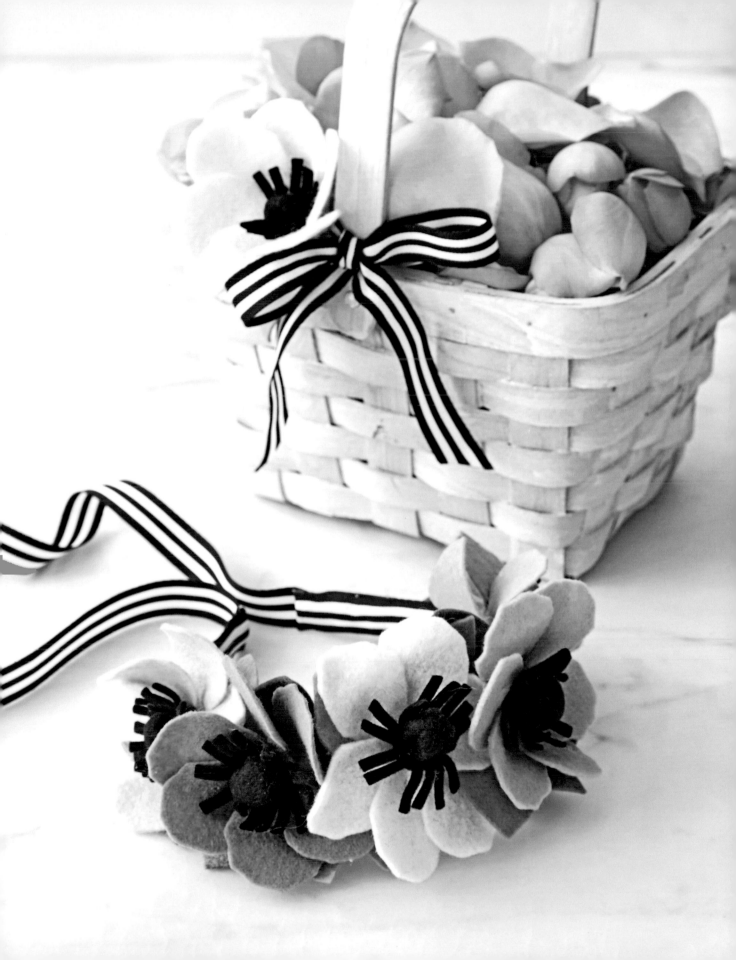

calligraphy signage

WANT A GORGEOUS SIGN BUT DON'T HAVE THE BUDGET (or turnaround time) to hire a professional calligrapher? This hack is for you. If you've never used a paint pen before, practice on scrap paper to get a feel for the pen's ink flow.

SUPPLIES

acrylic or plexiglass sign (see expert tip)
washi or painter's tape
paint pen
ribbon (optional)

1 Style a phrase on your computer in a beautiful script font (we love FontSpace.com for pretty typefaces), then print it in the size you wish it to appear on your sign.

2 Place the printout under the acrylic sign and secure it with washi or painter's tape.

3 Trace the letters with a paint pen. Let dry completely.

4 Remove the paper and hang the sign with ribbon, if desired.

expert tip

ASK SOMEONE AT YOUR LOCAL HARDWARE STORE TO CUT A PIECE OF ACRYLIC OR PLEXIGLASS TO YOUR DESIRED SIZE. ADD HOLES IF YOU PLAN TO HANG IT.

gold leaf card box

MOST COUPLES DESIGNATE A GIFT TABLE AT THE RECEPTION. Take things to the next level with a gilded card box. It will safeguard your guests' well-wishes, and afterward, it will make a nice addition to your newlywed nest.

SUPPLIES
vinyl with adhesive backing
scissors or craft knife
raw wood box with lid
tweezers
gold leaf
gold leaf adhesive
foam pad
Mod Podge glue
paintbrush

1 Style a monogram or phrase you love on the computer (we went with a wedding date: est. June 15, 2018), then print it in the size you wish it to appear on your box. Trace the lettering onto adhesive-backed vinyl and cut it out.

2 Attach the vinyl "sticker" to the top of the wood box.

3 Using tweezers, cover the entire box in gold leaf, including the stencil, according to the package instructions. Let dry overnight.

4 Peel away the "sticker" to reveal the wood. Using the foam pad, gently rub the gold leaf on the box to smooth it and remove any loose pieces.

5 Cover the entire box with Mod Podge for a glossy finish. Let dry completely.

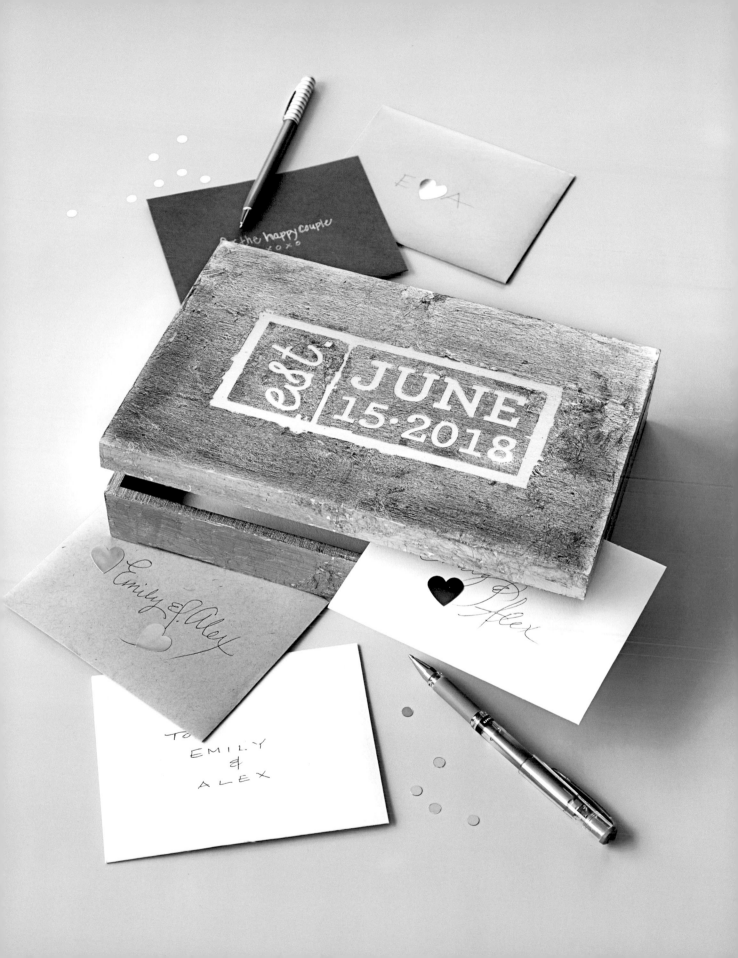

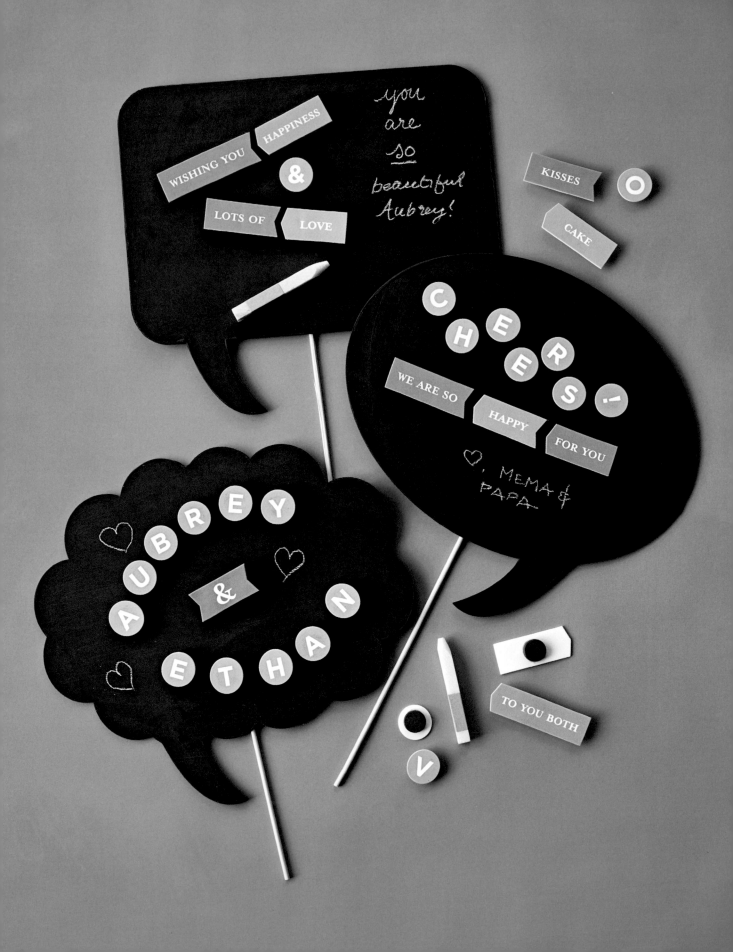

photo booth props

MAKE YOUR PHOTO BOOTH EVEN MORE FUN WITH BESPOKE PROPS. Guests will love mixing and matching phrases (with custom messages) for truly unforgettable pictures. Download our photo booth props template at TheKnot.com/yourstruly.

SUPPLIES
template
shrink film
scissors
hot glue gun and glue sticks
magnet circles
paintbrush
wood speech bubble signs
 (purchase or have them cut
 at your local woodshop)
magnetic chalkboard paint
wood dowels
chalk

1 Choose letters and words or phrases from our template (or style your own on your computer). They will shrink, so make the words twice as large as you'd like them. Color fades too during the shrinking process, so go bright. Print on the shrink film and trim to size. Bake according to the package instructions.

2 Remove the shrink film from the oven and place a heavy object (like a pot or dictionary) on top to keep the shapes flat. Let cool completely.

3 Hot glue the magnets to the back of the shrink film.

4 Paint the speech bubbles with magnetic chalkboard paint and let dry completely.

5 Hot glue the wood dowels to the backs of speech bubbles so they're easy for guests to hold.

6 Place the shrink-film phrase magnets and chalk in the photo booth so guests can create their own messages.

DOWNLOAD OUR PHOTO BOOTH PROPS TEMPLATE AT THEKNOT.COM/YOURSTRULY

fresh greenery backdrop

IF YOU'RE SAYING "I DO" IN A UNIQUE SPACE, create a memorable ceremony focal point with a custom backdrop. This lush installation (made with a few different kinds of fresh greenery for a textured look) can also double as a photo booth backdrop at the reception.

expert tip

SOURCE SUPPLIES FROM YOUR LOCAL GARDEN CENTER. YOU WANT THE BIRCH BRANCH TO BE WIDE ENOUGH TO PROVIDE A BACKDROP FOR TWO PEOPLE (OURS WAS 5 FEET LONG). OLIVE BRANCHES, MAGNOLIA LEAVES, FERNS, SEEDED EUCALYPTUS, AND EVEN EVERGREEN ARE ALL GOOD CHOICES FOR YOUR GREENERY. IF YOU WANT A FULLER LOOK, OPT FOR LEAFY VARIETIES (WE MIXED A COUPLE KINDS FOR A LUSH AND TEXTURED FINISH).

SUPPLIES

circles of cardboard or wood cut initials (size dependent on how big your backdrop will be)

tweezers

gold leaf

gold leaf adhesive

paint brush

foam pad

fresh greenery

floral wire

floral cutters

birch branch (see expert tip)

ribbon (optional)

1 Cut out your and your fiancé's initials from cardboard, leaving room for holes (either at the top and bottom if hanging vertically—as we did—or on the sides if hanging horizontally). Alternatively, ask someone at a local woodshop to create a more elaborate design for you.

2 Using tweezers, cover the initials in gold leaf, according to the package instructions. Let dry overnight.

3 Using a foam pad, gently rub the gold leaf on the initials to smooth it and remove any loose pieces.

4 Group branches of greens together. Secure with the floral wire in the middle and at the ends, creating a long strand of garland. Repeat to make additional strands based on desired width of installation.

5 Using the floral wire, secure the strands of garland to the birch branch.

6 Trim the ends of the garlands so they're similar lengths but maintain an organic look—perfectly imperfect.

7 Attach wood letters to greens with floral wire or hang them from the birch branch with ribbon, if desired.

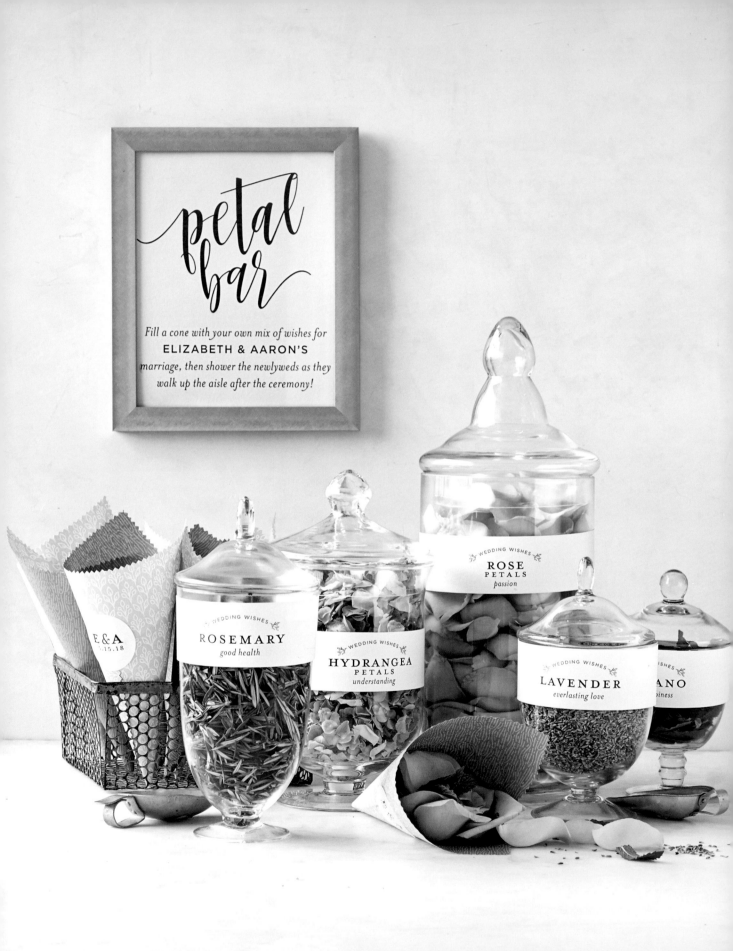

petal bar

Fill a cone with your own mix of wishes for
ELIZABETH & AARON'S
*marriage, then shower the newlyweds as they
walk up the aisle after the ceremony!*

WEDDING WISHES
ROSE
PETALS
passion

WEDDING WISHES
ROSEMARY
good health

WEDDING WISHES
HYDRANGEA
PETALS
understanding

WEDDING WISHES
LAVENDER
everlasting love

WEDDING WISHES
ANO
piness

petal bar

UPDATE THE TRADITION OF TOSSING RICE with floral and herb confetti instead. Keep guests busy preceremony with a petal bar. Ask them to assemble a fragrant blend of petals to toss after the first official kiss. Choose florals that have a significant meaning to you, such as the first flower you received from your fiancé, or roses that look just like the ones in your grandmother's garden.

SUPPLIES
ruler

scissors

heavyweight patterned paper

personalized stickers or
 washi tape

glue dots

signage

apothecary jars of various sizes

various petals and herbs

1 Cut the patterned paper into an 8-inch square. Roll the paper into a cone shape, being sure there is no hole at the bottom. Secure with a personalized sticker, washi tape, or glue dot. Display the cones in a basket for guests to fill.

2 Create signage for each type of petal and herb you have. Secure to the apothecary jars with glue dots.

3 Fill the apothecary jars with petals and herbs.

4 Add framed signs with instructions for guests.

escort luggage tags

IF YOU'RE HOSTING A DESTINATION WEDDING or looking for an escort card that can double as a favor, we've got you covered. Create a custom luggage tag—perfect for a travel-themed soiree or for your family and friends who have gone the distance to celebrate alongside you. Download our escort luggage tag template at TheKnot.com/yourstruly.

expert tip

TAKE THE TRAVEL THEME ONE STEP FURTHER. CREATE A MAP OF YOUR LOVE STORY AND ATTACH TAGS TO THE SIGNIFICANT CITIES WITH STICK PINS (THINK: MET IN COLLEGE IN CONNECTICUT, YOU MOVED TO NEW YORK CITY, YOUR PARTNER MOVED TO SAN FRANCISCO, AND YOU TWO FINALLY SETTLED TOGETHER IN WASHINGTON, DC). USE THE MAP AS AN INTERACTIVE ESCORT CARD DISPLAY AT YOUR RECEPTION.

SUPPLIES
template
ruler
fabric scissors
fine painters canvas
liquid seam sealant
sewing machine
natural-colored thread
cord
printable design (we used a map; optional)
clear iron-on vinyl (optional)
iron (optional)
card stock

1 Download and print the template.

2 Using scissors, cut an inch of canvas to start a fray. Then tear the remainder into 3-inch-wide-by-11-inch-long strips.

3 Using the template, mark and cut out "windows" on one end of each 3-by-11-inch piece.

4 Fold the fabric in half. Using the template as a guide, cut along the folded edge.

5 Run a bead of liquid seam sealer along the cut edges and on top of the window edges to stop the fabric from fraying further. Let dry completely.

6 Stitch according to template. Cut slits for the cord.

7 Print designs on the vinyl and add to the back of tags using an iron, if desired.

8 Create cards, including your guests' names and table assignments. Insert the cards into the windows on the tags.

9 Slip the cord through the slit and tie a knot to secure.

DOWNLOAD OUR ESCORT LUGGAGE TAG TEMPLATE AT THEKNOT.COM/YOURSTRULY

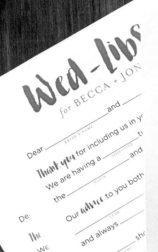

wed libs

WHILE YOUR GUESTS EAGERLY AWAIT THE START OF YOUR CEREMONY, keep them entertained with wedding Mad Libs. The ice-pop stick secures the pencil and allows the game to double as a fan for outdoor celebrations. Place baskets at the exit to collect them. You will definitely want to read the Wed Libs—instant bonus keepsake for you. Download our Wed Libs template at TheKnot.com/yourstruly.

SUPPLIES

template

8½-by-11-inch heavyweight card stock

scissors

corner punch (optional)

hot glue gun

glue stick

ice-pop sticks

washi tape

small pencils or pens

1 Download our Wed Libs template and print it on the card stock, or create your own.

2 Trim to size, according to the template, cutting the corners with a corner punch for a rounded effect, if desired.

3 Using hot glue, secure both sheets of Wed Libs together, inserting an ice-pop stick in between them.

4 Using washi tape, secure a pencil to the ice-pop stick.

expert tip

MAKE YOUR ENTERTAINMENT DO DOUBLE-DUTY. SWAP THE SIDE USED FOR ADJECTIVES AND NOUNS WITH DETAILS ABOUT THE WEDDING PARTY AND THE ORDER OF EVENTS.

DOWNLOAD OUR WED LIBS TEMPLATE AT THEKNOT.COM/YOURSTRULY

postcard guest book

THIS TWIST ON THE GUEST BOOK will keep the wedding fun going long after the last dance. Preaddress the postcards to yourself—don't forget to put a stamp on them too. Ask guests to share some advice or a favorite memory of the night and mail them to you. When you return from your honeymoon, you'll be welcomed with a mailbox full of well-wishes. Download our postcard guest book template at TheKnot.com/yourstruly.

expert tip

IF YOUR WEDDING GUESTS ARE THE DIY-ING TYPE, ARRANGE THE TABLE WITH CUSTOM RUBBER STAMPS, INK PADS, AND PENS AND LET THEM DECORATE THE POSTCARDS BEFORE WRITING THEIR MESSAGES.

SUPPLIES
template
card stock
scissors
postage stamps
rubber stamps in various designs
ink pads
pens
mailbox (optional)

1 Download the template and print it on card stock. Trim to size. Include a stamp and your home address.

2 Buy premade rubber stamps (hearts, cityscapes, motifs) or design your own custom creation, like a monogram or a logo. Decorate the postcards.

3 Display the postcards and pens on the guest book table at your reception with a mailbox, if desired. Include signage with instructions for guests to share some advice and drop their words of wisdom in the mail.

DOWNLOAD OUR POSTCARD GUEST BOOK TEMPLATE AT THEKNOT.COM/YOURSTRULY

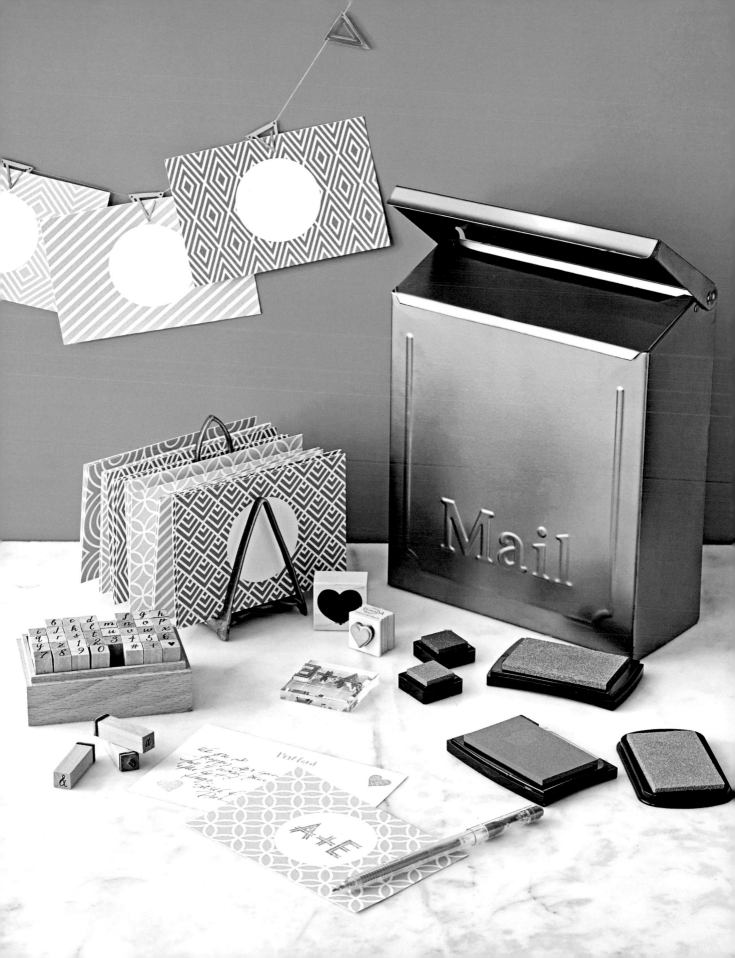

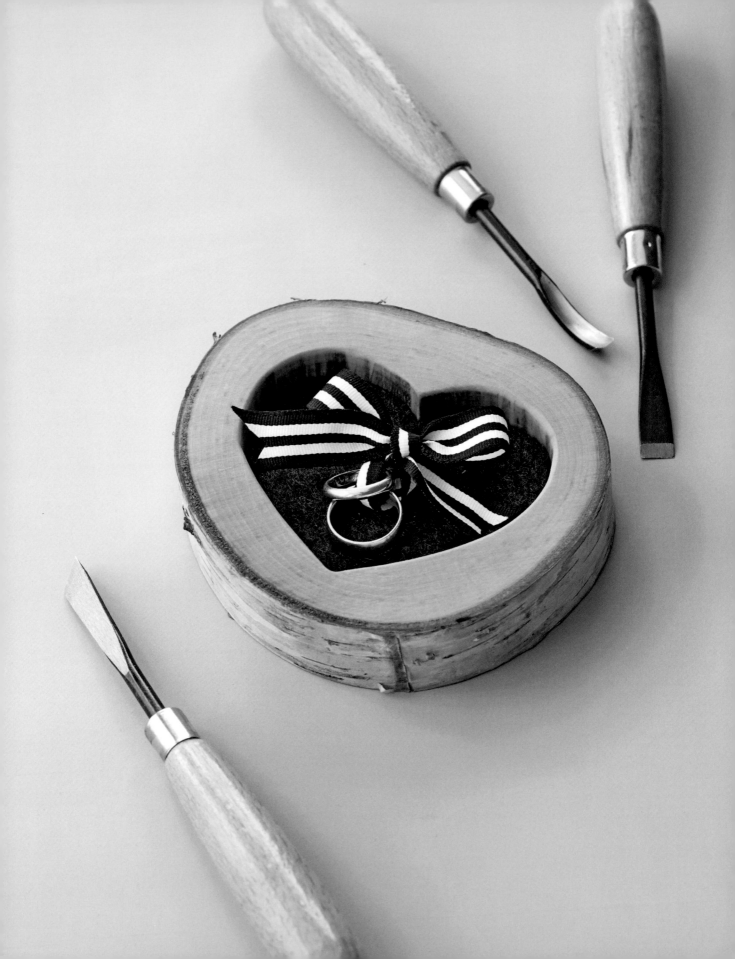

ring holder

THIS TWIST ON THE RING PILLOW is perfect for a laid-back affair like an outdoor mountain wedding or barn soiree. Best of all, you can use the handmade wood heart as a ring dish for years to come.

SUPPLIES

heart stencil

birch wood disk

carving tools

fine sandpaper

coconut oil

scissors

felt

ribbon

hot glue gun

glue sticks

1 Using the heart stencil, trace the shape on the face of the birchwood disk. Using carving tools, carve the heart into the disk. Sand all edges with the fine sandpaper until smooth. Cover the wood disk in the coconut oil to seal it.

2 Using the same stencil, cut a heart out of the felt.

3 Cut two small slits in the felt. Thread a 6-inch piece of ribbon through the opening (this is how you'll attach the rings). Secure the felt heart in the wood disk with hot glue.

4 Attach your wedding rings to the ribbon.

expert tip
USE THE SAME RIBBON FOR THE FELT FLOWER CROWN (PAGE 200) AND YOUR WOOD DISK—THIS WILL GIVE THE FLOWER GIRL AND RING BEARER A COHESIVE LOOK.

macramé dog leash

INCORPORATING YOUR FOUR-LEGGED FRIEND IN YOUR WEDDING DAY is the ultimate personal touch—he's family too. Have Scout looking his best with a handmade dog leash dip-dyed in your wedding colors or woven with sparkly ribbon. He may steal the show, but you won't mind one bit.

SUPPLIES

cotton cord (thick and thin varieties)

brass hook

scissors

hot glue gun and glue sticks

ribbon (optional)

fabric dye (optional)

expert tip

GO ONE STEP FURTHER AND EMBELLISH THE LEASH WITH FLOWERS OR BOWS. A BOW TIE ADDS AN EXTRA-SPECIAL STYLE STATEMENT.

1 Cut three strands of the thick cotton cord to desired leash length (for small dogs, 125 inches; medium to large dogs, 100 inches). Cut an additional 20-inch length of the thin cord.

2 Secure the hook to a stationary surface. Pull one piece of thick cord halfway through the loop of the brass hook, letting it hang. Lay the other length of thick cord over the left portion and wind it under the right strand. Braid the cords together.

3 When you've reached the end of the cord, fold the top into a loop, forming the handle of the leash, and glue the braid together to secure. Trim the ends with scissors.

4 Use hot glue to secure all six ends tightly to the back of the leash.

5 Wind the thinner cord around the joined end tightly. Glue at both ends, tucking it into itself.

6 If using ribbon, thread it in and out of the braid. Glue and tuck it at either end.

7 If using fabric dye, dip-dye the leash according to the package instructions. Let dry completely, then wash to set.

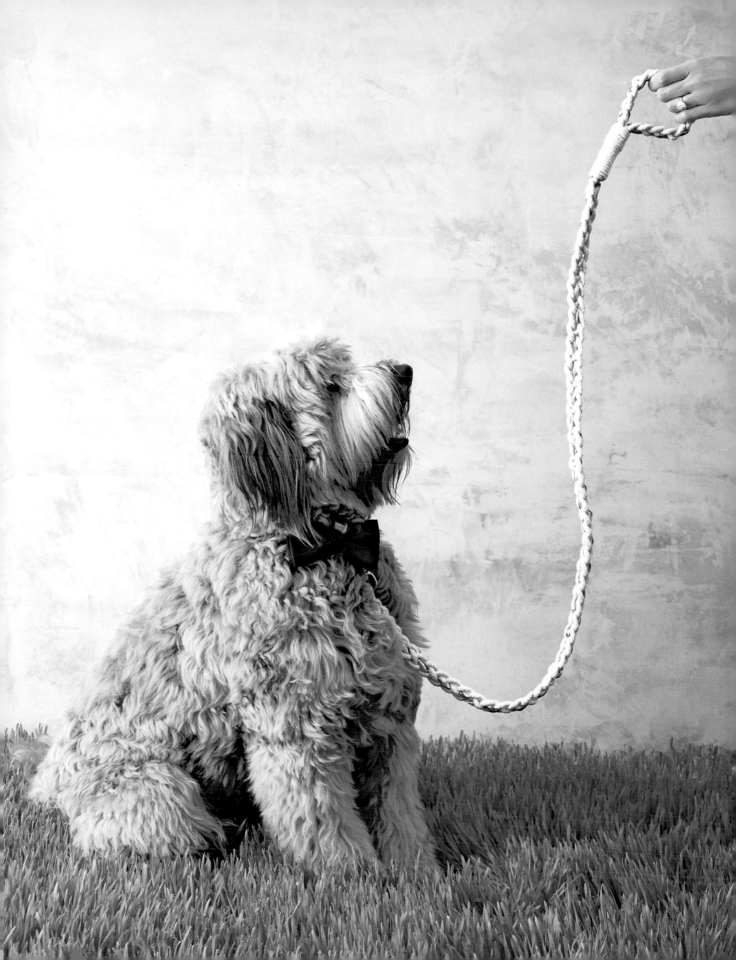

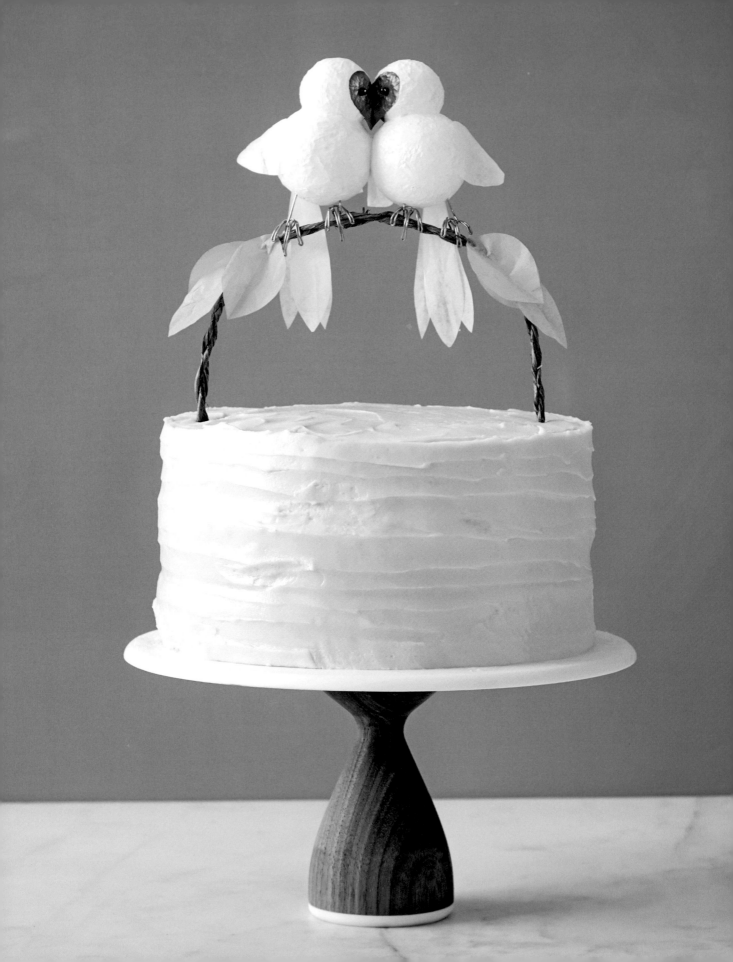

lovebird cake topper

WANT A UNIQUE TOPPER FOR YOUR WEDDING CAKE? Look no further than these charming rustic lovebirds. Crafted from tissue and foam, they're the perfect handmade ending to your wedding day.

SUPPLIES

hot glue gun and glue sticks

2½-inch foam balls

2 2-inch foam balls

scissors

white, gold, and green tissue paper

paintbrush

Mod Podge glue

4 stick pins with black heads

wire cutters

paper-wrapped floral wire (we used brown)

copper wire

pliers

1 Hot glue a small foam ball onto a larger ball, making the bird's head and body. Repeat with the second set to create two birds. Let dry completely.

2 Cut two small and two large circles of white tissue paper—they should be large enough to cover the foam balls.

3 Cover the bird bodies entirely with the precut white tissue paper. Using Mod Podge, secure the tissue to the foam. Give the entire bird a final coat of Mod Podge to smooth out the tissue paper. Let dry completely.

4 Cut two hearts from the gold tissue paper. Glue them onto the heads of the birds with Mod Podge, creating their faces.

5 Stick two black pins into each heart, creating the eyes.

6 Face the birds toward each other, creating a big heart with their faces. Secure them with hot glue at the bellies and faces of the birds. Let dry completely.

7 Using the white tissue paper, cut four wings and six tail feathers. Glue the two wings to the front and back of the bird, and attach three tail feathers in a fan shape to the base of each bird. Let dry completely.

8 Using the wire cutters, cut paper-wrapped floral wire into three 15-inch lengths. Braid them together, forming a branch for the birds to perch on. Curve the branch into a semicircle.

9 Cut four 4-inch lengths of copper wire. Using pliers, fold the wire back and forth to form four prongs, which will make up the feet of each bird. Leave a 1-inch leg. Poke two legs into each bird. Make sure they're all about the same depth so the feet will align on the branch. Glue to secure. Let dry completely.

10 Using the pliers, bend the wire feet around the branch, holding the birds in place. Secure with a dot of hot glue.

11 Cut out six leaves of green tissue paper. Fold in half to create depth and a real-leaf feel. Hot glue on the branch, on either side of the birds.

expert tip

CRINKLES AND WRINKLES IN THE TISSUE PAPER ARE A GOOD THING—THEY GIVE THE BIRDS A MORE REALISTIC LOOK. YOU COULD ALSO USE REAL FEATHERS!

breakfast-to-go basket

SURPRISE OUT-OF-TOWN AND OVERNIGHT GUESTS WITH BREAKFAST after your big celebration. They'll appreciate the thoughtful and tasty gesture (not to mention the coffee). Personalize the basket with your favorite treats, like homemade granola or blueberry muffins. You can even include a tea towel with local flair that guests can keep as a reminder of the fun they had celebrating with you.

expert tip

IF YOU PLAN TO HOST A GRAB-AND-GO BRUNCH, THIS ASSEMBLED BASKET MAKES IT SUPER EASY FOR GUESTS TO HIT THE ROAD. DISPLAY BASKETS ON A BUFFET TABLE ALONGSIDE A COFFEE SERVER, CREAM, AND SUGAR. OR FILL THE BASKET WITH NONPERISHABLES LIKE MUFFINS OR BANANAS AND SEND GUESTS HOME FROM YOUR WEDDING WITH A BREAKFAST "FAVOR" INSTEAD.

SUPPLIES

granola, store-bought or homemade (recipe follows)

breakfast food suggestions: fresh fruit, yogurt, nuts, muffins

airtight jars in various sizes

spoons

coffee cups

coffee

baskets

tea towels

ASSEMBLE

Package the granola and other breakfast items in jars. Arrange all the elements in baskets lined with tea towels.

GRANOLA

⅓ cup maple syrup

⅓ cup packed light brown sugar

4 tsp. vanilla extract

½ tsp. salt

½ cup coconut oil, melted

5 cups rolled oats

1 cup crystallized ginger, finely chopped

2 cups macadamia nuts, roughly chopped

2 cups dried cranberries

1 cup shaved coconut

1 Preheat the oven to 375°F.

2 Whisk together the maple syrup, sugar, vanilla, and salt in a large bowl. Stir in the coconut oil, oats, ginger, and macadamia nuts to coat.

3 Transfer the mixture to a baking sheet lined with parchment paper. Spread it out in an even layer and press down until tightly compacted. Bake until lightly browned, about 40 minutes, turning halfway through.

4 Let cool on the tray for about an hour. Break into pieces and stir in the cranberries and shaved coconut. (Store in an airtight container for up to two weeks.)

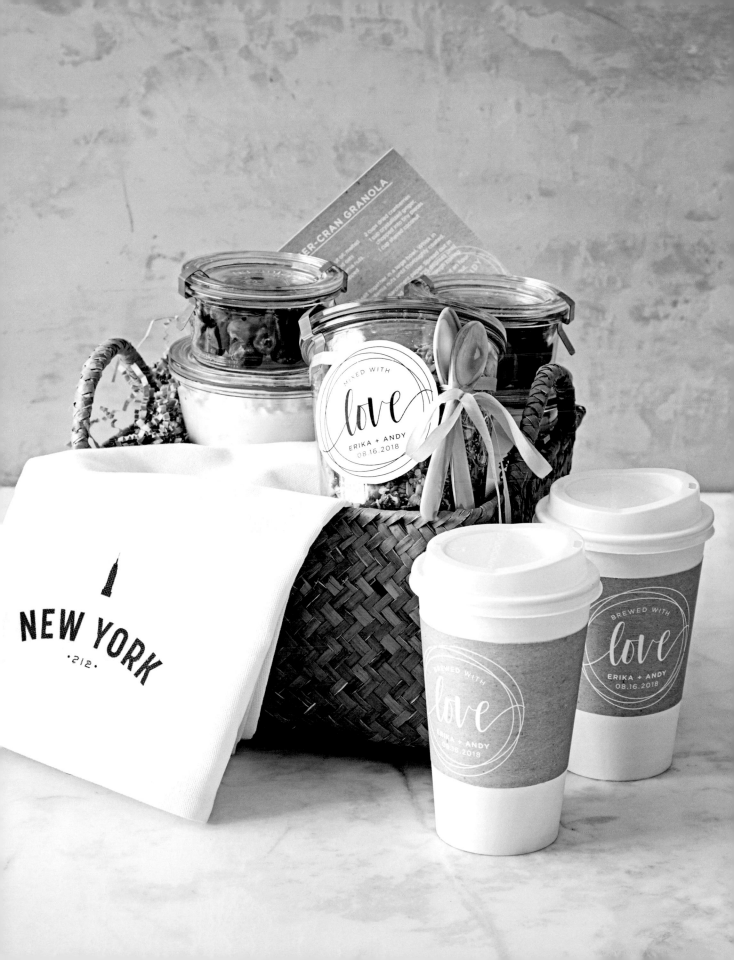

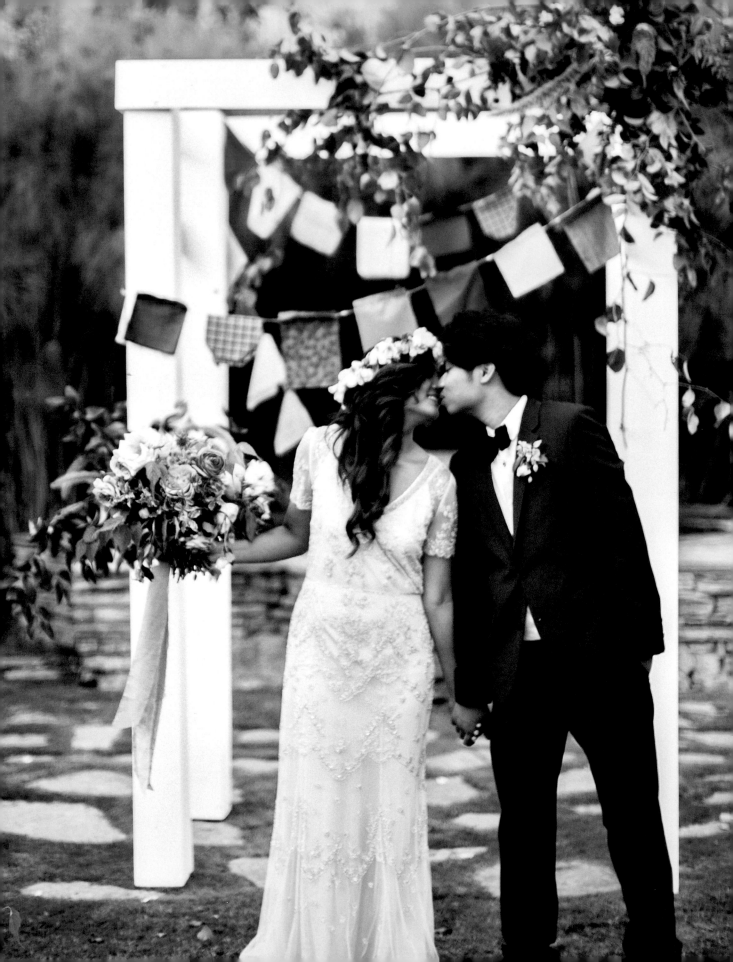

CREDITS

FOLLOW THE KEY BELOW WHEN LOOKING UP THE DETAILS OF EACH REAL WEDDING.

 Venue Event Design/Planner Photography Cake Flowers Stationery Rentals

INTRODUCTION

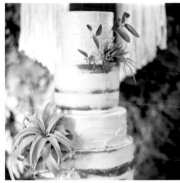

p. 2 Suzett and Sam
⌂ Gasparilla Inn & Club, Boca Grande, FL 🗒 Anna Lucia Events 📷 Carrie Patterson Photography ❋ Boca Blooms by Valley Forge Flowers ✉ TPD Design House 🪑 A Chair Affair, Event Effects Group, Events on the Loose, Sperry Tents Naples, Under Canvas Events, Unearthed Vintage

BOHEMIAN

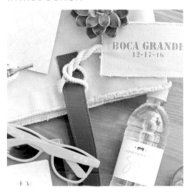

p. 26 Samantha and Hayden
⌂ Ceremony: First Baptist Church, Graham, TX; reception: Wildcatter Ranch, Graham, TX 🗒 Birds of a Feather Events 📷 Joshua Ratliff Photography 🍰 Layered Bake Shop ❋ The Southern Table 🪑 Minted.com 🪑 Bella Acento, BEYOND, La Tavola, Mike's Westside Rental, Sandone Productions, Suite 206, Taylor's Rental Equipment Co.

p. 32 Kristel and KJ
⌂ Ceremony: Rancho Los Cerritos, Long Beach, CA; reception: Padre, Long Beach, CA 🗒 Arielle Azoff/LVL Weddings & Events 📷 Shauntelle Sposto/Sposto Photography 🍰 IT'S-IT ❋ Petals and Pop 🪑 Emily Formentini, Modi Event Supply

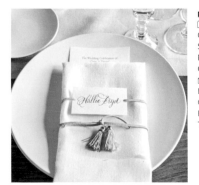

p. 36 Claire and Dan
⌂ Bride's family's ranch, Sonoma, CA 🗒 Kelly McLeskey-Dolata/A Savvy Event 📷 Edyta Szyszlo Photography 🍰 Forget Me-Not Cakes ❋ Shotgun Floral Studio ✉ Invitations: Sandy Bremner Designs; place cards: Rona Siegel Calligraphy 🪑 Bright Event Rentals, Found Vintage Rentals, Twilight Design, Zephyr Tents

p. 40 Lori and Jonathan
⌂ Estancia La Jolla Hotel & Spa, La Jolla, CA 🗒 Amorology 📷 Rico and Rachel Castillero/Studio Castillero 🍰 S'more Sweets ❋ Siren Floral Co. ✉ Peanut Press Creative 🪑 The Hostess Haven

CLASSIC

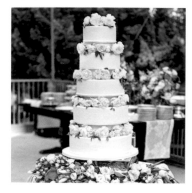

p. 48 Julie and Alec
🏠 Gulls Way Estate, Malibu, CA
📋 Jupiter Ambrosia 📷 Aaron
Delesie 🎂 Charm City Cakes West
❋ Flowers in Beverly Hills
✉ Happy Menocal 🪑 Casa de
Perrin, Revelry Event Designers

p. 54 Jasmine and Evan
🏠 Ceremony: Church of St.
Ignatius Loyola, New York City;
reception: The University Club of
New York, New York City
📋 Elegant Occasions by
JoAnn Gregoli 📷 Susan Baker
Photographer 🎂 The University
Club of New York ❋ Amaryllis
Event Décor ✉ Michael Zac
Design Group, ForYourParty.com,
PrettyStationeryShop at Etsy.com
🪑 Amaryllis Event Décor,
Something Different Party Rental,
Stortz Lighting

p. 58 Lan and David
🏠 Montage Laguna Beach, Laguna
Beach, CA 📋 Sophia Park/SPark
Event Consulting 📷 Brandon
Kidd Photography 🎂 Rita Pham/
M Cakes Sweets ❋ Jaclyne Breault/
Heavenly Blooms ✉ Hannah Shin
🪑 ChiavariChairRentals.com, Found
Vintage Rentals, Town & Country
Event Rentals, Wildflower Linen

p. 62 Kristina and Hayes
🏠 John's Island Club, Indian River
Shores, FL 📋 Claudia Hanlin's
Wedding Library 📷 Lindsay
Madden Photography 🎂 John's
Island Club ❋ William Bainbridge
Steele Designs ✉ Claudia Hanlin's
Wedding Library, Crane & Co.;
calligraphy: The Blooming Quill
🪑 Frost Productions, La Tavola,
TentLogix

ECLECTIC

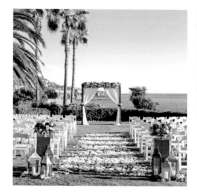

p. 70 Jean and Nic
🏠 Casa Hyder, San Miguel
de Allende, Mexico 📋 Emily
Clarke Events 📷 Sarah Kate,
Photographer 🎂 Don Pastel
❋ Bougainvillea ✉ The Detail
Department, Emily Clarke Events
🪑 Casa Hyder, La Tavola

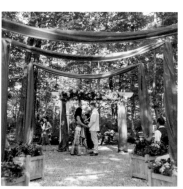

p. 78 Rachel and Andrew
🏠 Greengate Ranch and
Vineyards, San Luis Obispo, CA
📋 Weekend-of coordinator: Kristie
Lacy 📷 Emily Reiter/Anna Delores
Photography 🎂 Cake Cathedral
❋ Skyline Flower Growers
✉ BelleHanahPaperie at Etsy.com,
LittleMountainTop at Etsy.com
🪑 All About Events

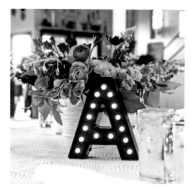

p. 82 Kelsey and Joe
🏠 Uppercut Boxing Gym,
Minneapolis 📋 Rocket Science
Weddings & Events 📷 Tanveer
Badal/Book of Love Photo
❋ Sweet Martha's Cookie Jar
❋ Rocket Science Weddings &
Events ✉ Printerette Press
🪑 BeThings, Beverly & Co.,
Bungalow 6 Design, Fabulous
Furniture Studio, La Tavola, Rudy's
Event Rentals, Ultimate Events

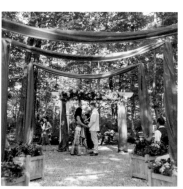

p. 86 Melissa and Patrick
🏠 The Barn on Walnut Hill, North
Yarmouth, ME 📋 Lani Toscano
Event Planning & Design
📷 Emily Delamater Photography
🎂 Eileen's Special Cheesecake
❋ Flora Fauna 🎂 Bella Figura
🪑 Heartwood Essentials, New
England Country Rentals, One Stop
Event Rentals

GLAM

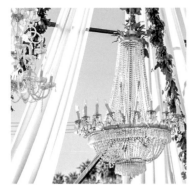

p. 94 Megan and Whit
🏠 Parker Palm Springs, Palm Springs, CA 📋 Heather Hoesch/ LVL Weddings & Events 📷 Jasmine Star 🍰 Over the Rainbow Desserts ❀ White Lilac Inc. ✉ White Lilac Inc., Wiley Valentine

p. 102 Carolina and Sherrard
🏠 Ceremony: The Lofts at Prince, New York City; reception: Harold Pratt House, New York City 📋 Natalie Trento Events 📷 Boris Zaretsky 🍰 Hanoli Cakes ❀ NYC Flower Project ✉ Overdressed Paperie ⛺ Broadway Party Rentals, CV Linens, The Finishing Touch NY

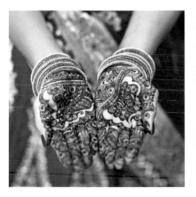

p. 106 Stephanie and Vik
🏠 Ceremony 1: Old Mission Santa Barbara, Santa Barbara, CA; Ceremony 2: Four Seasons Resort The Biltmore, Santa Barbara, CA; Reception 1: Wine Cask Restaurant, Santa Barbara, CA, Reception 2: Four Seasons Resort The Biltmore, Santa Barbara, CA 📋 Day-of planner: Percy Sales Events 📷 Braja Mandala Photography 🍰 Enjoy Cupcakes ❀ Ella & Louie ✉ PAPER by Paperless Post, calligraphy: Jasmine Yoon ⛺ Ambient Event Design, Event Décor Direct, Fusion Event Rentals, KeepLifeSimpleDesign at Etsy.com

p. 110 Kourtney and TJ
🏠 Delta Plantation, Hardeeville, SC 📋 Calder Clark 📷 Ryan Ray Photography 🍰 Minette Rushing Custom Cakes ❀ Blossoms Events ✉ Cheree Berry Paper ⛺ EventWorks, La Tavola, Nüage Designs, Snyder Rental

MODERN

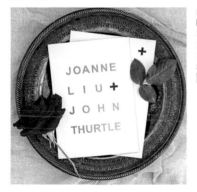

p. 118 Joanne and John
🏠 The James Leary Flood Mansion, San Francisco 📋 Lauren Geissler/ Downey Street Events 📷 Jesse Leake 🍰 The Whole Cake ❀ Waterlily Pond ✉ DIY ⛺ Got Light, La Tavola

p. 124 Jeff and Pete
🏠 Carneros Resort and Spa, Napa, CA 📋 Sarah Drake/Cole Drake Events 📷 Angie Silvy Photography 🍰 Carneros Resort and Spa ❀ M.Design ✉ Invitations and menu cards: DIY; escort and place cards: M.Design ⛺ Classic Party Rentals

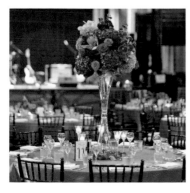

p. 128 Missy and Tom
🏠 Ceremony: Loring Pasta Bar, Minneapolis; reception: Varsity Theater, Minneapolis 📷 Melissa Oholendt Photography 🍰 Angel Food ❀ Wisteria Design Studio ✉ Lauren Tarbox Designs ⛺ Linen Effects

ROMANTIC

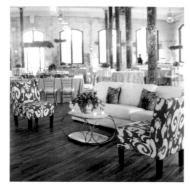

p. 136 Samantha and Chris
⌂ Ceremony: Greek Orthodox Church of the Holy Trinity, Charleston, SC; reception: The Cedar Room, Charleston, SC 📋 Lindsey Shanks/A Charleston Bride 📷 Ashley Seawell Photography 🎂 Ashley Bakery ❀ Palmetto Bloom ✉ Beckon Joy, Print Chas 🪑 BBJ Linen, A Charleston Bride, Innovative Event Services, Nüage Designs, Polished, Snyder Events, Technical Event Company

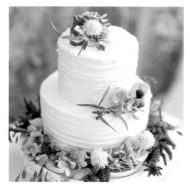

p. 142 Jennie and Daniel
⌂ Château du Grand Val, Combourg, France 📋 Loli Events 📷 Xavier Navarro Photographie 🎂 Beatriz Belliard Cake Design ❀ Flowerjugs ✉ Emily J. Snyder 🪑 Davoine Michel, Lesage Structure, Lomarec

p. 146 Lauren and Jeff
⌂ Ceremony: Founders Chapel, San Diego; reception: Rancho Valencia, Rancho Santa Fe, CA 📋 Laurie Arons Special Events 🎥 Joel Serrato Films + Photographs 🎂 Momofuku Milk Bar ❀ Flowerwild ✉ Amber Moon Design; calligraphy: Curlicue Designs Calligraphy 🪑 Casa de Perrin, Classic Party Rentals, Designing Life, Images by Lighting, La Tavola, Zephyr Tents

p. 150 Colette and Richie
⌂ Ceremony: Saint Barbara Parish, Santa Barbara, CA; reception: Four Seasons Resort The Biltmore, Santa Barbara, CA 📋 Jessica Kuipers/Bijoux Events 🎥 Joel Serrato Films + Photographs 🎂 Four Seasons Resort The Biltmore ❀ Ron Morgan Designs ✉ D.D. van Löben Sels, Union Street Papery 🪑 Bella Vista Designs, Classic Party Rentals, Elan Event Rentals, La Tavola

p. 154 Lauren and Andrew
⌂ Ceremony: The Episcopal Church of the Incarnation, Highlands, NC; reception: Old Edwards Inn and Spa, Highlands, NC 📋 Collins Coordination 📷 Jose Villa Photography 🎂 Lush Cakery ❀ Floressence Flowers ✉ Ellis Hill; Scriptura; illustrations: Arabella June; calligraphy: The Left Handed Calligrapher 🪑 Crush Event Rentals, Get Lit Special Event Lighting, La Tavola, Party Tables, Professional Party Rentals

RUSTIC

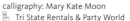

p. 162 Loreley and DJ
⌂ Ceremony: Teton Springs Resort & Club, Victor, ID; reception: Moose Creek Ranch, Victor, ID 📋 Day-of coordinator: Sandra Guido/Lovely Day Events 📷 Carrie Patterson Photography 🎂 Broulim's ❀ Magnolia Ranch ✉ Xowyo Paper + Press 🪑 Signature Party & Event Rental

p. 168 Kaitlyn and Kris
⌂ Terrain at Styer's, Glen Mills, PA 📋 Sara Doughty/Terrain 📷 Lauren and Tim Fair/Lauren Fair Photography 🎂 Nutmeg Cake Design ❀ Katie Blevins/Terrain ✉ Invitations: Minted.com; other: DIY 🪑 Terrain

p. 172 Kaylin and Anthony
⌂ Cerbo's Christmas Tree Farm, Branchville, NJ 📋 Winifred + Rose 📷 Jessica Olivero and Christina Block Photography/Jessica OH Photography 🎂 DIY ❀ DIY ✉ Andra Delores Design; calligraphy: Mary Kate Moon 🪑 Tri State Rentals & Party World

ADDITIONAL CREDITS

PAGES WITH MULTIPLE IMAGES ARE PROVIDED FROM LEFT, CLOCKWISE FROM TOP LEFT.

COVER

Dress: Mira Zwillinger; engagement ring: Mark Broumand; suit: Black Lapel; shirt: Bonobos; ties: The Tie Bar; wedding ring: Brilliant Earth; socks: Magnanni; shoes: Florsheim; florals: Jihyen Crowley, Gotham Florist

REAL WEDDINGS

p. 22: Xavier Navarro Photographie
p. 24: Jesse Leake

YOUR BOHEMIAN BLUEPRINT

p. 44: Erin McGinn Photography, Alice Donovan Rouse; The Nichols, Monarch Event Rentals, Davy Gray; Justin Wright Photography, Tenn Hens Design, You're Invited
p. 45: Koby Brown Photography, Katherine Lopez/Sweet August Events, Clementine Botanical Art; Emily Delamater Photography; Jeremiah & Rachel Photography, Goldfinch Events & Design at Glacier Under Canvas, Coram, MT

CEREMONY DETAILS

p. 46: Cambria Grace Photography, AE Events, Marc Hall Design; Jim Kennedy Photographers, Kismet Event Design, ATB Party Rentals, Classic Party Rentals, Raj Tents, Revelry Event Designers; Ashley Bosnick Photography, In Her Shoes Coordination, Visual Lyrics
p. 47: Care Studios, Destination Wedding Studio, Eventfully Yours; Valorie Darling Photography, Encore | Leslie Kaplan Event Design, Shawna Yamamoto Event Design; Luminaire Foto, Kehrin Hassan/Jet Set Wed, Island Events

YOUR CLASSIC BLUEPRINT

p. 66: Aaron & Jillian Photography; Sara Donaldson Photographs, Caroline Events, Bumblebee Linens, Lawson Event Rentals, Rusty Glenn Designs; Scott Clark Photo, Sacks Productions, Floral Art
p. 67: SMS Photography, Elizabeth Minch; The Nichols, Brock + Co. Events; Cly by Matthew Photography, A Formal Limousine at Rosecliff, Newport, RI

FLOWERS

p. 68: Heather Waraksa, In Any Event NY, Sayles Livingston Flowers, Classical Tents and Party Goods, Exquisite Events, Rentals Unlimited; Studio Uma; Callie Hobbs Photography, We Tie The Knots, Yonder Floral + Décor House, Eclectic Hive; Pen / Carlson, Clementine Custom Events, Revel Décor
p. 69: KT Merry Photography, Mt. Lebanon Floral; Riverbend Studio, Sabrina Hans Events, Shaadi Creations, Yanni Design Studio; Mint Photography, Whim Hospitality, Altared Weddings, Bee Lavish Vintage Rentals, Loot Vintage Rentals

YOUR ECLECTIC BLUEPRINT

p. 90: Justin & Mary, Petal Floral Design; T & S Photography, Foraged Floral, Rent Vintage Chicago, Revel Décor at Gallery 1028, Chicago; Redfield Photography, WeddingPaperDivas.com
p. 91: Hudson River Photographer, Jeff Brown/BrownHot Events, Carolyn Dempsey Design, Ketubah-Arts, La Tavola, Luxe Event Rentals, Resource One, Smith Party Rentals; Pure 7 Studios; Sasithon Photography, Harvest Real Food Catering, LICK Hudson

COCKTAIL HOUR

p. 92: Jen Lynne Photography, Bliss Weddings & Events, HMR Designs; Sara Donaldson Photographs, Lawson Event Rentals, Rusty Glenn Designs; Michelle Lange Photography; The Nichols; onelove photography; Michelle March, Ashton Events
p. 93: onelove photography, Off the Beaten Path Weddings; Perez Photography, DFW Chandelier Rental, M&M Special Events, Onstage Systems, Rent My Dust, Shag Carpet Productions, Renata Sharman, Photo Wagon; Marni Rothschild Pictures, Mac and B Events, B. Gourmet Catering

YOUR GLAM BLUEPRINT

p. 114: Gayle Brooker Photography, Ivy Robinson Events; Lisa Woods Photography, Drink Slingers; Kelli Boyd Photography, Lettered Olive
p. 115: Vero Suh Photography; Cambria Grace Photography, AE Events, Marc Hall Design, Be Our Guest Inc., Tommy Wholesale Products; Mel Barlow & Co., Alison Events at Oheka Castle, Huntington, NY

ESCORT CARDS

p. 116: Sweet Root Village, Cheers Darling Events, Laura Hooper Calligraphy, Buttercream Bakeshop; Vienna Glenn Photography, Polished Fun, Minted.com, LoveSupplyCo at Etsy.com; Adam Barnes Photography, Grit & Grace, Laura Hooper Calligraphy; Meg Perotti, Merrily Wed, Posh Paperie; Amalie Orrange Photography, Flaire Weddings & Events
p. 117: Samantha James Photography, Accents Floral Design, The Day's Design; Matt Lien, Hello Love Photography, Gus & Ruby Letterpress; Mary Wyar Photography, Brooke Lauber Cobb/Bee for the Day, Angel 101

YOUR MODERN BLUEPRINT

p. 132: Trent Bailey Studio; McCune Photography, Kelsey Events, Modern Art Catering; Sarah Kate, Photographer, Invited
p. 122: Amanda Megan Miller Photography, SQN Events, HMR Designs; Heather Waraksa, In Any Event NY; Corinna Raznikov Photography, Elegant Aura, Peterson Party Center at State Room, Boston

CAKES

p. 134: Milou + Olin Photography, Sweet on Cake; Addison Studios, Sweet Treets Bakery; Hunter Ryan Photo, Kakes by Karen; Sunglow Photography, The Pastry Studio; Mustard Seed Photography, Hannah Joy's Cakes; K.Corea Photography, McArthur's Bakery
p. 135: Kate Belle Photography, For Goodness Cakes; Melanie Gabrielle, Earth and Sugar; Julia Franzosa Photography, Amy Beck Cake Design, Liven It Up Events

YOUR ROMANTIC BLUEPRINT

p. 158: Carmen Santorelli Photography, Meadowsweet Events; VUE Photography at Atlanta History Center, Atlanta; Shannon Von Eschen
p. 159: Lisa Hessel Photography, Accents Floral Design; Mint Photography, Whim Hospitality; Vicki + Erik Photographers, Coral Pheasant Stationery, Niki Weeks

GUEST GIFTS

p. 160: Lauren Rosenau Photography; Dan Stewart Photography, Orchestrated Grace; Jodi & Kurt Photography, Kelley Cannon Events, Just Write Studios
p. 161: Emily Wren Photography, The Styled Bride, Love 'n Fresh Flowers; Michelle Beller Photography, La Fete Weddings; Carrie Patterson Photography, Anna Lucia Events

YOUR RUSTIC BLUEPRINT

p. 176: The Vondys; Lauren Fair Photography, Wildflowers by Design at Beech Springs Farm, Orrtanna, PA; Graham Terhune Photography
p. 177: Melina Wallisch Photography, Kristin Garuba Events, Three Branches Floral; Heather Waraksa, Luckybird Bakery; Justin & Mary, mStarr design, Julie Song Ink

EXITS

p. 178: Ali & Paul Co.; Perez Photography, Grit + Gold; Wedding Nature Photography; Justin & Mary; Carrie Patterson Photography, In Any Event LLC, The Writing Horse, Alltrans
p. 179: Liz Banfield, Bliss Weddings & Events; 1216 Studio Wedding Photography; Nicole Dixon Photographic, Madison House Designs

BACK MATTER

p. 226: Rico and Rachel Castillero/Studio Castillero
p. 234, **p. 240**: Ryan Ray Photography
p. 240: Alexandra Grablewski; blusher veil: Sara Gabriel; earrings: Jennifer Behr; wedding ring: Brilliant Earth; table, chairs, tablecloth, place settings, flatware, glassware: Wayfair Registry

ACKNOWLEDGMENTS

A large group of insanely talented individuals helped to create this beautiful book. I want to thank The Knot team: Kellie Gould, Kellee Kratzer, Rebecca Crumley, Lauren Kay, Kathy Nguyen, Maria Bouselli, Katie Kortebein, Shelley Brown, Farah Prince, and Katie Ragan.

In addition to the in-house team, I want to thank Meghan Corrigan and Meghan Overdeep, and the genius wedding pros who shared their ideas and support. And a big thank-you to DIY lifestyle designer Lia Griffith who partnered with us to create 20 original projects to help bring your wedding to life. We must also show our appreciation to Pernille Loof, the talented photographer who shot our crafts with the help of prop stylist Lisa Lee, as well as all the real wedding photographers who graciously shared their work with us—without them, this book would not exist. We would also like to thank the pros who worked with us on our cover shoot: photographer Alexandra Grablewski, florist Jihyen Crowley of Gotham Florist, and hair and makeup artist Gregg Hubbard of Bernstein and Andriulli.

A special thanks to our team at Potter, including our editor, Amanda Englander, our art director, Stephanie Huntwork, as well as our agent, Chris Tomasino. And finally, a big thank-you to all our Knotties, who keep planning the most incredible weddings and who inspired us to create this book.

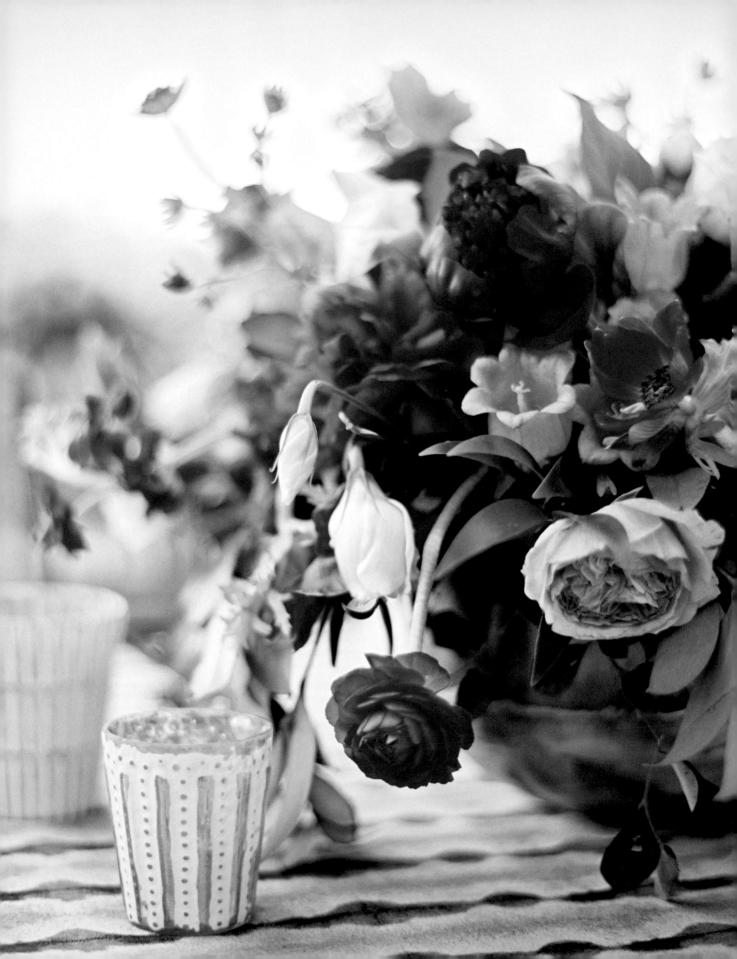

INDEX

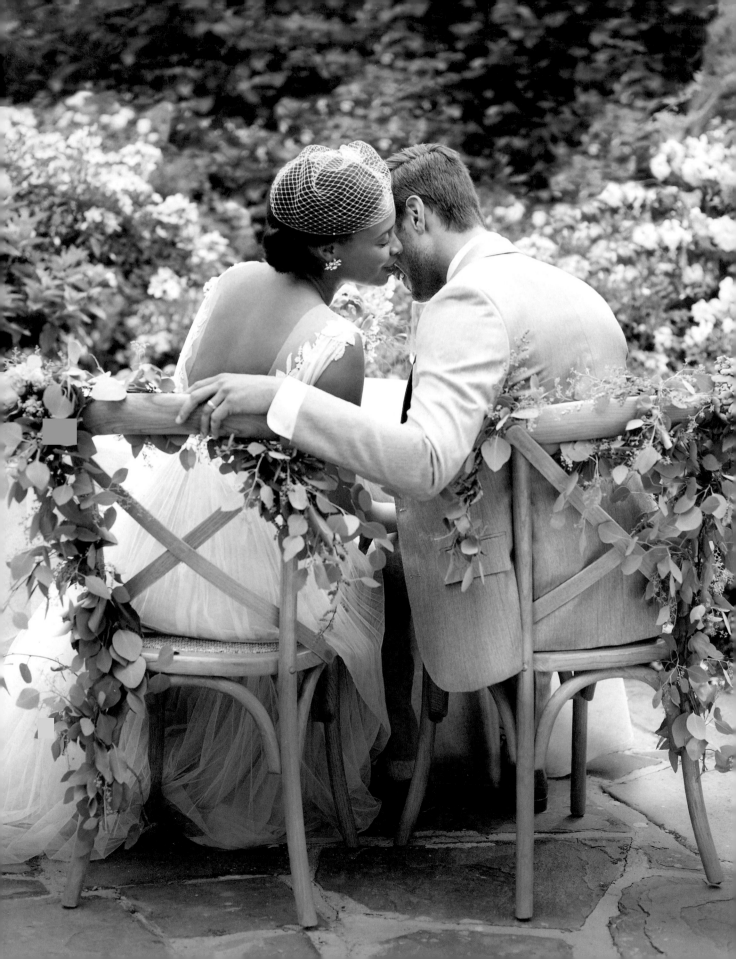